W9-BCK-152

CONTENTS

ABOUT THIS BOOK

This book is primarily concerned with the visual arts. It provides a clear and brief overview of some of the key debates that have shaped artists and art theorists concerns. As the book is arranged broadly chronologically, you will find some ideas, such as *truth, utility, beauty, form,* and *meaning,* are discussed more than once, as different ages reflect on them.

We have tried to use as many direct quotations as possible to help illustrate points. Direct quotations when they appear in speech-bubbles are always in quotes, other speech-bubbles contain more speculative dialogue.

INTRODUCTION

The most obvious place to start is by describing what art is. What could be simpler?

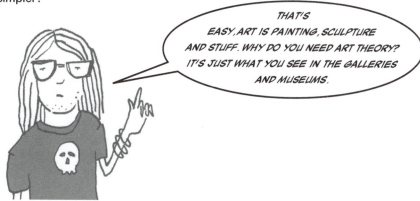

There is an everyday idea of what art is, but the problem is that it tends to break down—or break up—as you try to explain it. A separate, but related problem is to know if the art is any good. To do this you need a **theory of art**. A theory that explains both how you recognise art, what distinguishes it from other things, and what it is for.

Oscar Wilde 1854–1900, who was a great wit, once said:

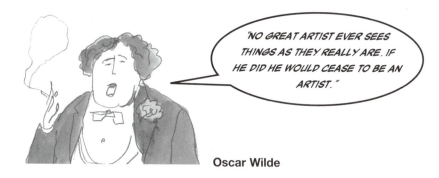

Oscar Wilde

This tells us that for Wilde:

Artists have superior insight.

Art represents reality. It does not present things "as they really are."

And artists are always men!

The assumptions that underlie this seemingly flippant comment by Wilde contain several ideas about art which are, in fact, a theory of art. Everybody has a theory of art, although they probably have not stopped to consider it.

1

EVERYBODY HAS A THEORY OF ART

Here are some old favourites:

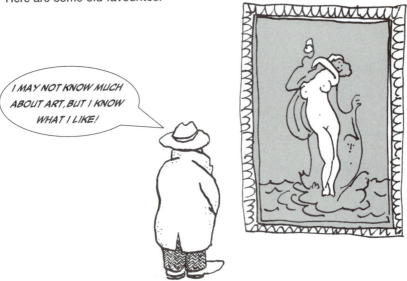

This theory doesn't get you very far, because art may well be about asking you to think about things you don't know or understand.

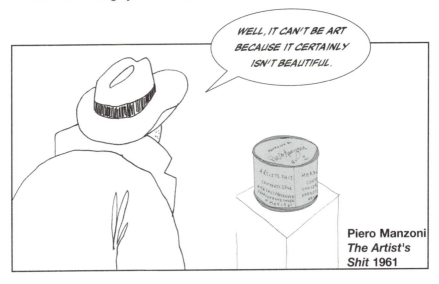

Piero Manzoni
The Artist's Shit 1961

The idea about what makes an object, or experience, attractive or beautiful came to be known as the theory of aesthetics. Therefore an art object was valued for itself alone and not for its purpose or function. But, nowadays, plenty of art isn't attractive or beautiful and isn't meant to be—it might well be ugly and a bit gross. So this theory, although once very important, now seems less useful when looking at art.

Sometimes commercial value and artistic value get confused:

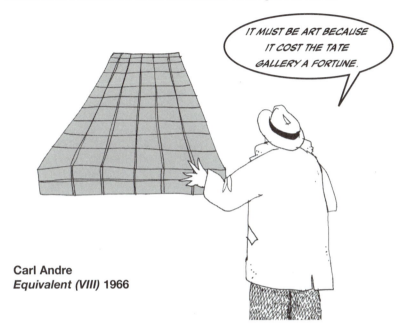

Carl Andre
Equivalent (VIII) 1966

So, it is worth remembering that:

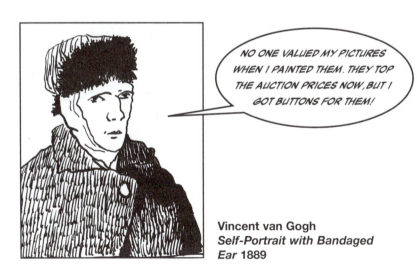

Vincent van Gogh
Self-Portrait with Bandaged Ear 1889

The point is, that what is valued as art today may not be later, and the *idea* of what art is today is very different from the idea of what art was in say, the 1960s, let alone van Gogh's day or the Renaissance. Our appreciation of these differences adds to our interest in art.

WHAT ACTUALLY IS ART THEORY THEN?

A theory is basically a reflection, often a self-reflection, on things we see and understand. Art theory is a set of principles that attempts to reflect on why we describe certain objects or events as art, and which can help identify common characteristics of works of art.

What we can say for sure is:

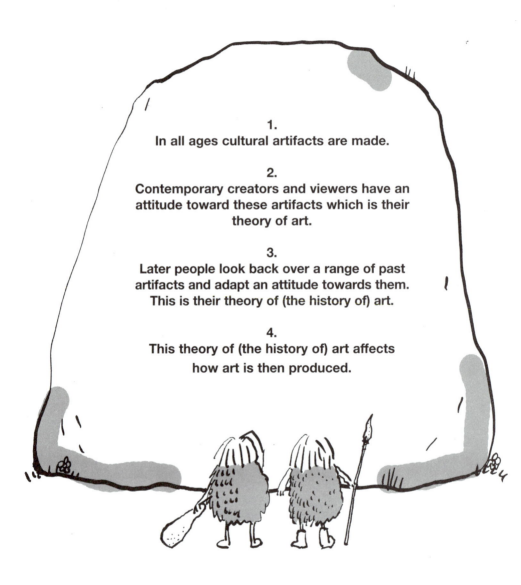

1.
In all ages cultural artifacts are made.

2.
Contemporary creators and viewers have an attitude toward these artifacts which is their theory of art.

3.
Later people look back over a range of past artifacts and adapt an attitude towards them. This is their theory of (the history of) art.

4.
This theory of (the history of) art affects how art is then produced.

Any theory of art will need to be able to answer the questions a particular age thinks are relevant for art:

But given that art is so complicated why don't we just have a history of art?

The problem of having a history of art is that in order to arrange your material you need a theory of art: when art started, what it is, and how it developed. Some people argue that art started with the Greeks and ended with **Marcel Duchamp** 1887–1968, but that is really just one theory of classical Western art; and although it has proved very popular, it's certainly a theory with limitations.

THE NEXT QUESTION IS WHERE TO START?

> ART STARTED WITH CAVE PAINTING, GOT SPEEDED UP BY THE GREEKS, FORGOTTEN ABOUT FOR AWHILE AND THEN REINVENTED IN THE RENAISSANCE. THE ROMANTICS MADE IT ALL PERSONAL AND NOW IT'S VIDEOS, INSTALLATIONS AND STUFF.

This pretty much sums up the common-sense idea of the history of art, and of course it is both completely wrong and kind of right at the same time.

It is an illusion that current ideas of art are universal, that is to say they represent some quality that goes back to the Greeks or beyond. This is a retrospective invention in which we paint a history of art as being a development towards the universality of art, which is itself an Enlightenment idea.

Paleolithic man, the Greeks, and all the cultures in between, didn't talk about art like we do. Even the great artists of the Renaissance had different ideas as to what art was. They would all have had their own theories about what they were making.

THE WORD *ART*

The word *art* comes from the Latin *ars,* which roughly translates as "skill" or "technique" and this is an important idea. If you are trying to find a category that fits across all eras and cultures the idea of images, and objects, being skillfully or technically put together is a useful notion.

This is one definition of art—that, whatever it is, an art object was at some point technically made or arranged. It's not exactly a brilliant definition but it's quite a good starting point. Above all it reminds us that art is a man-made activity.

WOULD YOU LOOK AT THOSE EXQUISITE FLOWERS, THEY'RE VERY SKILLFULLY ARRANGED, DON'T YOU THINK?

The idea of the *invention* of art is an important approach to how we theorize art. Once you realize art was invented, then you have to start thinking about who invented it, when they did, and why. In other words, to have a theory about art.

To develop a theory of art we need to think about the nature of art. We need to consider how it develops, and the practices that have given it shape. The nature of art, we know, will never be fixed. It will continually change through time. In general terms, this means thinking about what artifacts people were making at various times, and what significance they gave them:

It's kind of like when is a pot not a pot?

Ming Vase
1431

WHAT DO YOU MEAN? I AM NOT JUST ANY OLD POT!

9

WAS THERE ART BEFORE ART?

There wasn't much written before the great early civilizations of the Egyptians, Assyrians and Greeks. So we don't really know what older cultures thought about the artifacts they were making, whether they singled out some of them as special or different like we do. Until there was writing we don't really know what the contemporary motivations of the makers were. We only have the objects themselves and we impose interpretations onto them.

We can see the beautiful cave paintings made by **Paleolithic** man but we haven't the foggiest notion of his reasons for making them. The oldest known cave painting is 27,000 years old (in Angoulême in Western France) and although it might look like a Picasso we can be absolutely sure it was made for very different reasons.

Paleolithic man, would certainly have had an idea about why he was making drawings, perhaps something spiritual, or ritualistic, and to do with a visual language. This would have been his theory. Perhaps it was to help him catch woolly mammoths.

A lot of recent scholarship about cave painting stresses the way that the paintings may have been one small part within Paleolithic man's creative activities. The drawings often mimic shadows on the cave wall, so fire to give light might have been important, and the acoustics of the caves are also sometimes special, so perhaps caves were used for chanting or singing as well.

The one thing we can be certain of, though, is that this prehistoric time lasted a very long time (for tens of thousands of years), and although we have objects from caves and the **Stone Age** and the later **Bronze Age** 4000 B.C., we can only speculate as to why each culture made the artifacts in the way they did. Why are some Bronze Age artifacts so beautifully decorated? What sort of function would they have served? We don't know their theories; we just have later interpretations of their history. And sometimes their artifacts or activities have been called art.

The three great civilizations before the Greeks 776–146 B.C. were the **Egyptians** 3500–30 B.C. from by the Nile, and the **Babylonians** and **Assyrians** 3500–400 B.C. from Mesopotamia. These cultures, although quite different, have given us a lot of wonderful objects which we now look at and think about as art. Of course we do know that these cultures didn't think of these objects as art, at least not in the way we do—because our theory of art is a recent concept.

Egyptian culture was very pictorial. They wrote in hieroglyphics, which were visual symbols of the world around them, and made wonderful paintings and sculptures to decorate their buildings, particularly their temples, pyramids and tombs. In Egypt, paintings would have been made by craftsmen. There was a big crossover between writing and pictorial painting, with craftsmen who were proficient at hieroglyphics moving on to make paintings, so both can be seen as part of the same discipline.

The Egyptians painted the world they knew—so we can look at their paintings and find out a lot about life in ancient Egypt. They celebrated the lives of the pharaohs, who were almost God-like, and their subjects, the general populace. Egyptian art is often characterized by the flat poses they used to draw figures, a technique now called *frontalism*. They arranged scenes with the background above the figures. With depictions of the pharaohs it was very important that nothing obscured any part of the pharaoh. This style of working although different from our own is not unsophisticated—in fact it is highly sophisticated—and shows a way of making representational art that is very detailed—nothing is hidden.

We don't know how Egyptians judged the value of what they made. By looking at the artifacts that survive from the most important tombs of the most important pharaohs, value was perhaps something to do with detail, or *nfr*, which is the Egyptian word for *youth, perfectness* and *goodness*.

YEAH, YEAH, I KNOW:
DIE YOUNG, STAY PRETTY.

The other thing that ancient Egyptian art valued, as their whole civilization did, was tradition. The Egyptian civilization lasted about 3000 years, a huge length of time, and stylistically and ideologically they liked things to be done as they were in the past. Therefore, most Egyptian art remains stylistically similar.

There is, however, an exception.

A pharaoh called **Akhenaten** 1370 B.C., who ruled for actually quite a short time, rejected the traditional Egyptian way of doing things, specifically its pantheon of Gods. He embraced a form of monotheism based on worshipping the sun, and had all the temples containing the old art closed. The art from Akhenaten's reign is decidedly different from traditional Egyptian art. It embraces a form of naturalism. In many ways it looks more like the later Greek art, which it may well have influenced. After Akhenaten's short reign Egyptian art returned to the traditional way of doing things. Akhenaten's theory of art was rejected by the later pharaohs.

The other very ancient civilizations were near Mesopotamia. The **Babylonians** and **Assyrians** made many objects. What survives are beautiful statues and carvings which are very different to the artifacts from Egypt. They were not so interested in everyday scenes of everyday people, but made a courtly art depicting hunting and warfare.

We don't know much about either of these cultures' own theories of making, what we do know is that we don't know their particular theory of art, we just have our own theories on it.

THE GREEKS

Ancient Greece was made up of a very dynamic series of city-states, including Athens, Corinth and Sparta. They were united by religion, sport, and a culture which was very much open to new ideas and change. They loved debating ideas, philosophizing, making theories, and progress. They also made extraordinary art. They built temples, carved statues, decorated vases, and even made paintings, but most of the paintings have been lost. With their love of art and love of discussion they are bound to be important for art theory.

We know the Greeks, like the older civilizations before them, didn't have a word for art, and therefore didn't have a specific concept of art. The closest they get is using the word *techne* which, like the Latin *ars*, really translates as "skill," and can be used to describe anything from the painting of a picture, to the ploughing of a field.

The Greek philosopher **Plato** 428–354 B.C. famously wrote about art in his great work ***The Republic,*** written in the 4th century B.C.. Chapter 10 is like his theory of art, in which he rejects art as a practice because he says every art object is really just a degraded version of the *ideal.* In his **Theory of Ideal Forms** Plato sees truth lying in the idea outside of reality. With reality being a copy of the ideal, art becomes a copy of a copy, and a confusion from the ideal. For Plato, art is therefore against truth, it is a form of play and not to be taken at all seriously. **Aristotle** 384–322 B.C. though, who was a generation younger than Plato, did accept the idea of representation:

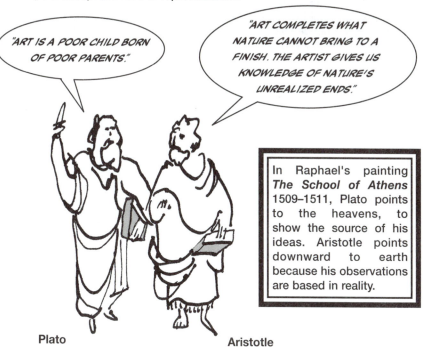

"ART IS A POOR CHILD BORN OF POOR PARENTS."

"ART COMPLETES WHAT NATURE CANNOT BRING TO A FINISH. THE ARTIST GIVES US KNOWLEDGE OF NATURE'S UNREALIZED ENDS."

In Raphael's painting *The School of Athens* 1509–1511, Plato points to the heavens, to show the source of his ideas. Aristotle points downward to earth because his observations are based in reality.

Plato Aristotle

ARISTOTLE AND ART

Aristotle, unlike Plato, didn't see art as a degraded form of play, but as a way of representing the inner significance of things. He didn't actually write about art, he wrote about poetry, but his views are seen to connect with art because he talks a lot about *mimesis,* which means in Greek *imitation*. It is this idea of art as being a transcription or copy that has proved such an enduring one in the western world. For Aristotle, the closer an art object is to the thing it depicts the better it is. The purpose of art was that it offered *unity*. A work of art should be *complete* in itself. It would need no further addition or refinements, and would appeal both to the emotions and to the intellect. He also thought, like Plato, that beauty was an objective quality *inherent in* an object rather than existing only in our *response to* that object.

THE MIMETIC THEORY OF ART

There are many Greek stories recounting the mimetic theory of art. Perhaps the best known are **Zeuxis and Parrhasios** and the **Maid of Corinth**.

Zeuxis and Parrhasios, who were Greek artists, had a competition to see who was better at painting—to see who could make a painting that looked most like the thing it depicted. Zeuxis painted grapes that were so life-like birds tried to peck them, but Parrhasios fooled his rival by painting a curtain that Zeuxis tried to open to reveal the picture behind it, so Parrhasios won.

The Roman writer **Pliny the Elder** A.D. 23–79 gives an account of the Greek legend of the invention of drawing, in his *Natural Histories.* The story goes that, when the **Maid of Corinth's** lover was departing to go and fight in a distant war, she noticed how his shadow had been cast by a candle on the wall of their room. She picked up a piece of charcoal and drew round the shadow, and created a perfect likeness or mimetic image.

IS IT BETTER TO BE BEAUTIFUL?

Plato and Aristotle couldn't really agree on art, but they did agree that objects should try and be useful and beautiful. Plato talked about beauty in terms of an object's *suitability* and *utility* for its purpose. In other words, if a thing is fit for its function then it will be beautiful. This idea of *functionalism* re-occurs throughout the history of Western art. Aristotle likewise thought objects should possess a unity of form.

This poses a basic theoretical problem: are beauty and utility related? The idea of beauty as functional design continues right through to the present day. You need only think of the Modernist Bauhaus artists championing the "economy of form," "truth to materials" and that "form follows function."

The problem with this functionalist approach, is that it doesn't explain how useless things can be beautiful.

A CRETAN EXPLAINS GREEK ART

In the West we have a history of art that often starts with our favorite people, who, of course, are the Greeks.

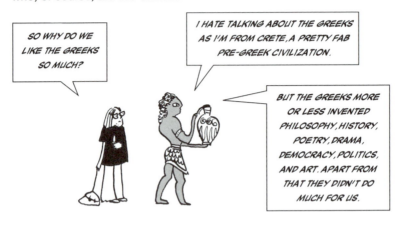

SO WHY DO WE LIKE THE GREEKS SO MUCH?

I HATE TALKING ABOUT THE GREEKS AS I'M FROM CRETE, A PRETTY FAB PRE-GREEK CIVILIZATION.

BUT THE GREEKS MORE OR LESS INVENTED PHILOSOPHY, HISTORY, POETRY, DRAMA, DEMOCRACY, POLITICS, AND ART. APART FROM THAT THEY DIDN'T DO MUCH FOR US.

THEN WHAT'S THE POINT ABOUT GREEK ART?

THE POINT IS THAT THEIR PORTRAYAL OF THE HUMAN FORM WAS A KIND OF QUANTUM LEAP IN IDEAS ABOUT ARTISTIC REPRESENTATION.

WELL, THEIR WAY OF MAKING ART OBJECTS WAS VERY DIFFERENT TO EVERYTHING THAT HAD GONE BEFORE, AND WAS VERY SOPHISTICATED. THEIR REPRESENTATION OF THE HUMAN FORM WAS VERY DETAILED, REALISTIC AND NATURALISTIC. OR, IN OTHER WORDS, IT WAS VERY DIFFERENT TO MOST OF THE PRECEDING ART WHICH WAS FORMAL, ABSTRACT AND OFTEN TWO-DIMENSIONAL.

IN ENGLISH PLEASE.

"THE ACHIEVEMENTS OF GREEK ART ARE OUT OF ALL PROPORTION TO THEIR SOCIAL DEVELOPMENT."

"IN ALL HISTORY, NOTHING IS SO SURPRISING OR SO DIFFICULT TO ACCOUNT FOR AS THE SUDDEN RISE OF CIVILIZATION IN GREECE."

SO WHAT DOES ALL THAT MEAN IN SIMPLE LANGUAGE?

Karl Marx
181–1883

Bertrand Russell
1872–1972

THAT THE GREEKS CREATED A WHOLE NEW WAY OF LOOKING AT THE WORLD, AND OF MAKING IMAGES ABOUT IT, THAT WAS UNIQUE IN HISTORY AND AFFECTED THE ROMAN'S AND THE WHOLE OF THE CLASSICAL WORLD. THE GENIUS OF THIS CLASSICAL ERA WAS LATER FORGOTTEN AND REEMERGED DURING VARIOUS RENAISSANCES.

SO WHY DID IT TAKE UNTIL THE RENAISSANCE TO BE AWARE OF THIS?

ACTUALLY ONLY THE WESTERN WORLD HAD TO REDISCOVER THE CLASSICAL ERA, THE EASTERN AND ARAB WORLDS KNEW A LOT ABOUT IT. IN OUR TRADITIONAL WESTERN VIEW OF HISTORY AND THEORY ONLY THE WESTERN VIEWPOINT COUNTS.

WELL THAT'S A BIT UNFAIR, ISN'T IT?

17

ROMAN ART AND LATE CLASSICAL ART

The Romans conquered Greece and were bowled over by the sophistication and beauty of Greek art. They brought masses of Greek artworks to Rome as the spoils of war, and put them on display in their squares and gardens. In doing this they were really decontextualizing Greek art. Removing the sculptures from their original sites, from the temples, and exhibiting them as trophies changed their meaning.

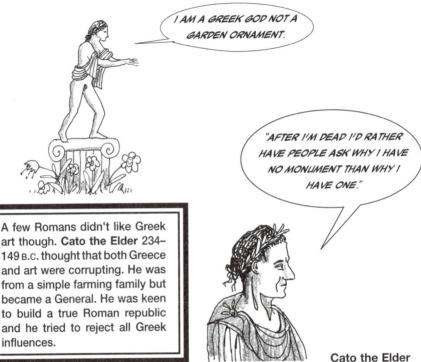

I AM A GREEK GOD NOT A GARDEN ORNAMENT.

"AFTER I'M DEAD I'D RATHER HAVE PEOPLE ASK WHY I HAVE NO MONUMENT THAN WHY I HAVE ONE."

A few Romans didn't like Greek art though. **Cato the Elder** 234–149 B.C. thought that both Greece and art were corrupting. He was from a simple farming family but became a General. He was keen to build a true Roman republic and he tried to reject all Greek influences.

Cato the Elder

The Romans ignored Cato and began copying what they were stealing, in fact it's hard to say if many Classical artworks are actually Greek or Roman. The **Emperor Augustus** 31 B.C.–A.D. 14 was very keen on promoting Greek art, so his theory of art was 'more sophisticated de-contextualized Greek copies, please'.

The Romans did invent some things though. They created **civic sculpture**. The statue of the ***Roman Emperor Marcus Aurelius*** A.D. 2, in Piazza del Campidoglio in Rome, is both a portrait and a political monument. So, it's thanks to the Romans that we have equestrian sculptures of generals in more or less every city in the West.

Late Classical art, in both Greece and Rome, became increasingly stylized. It seems less to do with faithful mimetic representation and beauty, but hints at strong psychological and emotional charges. It is a very expressive art, which is very different from earlier Classical work. This progression, or deterioration, from one style to another was to become important in theorizing about how art develops.

ANTIQUITY

In terms of a theory of art, there are a number of key historical questions and problems arising from the early Classical periods:

1 Although the Greeks and Romans didn't talk about *art* in the way that we do, they clearly had some idea about well-made or beautiful things that were created by skilled people or craftsmen.

2 Mythology gave interesting ideas and examples about the Gods and their power to create—ideas which suggest a theory of art without spelling it out. In the Greek legend **Orpheus** is seen as a God whose music charms the world, and its power can be seen as analogous to the capacity of art. In other words people thought in a mythological sense.

3 The Greeks seriously tried to catch the nature of man in their art and to represent *character*, *soul*, and the *emotions*. Thus we have the beginnings of all of the theoretical questions about what art is for, and how it achieves its *effects*.

4 The Greeks also raised the idea of *inspiration* which relates to the creative ideas of the artist, and the concept of *genius*.

5 The Roman writer Pliny, in his *Natural Histories* talked about the power of images and illusion, thereby returning to the question of *mimesis*, of copying reality. This is the beginning of the complicated question of what art does, and of how it represents the world as we know it.

6 The only surviving theoretical text on art which is complete is, **On Architecture** by the Roman writer **Vitruvius** 70 B.C.–25 B.C.. This means that a lot of our ideas about what the Greeks and Romans thought of art has to be deduced from fragmentary texts, comments and from things philosophers at the time said, or were reported to have said.

THAT LEONARDO NICKED ALL MY BEST IDEAS.

Vitruvius

Leonardo da Vinci
Vitruvian Man 1492

ART AND RELIGIONS

At the time of the fall of the Roman Empire in the West A.D. 476, there were many other thriving cultures in the world, all with different traditions. Eastern art was much more influenced by ideas derived from religion, and stylized or symbolic designs. Eastern philosophy, in all its infinite varieties, is generally more holistic, and interested in poetics and the ideal, than Western philosophy. In essence a lot of Eastern art is about contemplating the natural world, in order to think of greater things.

BUDDHISM

In the Indian subcontinent in 500 B.C. there was a holy man called **Gautama Siddhartha** 563–483 B.C., who had rejected a life of luxury for one of simple meditation. He sat under a fig tree in contemplation and became enlightened. Later generations called him the "Enlightened One" or Buddha. His philosophy was very simple: to achieve happiness and peace in the world, people needed to stop wanting things and wish for nothing. If people could do that, they would enter *nirvana*.

Buddhist artists looked beyond the surface to discover the reality that lay underneath it, the appearance of things wasn't as important as the spiritual values that could be drawn out of the *act* of painting or illustrating. Early Buddhist art reflects closely the teachings of the Buddha. For example, a wheel depicting the essence of Buddhist teaching, "The Four Noble Truths," were symbolically painted, and sometimes carved as footprints to show the impact of Buddha's beliefs on the world.

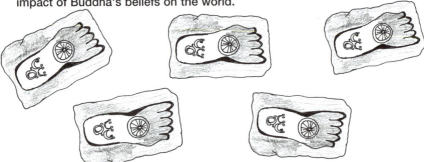

In fact, in early Buddhist art there seems a real reluctance to show symbols of the Buddha himself. Figurative representations of the Buddha only started after the conquests of **Alexander the Great** 356–323 B.C. brought the influence of Greek culture to the Indian su B.C.ontinent.

Buddhism was not confined to India though. It spread across the whole of the East, initially to China and then beyond. Each region adapted indigenous and vernacular styles of art making to celebrate the Buddha and his teaching. In Japan there was an interesting crossover between Buddhism and the Shinto religion. Shinto was an ancient set of beliefs based on ancestor worship. In Shinto temples there are, not only no figurative representations, but also the art was made to be destroyed every 20 years. The Shinto theory of art is that art should be impermanent and nonfigurative.

CHINA

There were two other great religions in the vast Chinese Empire as well as Buddhism: Taoism and Confucianism. These three religions were not totally opposed to each other. **Confucius** 551–479 B.C. was a great teacher and developed a philosophy that was about people living together in peaceful harmony. The essence of Confucius' teaching was observing "tradition," "outward appearances," and "the family." **Lao-Tzu** b.604 B.C. was more spiritual and magical than Confucius. He saw a special life-force, or **Tao**, inhabiting everything in the world, and believed that people needed to respect this force, in a similar way to grass responding to the power of the wind.

TAOISM

Lao-Tzu's teaching was both spiritual and supernatural. Taoist art, while sharing some ideas with Buddhist art—such as enlightenment through contemplative making—is remarkably different in other areas. The Buddhist gains nothing, except the realization that there is nothing to gain, when he becomes enlightened. This is the opposite of the Taoist sage, who acquires special knowledge, that removes him from the world. Taoists were more interested in the real world than Buddhists. Taoist artworks often contain dragons or magical scenes, so the importance of representation, albeit fairly fanciful representation, is vital to the Taoist artist.

CONFUCIUS IN CHINA

The **Analects of Confucius** *500* B.C. describe the conception of painting that was generally accepted in the Chinese tradition. It was used as the introduction of the great **Catalogue of the Imperial Collection of Paintings** *6–1* B.C.

> *"DIRECT YOUR ENDEAVOURS TOWARDS THE TAO, SUPPORT YOURSELF UPON ITS ACTIVE FORCE, FOLLOW SELFLESS HUMANITY AND INDULGE IN THE ARTS. AS TO THESE ARTS, A SCHOLAR WHO IS STRIVING FOR THE TAO MUST NEVER NEGLECT THEM, BUT HE SHOULD MERELY TAKE A DELIGHT IN THEM AND NO MORE. PAINTING IS LIKEWISE AN ART. WHEN IT HAS REACHED THE LEVEL OF PERFECTION ONE DOES NOT KNOW WHETHER ART IS THE TAO OR TAO ART."*
>
> CONFUCIUS

Confucius makes it clear that art is essentially about the activity of *doing* or *making*, and this is similar in both Taoism and Buddhism. It is in the actual *making* of art that perfection lies. The art could be a carefully transcribed saying by Confucius, executed with a calligraphic brush stroke, that expressed in its perfection a philosophical abstraction.

> *WHERE'S MY SMOCK? IT'S TIME FOR MY ART CLASS.*

For Confucius, scholars, gentlemen or noblemen should be involved in art, in order to cultivate their character, and to understand the "essence of things." Art was a method of self-improvement and devotional contemplation.

IN THE WEST CLASSICAL ART WAS FORGOTTEN

AFTER THE COLLAPSE OF THE ROMAN EMPIRE WESTERN EUROPE DESCENDED INTO WHAT IS POLITELY CALLED THE DARK AGES.

WHAT IS IT CALLED IF YOU'RE NOT POLITE?

DON'T BE CHEEKY YOUNG MAN, IN THE REALLY DARK AGES, THEY BANNED CANDLES AS SINFUL.

OK, BUT WHAT DID IT MEAN FOR ART? APART FROM THE FACT THAT YOU COULDN'T PAINT AT NIGHT.

EVERYONE HAD FORGOTTEN THE QUALITIES AND IDEAS IN GREEK AND ROMAN ART, AND NOW HAD TO PAINT IN THE APPROVED CHRISTIAN WAY, WHICH MEANT REFLECTING THE IDEA OF THE DIVINITY AND GLORIFYING GOD. THERE WAS SOME SECULAR ART TOO, BUT CHURCH AND STATE WERE VERY MUCH ENTWINED AT THIS MOMENT. TO PUT IT BROADLY THE POINT OF MOST ART WAS TO GLORIFY GOD.

THE EASTERN EMPIRE

The Roman Empire only fell in the West while the Eastern Empire, set up in Constantinople in 313, continued until its capture by the Turks in 1453. After the fall of Rome, Constantinople, also known as Byzantium, was the premier and most civilized city in the Mediterranean. It was also Christian, and it is this Christian Byzantine art that survived. At this time the Christian doctrine on art was pretty straightforward, **Pope Gregory** 540–604 in Rome had proclaimed: "Pictures are used in the churches in order that those ignorant of letters may by merely looking at the walls read there what they are unable to read in books."

The wall **mosaics** in Byzantine churches reflect wealth, light and color. These vivid, inspirational, and educational artworks, were meant to be awe-inspiring on every level. The lavishness of them is important: through wealth they show the power and authority of the church and the Christian message.

Icons became popular throughout the Eastern Empire. They are literally an image of Christ or a saint. They are stylized and tend to look similar, the reason being, that the artist making them was thought to be expressing God's vision rather than a worldly one. The icon was not seen as a man-made image but rather as a divine one. Therefore, any trace of artistic personality was thought to be bad.

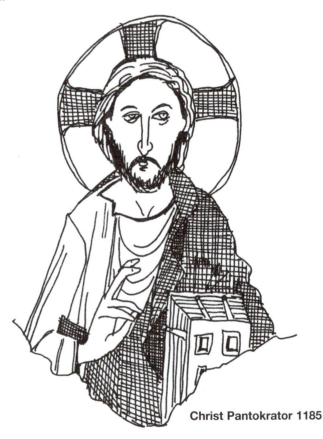

Christ Pantokrator 1185

ICONOCLASM

The theory that separates icons from man-made images was vital to the early Eastern church. It was continually debating whether the holy could be shown in paint. The **Ten Commandments,** that the prophet Moses received, were very specific on this point:

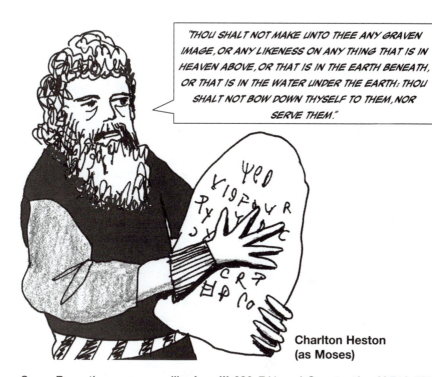

"THOU SHALT NOT MAKE UNTO THEE ANY GRAVEN IMAGE, OR ANY LIKENESS ON ANY THING THAT IS IN HEAVEN ABOVE, OR THAT IS IN THE EARTH BENEATH, OR THAT IS IN THE WATER UNDER THE EARTH; THOU SHALT NOT BOW DOWN THYSELF TO THEM, NOR SERVE THEM."

Charlton Heston (as Moses)

Some Byzantine emperors, like **Leo III** 680–741 and **Constantine V** 718–775, thought that religious images encouraged **idolatry** and were blasphemous. Idolatry was thought to be a pagan sin, and one clearly banned by God's revelation to Moses. Consequently, during the 8th and 9th centuries nearly all the mosaics and icons in the churches within the Empire were destroyed, as well as a lot of the monasteries where they were made. This **Iconoclasm,** or breaking of images, reoccurs throughout world history, because Judaism, Christianity, and Islam all regard Moses as a prophet. The Iconoclastic Controversy centered on interpretations of biblical words (or theories) being read in different ways. Both sides saw a distinction between an image and what it depicts; for the Iconoclasts this meant that the icon was only pretending to be God, and was therefore blasphemous as well as idolatry; for the icon supporters it meant that since the image was clearly a representation, it followed that it was impossible to make a graven image like God, and consequently the charge was meaningless. Iconoclasm is important when thinking about art theory. It shows how the interpretation of theories varies, and how theoretical positions may dictate what happens in the visual arts. If the controversy hadn't been sorted out, by a synod in 843, with the so-called "Triumph of Orthodoxy," where religious imagery was reinstated, it is even debatable if we would have much Western art at all.

ISLAMIC ART

Islam is a relatively young religion, compared to Buddhism, Taoism and even Christianity or Judaism, but it soon became a powerful world force.

Islam is the religion of Muslims, and means, in Arabic, the "submission to the will of God (or Allah)." The **prophet Mohammed** A.D. 570–632 had two visions of the angel Gabriel near Mecca, in what is now Saudi Arabia. The Prophet realized that in these visions God had spoken directly to him. It is worth noting, that the followers of the Prophet spread over an immense geographical area, stretching from Spain and North Africa, via the Middle East, across to Southeast Asia. Consequently, there are many different forms of Islamic art, ranging from traditional folk art to that of highly skilled artists and craftsmen.

Islamic art rejected the naturalism of the Western tradition, and this leads to much Islamic art being abstract, geometric, floral, and decorative. The Prophet's teaching does not explicitly ban representational art, but chapter 42, verse 11 of the **Koran** does say: "(Allah is) the originator of the heavens and the earth . . . (there is) nothing like a likeness of Him." And this, coupled with a later warning against idolatry, results in the Islamic tradition of not depicting people or animals in their art. There are some exceptions though—and there even exist a few paintings of Allah himself.

Islamic art is clearly very different from the dominant Eastern and Western traditions. It is based on a theory that sees the main function of art as glorifying Allah through beauty and writing. Out of all the visual arts, calligraphy has been most highly regarded as a fine art by Islam. Often quotes from the Koran are used to adorn all sorts of things, and feature intricate and complicated designs that are based on "sacred geometry."

SACRED GEOMETRY

In Islamic society, not only does art reflect its cultural values, but even more importantly, it reflects the way in which Muslims view the spiritual realm, the harmony of the universe, the whole of life, and the relationship of the parts to the whole. Islamic art displays a harmony of form, function, and the aesthetic that is unique, but is also in some senses set, as it does not encourage change. This unity of form, style, technique, and purpose is particular to Islamic art but its variations are almost limitless. Much of this variation and structure is based in mathematics, which originated in the Indian su B.C.ontinent and Arabian countries. Indeed Western numerals are Arabic, and the word algebra derives from the name of a book, *Al-Jabr-wa-al-Mugabilah,* by the Muslim scholar **al'Khwarizmi** A.D. 780–850. Muslim scholarship saw correlations between their sacred text and mathematical computation, including the geometry that was revealed in observing the planets. One of their big inventions was the concept *zero,* which enabled far more complicated sums to be done than before. Islamic scholars embraced Greek philosophy and mathematics, translating and disseminating this knowledge for posterity. The cultivation of mathematical analysis combines well with the ascetic spirituality of their religion. The works of the Greeks, **Euclid** 325–265 B.C. and **Pythagoras** 580–500 B.C., were among the first to be translated into Arabic, together with Aristotle's books, and it was through these translations that the West later rediscovered much of the classical past.

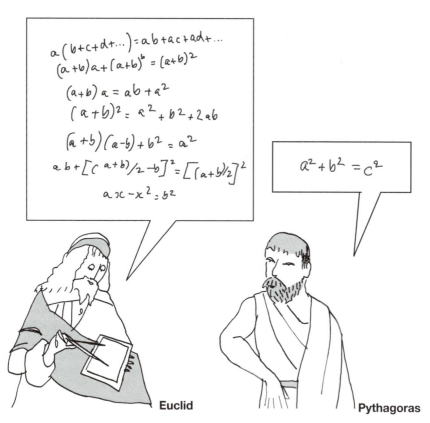

Euclid

Pythagoras

CHRISTIAN ART

WHAT HAPPENED IN THE MIDDLE AGES?

PEOPLE GOT TIRED AND SLEPT A LOT...

NO, I MEAN WAS THERE VIKING ART, OR JUST MIDDLE-AGED ART?

SOMETHING CURIOUS HAPPENED TO WESTERN ART IN WHAT WE LOOSELY CALL THE MIDDLE AGES; IN ONE WAY IT BECAME RATHER MORE LIKE EASTERN ART, CONNECTED TO A WIDER RELIGIOUS SENSE. THE DOMINANCE OF CHRISTIAN THOUGHT MEANT THAT THE GREEK IDEAS OF NATURALISM WERE ALTERED BY THE THEOLOGICAL IDEA THAT MAN WAS A CREATION OF THE SUPREME BEING AND EVERYTHING HAD TO BE ADJUSTED TO THAT.

SOUNDS LIKE STAR WARS!

CHRISTIAN ART BECAME A BIT PROPAGANDISTIC, GLORIFYING GOD, AND TELLING THE CHRISTIAN STORY, TO A NONLITERATE AUDIENCE. IT WAS LIKE A HUGE EDUCATIONAL COMIC.

MEDIEVAL ART

In the turbulent period after the fall of the Roman Empire in the West, a number of European kingdoms emerged, with the shared religion of Christianity acting as a unifier. Very early Medieval art was stylistically simple, but a little later with **Carolingian** art (800–870, during the reign of Charlemagne) and **Romanesque** art (11th–12th centuries) there grew a deep respect for Classical and Eastern forms. This was picked up particularly by the Crusaders who discovered Islamic culture while fighting to *liberate* Christ's tomb, in Jerusalem, from the Muslims. In art-speak **Gothic** refers to art and architecture in the 12th–16th centuries—the name came from the later Renaissance artists who thought this earlier work was so very unsophisticated it must have been made by Barbarians or Goths.

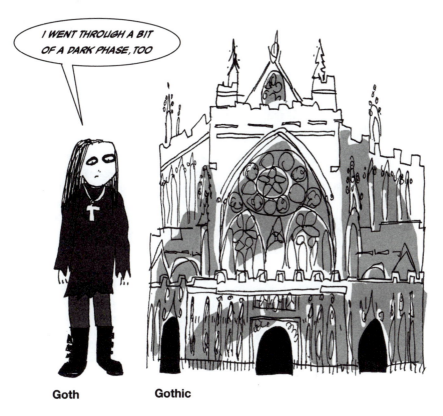

Goth Gothic

Gothic architecture is all big cathedrals, with pointed arches, and flying buttresses, supporting intricate sculptures and beautiful decoration. Based on sophisticated engineering, the building's skeleton could house huge stained glass windows. **Abbot Suger** 1081–1155 described in detail the improvements he made to the French cathedral of St. Denis (one of the first Gothic cathedrals). He stuffed his building full of precious materials and artworks, symbolising "divine radiance," and thought that the new stained glass windows reflected the "light of God." In painting and sculpture a very elegant, colorful, and decorative, religious art developed at the end of this period, which is known as **International Gothic**.

Some Medieval theologians disagreed with the idea of richly decorated Gothic churches. **St. Bernard of Clairvaux** 1090–1153 was the complete opposite of Abbot Suger. St. Bernard thought that this new tendency of overadornment would put people off praying by emphasizing worldly riches, and that the money should go to the poor.

St. Thomas Aquinas 1225–1274 developed a type of scholastic philosophy that tried to account for the divine order that he saw in the world. Everything was related to everything else—and there was order between God, nature and man. Because God was the great creator, all human creativity was but a mere shadow of divine creativity. This could equally be seen in a sculpture, painting, or in a well-executed craft. Like the Greeks before them, these Medieval creators considered that there was no real difference between art and a host of other skills. Medieval artists thought their toil was for God. The artists belonged to **guilds,** as did other craftsmen, from carpenters to bakers, and they all aimed to celebrate God through the perfection of their craft. Aquinas was interested in beauty which he saw in nature, and attributed to the divine. Beauty, for Aquinas, relied on *integrity, proportion* and *clarity*—Greek ideas—which he carefully fused with his Christian beliefs. Beauty he thought could be found in God's creations more easily than man's, so the artist or craftsmen could only strive for an unreachable perfection.

In a lot of Medieval art you see the use of **symbolism.** All sorts of objects are used to represent other things, such as Christ being represented by a lamb, or a white lily being used to describe purity or virginity. This type of symbolism tried to find related qualities between objects, and is again Greek in origin. It was developed in the Medieval period into a style of *transcendental* philosophy where everything relates to God and to the story of Christ.

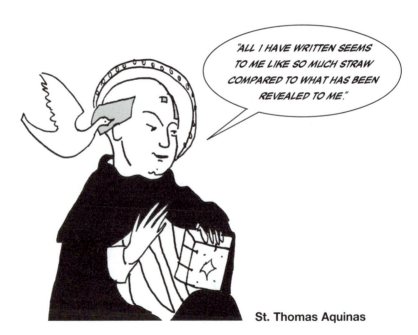

"ALL I HAVE WRITTEN SEEMS TO ME LIKE SO MUCH STRAW COMPARED TO WHAT HAS BEEN REVEALED TO ME."

St. Thomas Aquinas

THE RENAISSANCE

The word *renaissance* means "rebirth," and it refers to a time when artists rediscovered the art and philosophy of the classical world. Recent scholarship wants to place this rediscovery of the classical past, earlier and earlier. There are several early renaissances, for example, the Carolingian Renaissance and the 12th-century Renaissance. Then you have the big one. The significance of the **Italian Renaissance** in the 14th–16th century remains one of the great *facts* of Western art history. The **High Renaissance** is really the end of this period, when **Michelangelo** 1475–1564, **Raphael** 1483–1520, and **Leonardo da Vinci** 1452–1519 were all doing their thing. But this renaissance did not stop in Italy, it spread quickly to Northern Europe.

The fact that the Renaissance began in Italy was due in part to politics. Italy at the time was organized not as kingdoms or fiefdoms, like the rest of Europe, but as republican city-states. This meant that cities competed and traded against each other. New wealthy patrons emerged, like the Florentine **Medici**, who were bankers and businessmen, and who were able to support and commission new works from artists and poets.

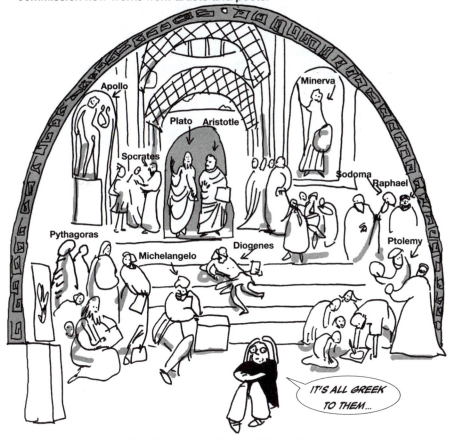

Raphael's painting, *The School of Athens* 1509, in the Vatican, is a tribute to the Greek School influencing the Italian Renaissance.

HUMANISM

Humanism is the set of beliefs that underpin the Italian Renaissance. Literally, humanism means the study of Classical texts or literature—the *literae humaniores*.

The study of Classical texts encouraged people to want to think for themselves—to put man rather than God at the center of their intellectual world view. In the classical texts we see the tradition of scepticism—of doubting authority. In Plato's *Euthyphro* we even have philosophers such as Socrates questioning whether God is good. For the Renaissance scholar this informed the belief that man could think independently from God. The revival of interest in the Classical age was essentially a renewal of a classical Athenian spirit. One in which scholars and citizens discussed things, and were interested in everything, and were free. The mind was to be used, not to confirm religious doctrines, but to learn from life.

This belief in man's ability to reason encouraged independent scientific inquiry, which led to exciting new discoveries. There were advances in medicine; or the invention of the printing press by **Johannes Gutenberg** 1398–1468, in Germany in 1450, that allowed automated printing; or the invention (or reinvention really as it was a Chinese discovery) of gunpowder that changed the nature of warfare. It was also in this period that the voyages of discovery began, the Genoese sailor **Christopher Columbus** 1451–1506 sailed west to try and find a quick trade route to China and India, and accidentally bumped into **America** in 1492.

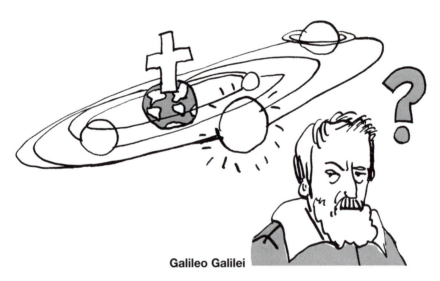

Galileo Galilei

At the end of the Renaissance **Galileo Galilei** 1564–1642 with his new scientific telescope was able to prove that the sun didn't go round the earth, and therefore that the earth couldn't be at the center of the universe, which mucked up the church's view of a divine cosmos with God's masterwork, man, at its center.

THE RENAISSANCE IDEA OF AN ARTIST

The Renaissance saw the transformation of the artist's role from a simple member of a medieval guild to that of an intellectual or even genius. The idea of genius really got going in the Renaissance, although it is Classical in origin. A genius was above all an individual, who had *innate*, rather than learned, abilities, and this idea of individualism is clearly different from the collectivism of the guild. The Italian artist, **Cennino Cennini** 1370–1440, wrote the first Italian book on painting *Il Libro dell' arte* 1390, just as the Renaissance was starting. He studied first in Florence and championed the artist **Giotto** 1267–1337. He writes about the practicalities of making paintings, and about the change in status of the artist, from the guilds, to a more poetlike free spirit. Here he echoes the Roman writer **Horace** 65–8 B.C. whose statement "as in painting, so in poetry" was significant in the Renaissance, because it stressed the creative importance of poetic imagination.

"PAINTERS AND POETS ALIKE HAVE ALWAYS HAD LICENSE TO DARE ANYTHING."

Horace

THE AUTHORITY OF GREECE AND ROME

There can be no doubt that during the Renaissance theorists thought that the classical world was totally awe-inspiring, held all the answers they needed, and was the height of all human achievement. The Renaissance poet **Petrarch** 1304–1374, who spent a lot of his time rediscovering and publishing Classical texts, actually coined the term the Dark Ages, to refer to the barren period of human accomplishment after the fall of Rome. The fact that Petrarch, a Christian, saw pagan Rome as supremely cultured, shows how the Renaissance valued human accomplishments. The Renaissance artist and writer **Giorgio Vasari** 1511–1574 even claims that the painter **Andrea Mantegna** 1431–1506 thought Classical sculptures were greater than nature!

"ANDREA MANTEGNA ALWAYS MAINTAINED THAT THE GOOD ANTIQUE STATUES WERE MORE PERFECT AND BEAUTIFUL THAN ANYTHING IN NATURE. HE BELIEVED THAT THE MASTERS OF ANTIQUITY HAD COMBINED IN ONE FIGURE THE PERFECTIONS WHICH ARE RARELY FOUND TOGETHER IN ONE INDIVIDUAL, AND HAD THUS PRODUCED A SINGLE FIGURE OF SURPASSING BEAUTY."

Andrea Mantegna

Giorgio Vasari

PRACTICAL THEORIES OF RENAISSANCE ART

The artists of the Renaissance developed a number of practical theories to help them make art—to help them understand what they saw and to learn from it. They wanted to make works that were highly mimetic, or representational, but also retained poetic imagination.

DRAWING AND COLOR

The Renaissance art theorist **Francesco Lancillotti** b.1509 laid out the four separate elements to painting: *Disegno, Colorito, Compositione, Inventione* (Drawing, Color, Composition and Artistic Invention).

The division between drawing and color is consistently important within Renaissance art theory. Initially it was a practical division because the two processes were carried out separately. Later, drawing was seen to represent a more rational form of expression and color a more expressive form. This is one of the reasons why the artist and writer Vasari championed the Roman and Tuscan Renaissance painters (like Michelangelo), who valued drawing over color, rather than the more colorful and expressive Venetian painters like Titian. Of course Venetian art theorists, such as **Pietro Aretino** 1492–1556, rejected much of the emphasis on the supremacy of rational expression, choosing to focus on the sensuous and luxurious qualities that they saw as more important.

Pietro Aretino

COMPOSITION

The Renaissance developed the theory of the **Golden Section** or **Golden Mean** which relates to the "sacred geometry" in both Greek and Islamic art. The Golden Mean, was thought to be a perfect "God-given" and economical ratio. It enabled artists to *objectively* divide up a flat picture in what they believed was the most beautiful way possible. This was achieved when a rectangle was divided in two, so that the smaller section was of the same proportion as the larger one. Although **Euclid** and **Pythagoras** in 600 B.C. had initially studied this mathematical observation, it was during the Renaissance that this proportion was reinterpreted as divine and supremely harmonious. The Renaissance mathematician **Luca Pacioli** 1445–1514 even called his book on the subject *The Divine Proportion*. The Golden Mean was used by many artists, such as **Piero della Francesca** 1416–1492 and **Leonardo da Vinci** 1452–1519.

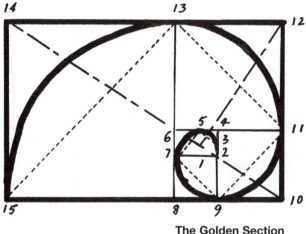

The Golden Section

INVENTION

For **Leonardo da Vinci**, art was a method of discovery. It was a way to find out about nature and about man. To understand the human form, he suggested drawing from anatomical dissections. For him the use of mathematical proportion was also important because it revealed natural laws. He carefully studied ways to represent the natural world and the human body in his paintings.

Leonardo also believed that artists imbued their work with emotion through their imagination. He was one of the first theorists to champion the sketch, as he felt this helped create invention, and that this vitality could be transferred into a finished painting. In fact, he even suggested that artists should sketch cracks in a wall to help inspire them.

Leonardo was far more prolific in his writing than in his painting, and he filled masses of notebooks with ideas on all aspects of natural philosophy. Although he published nothing during his lifetime, his writings were widely circulated after his death, and his ideas on painting and art, which he saw as a natural extension of more general scientific inquiries, became very influential.

GHIBERTI VS. BRUNELLESCHI

A good example of the Renaissance's desire to reinterpret the Classical is apparent when considering the case of **Lorenzo Ghiberti** 1378–1455 and **Filippo Brunelleschi** 1377–1446. In 1401 there was a competition to design a set of doors for the Cathedral's Baptistery in Florence. Ghiberti won the competition with his fusion of Classicism and imagination. It wasn't a strict Classical reinterpretation, but an example of how the Classical should connect with *life*. Brunelleschi failed to win as his use of Classicism was more naturalistic and appeared clumsy by comparison.

Major players in the Renaissance—after *Ghiberti's Baptistery Doors* 1404–1424.

LINEAR PERSPECTIVE

Although Brunelleschi lost the competition he did help with one of the big rediscoveries of the Renaissance—linear perspective.

Perspective is a representational system that allows the artist to transcribe a three-dimensional world onto a flat piece of paper. This system, although developed by Brunelleschi in his *Costruzione Legittima,* was popularized by another architect, **Leon Baptista Alberti** 1404–1472. In his book *On Painting,* Alberti commands the artist to work with what is seen, not imagined. In other words to use his eyes. This was underpinned by an emphasis on mathematics and reason, based on careful grids, parallel lines, and set vanishing points.

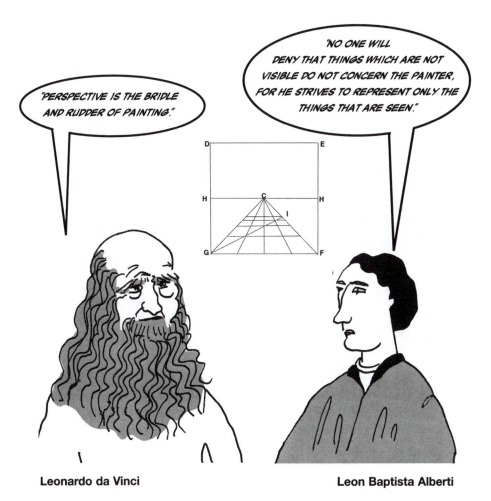

Leonardo da Vinci

Leon Baptista Alberti

It is worth remembering that the human eyes do not see *with* perspective, as we have two eyes and therefore no *fixed* point of view. Other methods of suggesting the depth of a third dimension in painting and drawing exist, for example in Egyptian art where space is arranged vertically.

THE INVENTION OF OIL PAINTING

The invention of oil painting was another big change for art. This technology was not developed in Italy but in Flanders by **Jan van Eyck** 1385–1441. The Flemish thought it such a wonderful invention that they tried to keep it a state secret. Before oil painting, most painting was fresco, which, when you think about it, was a Roman tradition, or what is called tempra, which is a quick drying opaque paint. Van Eyck discovered that you could suspend pigment in linseed oil, and then apply it to carefully prepared wooden boards, thereby creating a slow drying paint that could be worked on over extended periods of time. The development of oil paint was a huge discovery; it resulted in far more realistic paintings being made, as the application of thin glazes allowed a whole new level of *naturalism* to be achieved. Suddenly these new hyper-naturalistic paintings became portable, more resilient to changes in climate, and consequently far more of a commodity to be bought and sold. The invention of oil painting is a good example of how technological developments effect art.

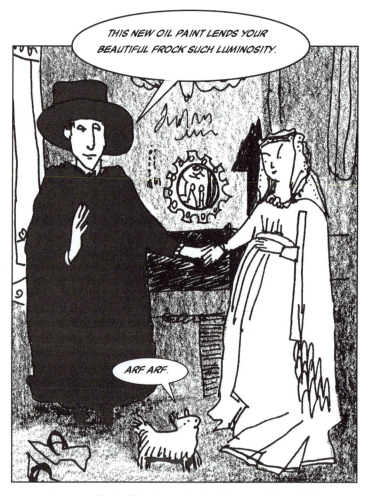

Jan van Eyck *The Betrothal of the Arnolfini* 1434

MANNERISM

When Michelangelo was making his late work, he began making very stylized paintings. They contained figures with unnaturally elongated limbs and discordant colors. These paintings, together with ones by artists like **Jacopo Pontormo** 1494–1556 or **Rosso Fiorentino** 1495–1540 are described as **Mannerist**. They seem to have rejected the harmony and grandeur of the early Renaissance in favor of skillful distortions. For some theorists, this work was corrupt, because it relied too much on the artist's imagination. This negative use of the term has stuck, with works from different periods being referred to as mannerist to imply the use of clever technical skills, which are thought insincere. To the mannerist artist, however, this heightened artificial language reflected a renewed and fervent spirituality.

Michelangelo depicts himself as the flayed skin of St. Bartholomew in the *Last Judgment,* a Mannerist counter action to the Classicism of his Sistine Chapel ceiling.

Giorgio Vasari 1511–1574 is sometimes called the first art historian because he wrote an early history of the Italian Renaissance—*The Lives of the Artists* 1598. This book explains his theory of the *history* of art, of art having been born, matured, and dying, while also racing through the key artists of the period. For Vasari, art was born with the rediscovery of Classical models in the 14th century and then grows through the Renaissance, until it reaches the achievements of Michelangelo, after which it can only decline. This was simply because Michelangelo had *God-given gifts*—he was divine. In fact Vasari said all future artists should just imitate Michelangelo, because he was so good and no one could ever make better work than him.

RELIGIOUS TURMOIL

The Italian Renaissance was expensive, particularly for the church which commissioned so much art. Sometimes this money was found in unscrupulous ways. **Martin Luther** 1483–1546, a monk from Wittenberg in Germany, thought the Catholic church had become completely corrupt. Luther launched what was to become the **Reformation**. He was for a form of Christianity based on the Bible and simplicity. He thought that every believer was their own priest, and you needed nothing but faith to enter Heaven. His followers, the Protestants, were originally iconoclasts, they smashed and desecrated church art for being unnecessary and for being blasphemous.

THE BAROQUE

The Catholic church, following a lead from the Jesuits, responded to the Reformation by trying to clean up its act and enhance its dignity through helping the poor. This **Counter-Reformation** was also concerned with art. During the so-called **Council of Trent**, a series of meetings that tried to counter the Protestant's accusations, the church devised a policy for religious art. They rejected the charges brought against them by the iconoclasts and welcomed the use of images in their churches, but they also wanted to distance themselves from the mannerists who they felt were a bit formulaic. The church demanded a new emotional art, that was able to support and even transcend the written word. They wanted a more populist, sensational, dynamic and uplifting art.

The Baroque, a 19th century term for art between the late Renaissance and the Neoclassical period, was an art of reconciliation. Baroque artists, whether **Michelangelo Caravaggio** 1571–1610, **Gianlorenzo Bernini** 1598–1680, or **Peter Paul Rubens** 1577–1640, were all making work that tried to bring together qualities that had traditionally been rejected by Renaissance art theory. The artists working during the Baroque period were to bring together opposi-tions, like emotion and intellect; reason and intuition; design and color; progress and Classical principles. Above all else, Baroque art stresses sensation, imme-diacy and impact.

Gianlorenzo Bernini
The Ecstasy of St. Theresa 1645

FROM THE RENAISSANCE TO THE ENLIGHTENMENT

The idea of art that flourished from the Renaissance to the Enlightenment was clearly bound up with the social, economic and religious forms of organization that existed in Europe at the time, but there were also technical developments, like perspective and composition, that led to changes in the theory of art.

Some of the key ideas can be summed up as:

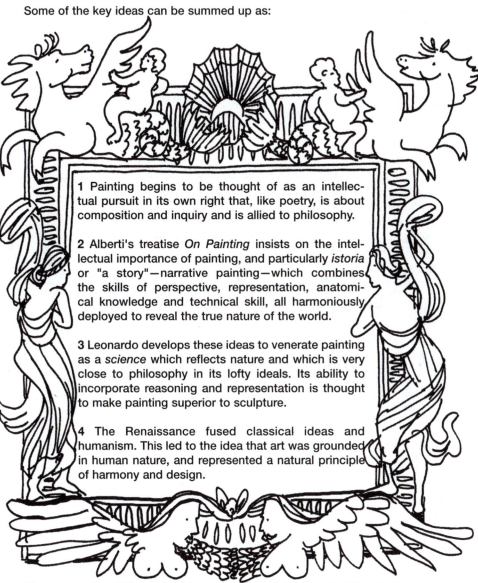

1 Painting begins to be thought of as an intellectual pursuit in its own right that, like poetry, is about composition and inquiry and is allied to philosophy.

2 Alberti's treatise *On Painting* insists on the intellectual importance of painting, and particularly *istoria* or "a story"—narrative painting—which combines the skills of perspective, representation, anatomical knowledge and technical skill, all harmoniously deployed to reveal the true nature of the world.

3 Leonardo develops these ideas to venerate painting as a *science* which reflects nature and which is very close to philosophy in its lofty ideals. Its ability to incorporate reasoning and representation is thought to make painting superior to sculpture.

4 The Renaissance fused classical ideas and humanism. This led to the idea that art was grounded in human nature, and represented a natural principle of harmony and design.

Throughout the 17th and 18th centuries social and scientific development would undermine those certainties and once again redefine how art theory thought about the world. In fact in the 18th century a whole set of social, philosophical and organizational changes led to the invention of art as we know it today.

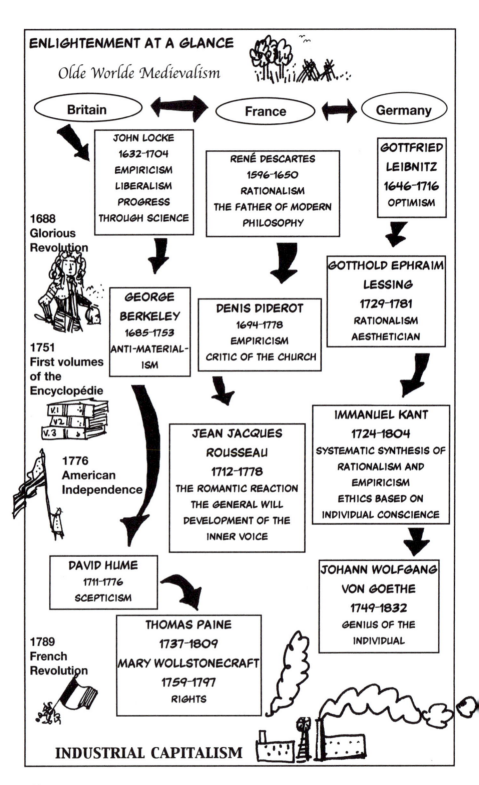

ENLIGHTENMENT AT A GLANCE

Olde Worlde Medievalism

Britain ⬌ **France** ⬌ **Germany**

JOHN LOCKE
1632-1704
EMPIRICISM
LIBERALISM
PROGRESS
THROUGH SCIENCE

RENÉ DESCARTES
1596-1650
RATIONALISM
THE FATHER OF MODERN
PHILOSOPHY

GOTTFRIED LEIBNITZ
1646-1716
OPTIMISM

1688
Glorious
Revolution

GEORGE BERKELEY
1685-1753
ANTI-MATERIAL-ISM

DENIS DIDEROT
1694-1778
EMPIRICISM
CRITIC OF THE CHURCH

GOTTHOLD EPHRAIM LESSING
1729-1781
RATIONALISM
AESTHETICIAN

1751
First volumes
of the
Encyclopédie

1776
American
Independence

JEAN JACQUES ROUSSEAU
1712-1778
THE ROMANTIC REACTION
THE GENERAL WILL
DEVELOPMENT OF THE
INNER VOICE

IMMANUEL KANT
1724-1804
SYSTEMATIC SYNTHESIS OF
RATIONALISM AND
EMPIRICISM
ETHICS BASED ON
INDIVIDUAL CONSCIENCE

DAVID HUME
1711-1776
SCEPTICISM

THOMAS PAINE
1737-1809
MARY WOLLSTONECRAFT
1759-1797
RIGHTS

JOHANN WOLFGANG VON GOETHE
1749-1832
GENIUS OF THE
INDIVIDUAL

1789
French
Revolution

INDUSTRIAL CAPITALISM

THE INVENTION OF ART

THAT SOUNDS LIKE A WEIRD CLAIM.

NOT AT ALL, IT JUST MEANS THAT THE INSTITUTIONS, PRACTICES AND AUDIENCES THAT MAKE UP THE MODERN ART WORLD ONLY CAME INTO PLACE DURING THE ENLIGHTENMENT. A NEW AUDIENCE, A NEW AESTHETIC AND A NEW IDEA OF ART AND ARTIST CAME TOGETHER BECAUSE OF COMPLICATED SOCIAL AND HISTORICAL CHANGES.

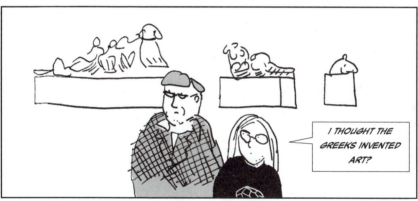

I THOUGHT THE GREEKS INVENTED ART?

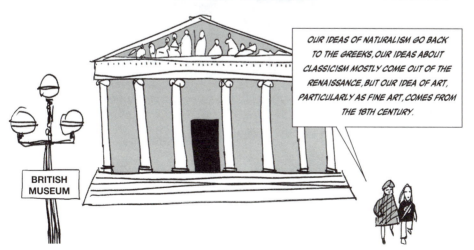

BRITISH MUSEUM

OUR IDEAS OF NATURALISM GO BACK TO THE GREEKS, OUR IDEAS ABOUT CLASSICISM MOSTLY COME OUT OF THE RENAISSANCE, BUT OUR IDEA OF ART, PARTICULARLY AS FINE ART, COMES FROM THE 18TH CENTURY.

WHAT IS THE ENLIGHTENMENT?

The 17th and early 18th centuries were a violent period of religious warfare in Europe. During these turbulent times a number of thinkers came to believe that **human reason**, rather than the church, could explain almost everything—solve all problems and lead to a new Golden Age. This humanism, as we have seen, is based on mankind's ability to reason and think independently, rather than following the doctrines of the church. It was through this independent thought that mankind as a whole could become *enlightened* and make the world a better place.

The **Enlightenment** was founded on the opposing ideas of **Rationalism** and **Empiricism** that were eventually brought together by **Immanuel Kant** 1724–1804, who famously said: "Enlightenment is man's emergence from his self-incurred immaturity."

RATIONALISM promoted *reason* or thinking as an independent quality, and although having its origins in the philosophy of Plato, really was rediscovered as a critical activity by **René Descartes** 1596–1650. Descartes doubted his own existence until he realized he could not doubt his own thoughts.

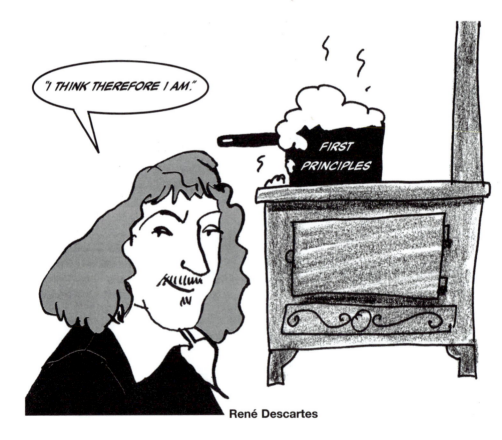

René Descartes

EMPIRICISM is about actual experience. Knowledge gained from the *senses* is seen as being more important than isolated reason. Empiricism helped stimulate the development of science, because it is through scientific enquiry that empirical knowledge can be gained.

John Locke 1632–1704 was an important philosopher in that he insisted on the reality of human understanding and thinking. That, in his words, "the mind is furnished with ideas from experience alone." In short, Locke was against Plato's "theory of universals" and insisted on experience, or empiricism, as the basis of all rational activity.

His most famous work, *An Essay Concerning Human Understanding* 1690, had a powerful influence on the Enlightenment, since he argued that man was born "a blank slate" and that his ideas were derived not from God, but from experience. The long-term effects of this kind of thinking on art theory was precisely to turn attention away from mythology and religion and towards experience and reality.

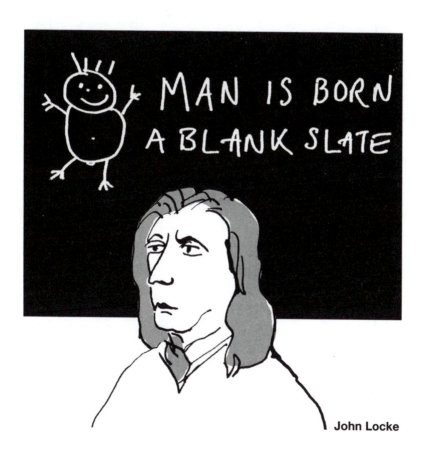

John Locke

ROCOCO

The Rococo can be seen as an Enlightenment art because it was secular. It was a much lighter style than the Baroque, and had none of its heavy religious preaching. This makes it, in fact, very *modern*. Rococo art was made for the aristocracy, during the reign of Louis XV in France. It then spread across much of Europe. It is all sweetness, color, artificiality, and interior design. The aristocratic society at the time enjoyed witty conversations and manners and a style of art that was also light and fanciful. The Rococo is typified by the elegant prettiness of **Antoine Watteau** 1684–1721, **François Boucher** 1703–1770, and **Jean-Honoré Fragonard** 1732–1806.

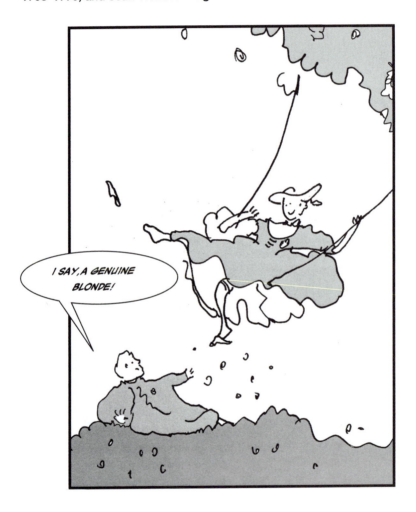

Jean-Honoré Fragonard
The Swing 1767

ACADEMICISM

Academic art literally means art from the academy, or art made adopting the rules and styles of the 16th and 17th century European city art academies. Their common aim was a desire to connect with the classical past and divorce themselves from the medieval guilds. The French painter **Charles Le Brun** 1619–1690, who had spent time in Rome, was instrumental in the development of the **French Académie**. Academic theories of art basically dominated art until the 20th century.

The French Académie held an annual exhibition of paintings in the Salon d'Appolon, in the Louvre, each year, and also ran the Ecole des Beaux-Arts where future artists were trained. Academic theories of art valued the rational and empirical tradition of the Enlightenment. Everything was neatly ordered, deadly serious and justifiable. The academy valued tradition, technique and hierarchies.

The Academy created a hierarchy of artistic subjects. History painting was seen as the most important and then portraits, landscapes, and lastly the humble still life. Each genre had a recommended size and significance. The Academy also favoured idealism as opposed to naturalism. This meant that things were painted as though *ideal* or perfect. Beaux-Arts students progressed from copying prints of Greek and Roman sculptures, to copying plaster casts of them, to finally drawing from the figure, often in a Greco-Roman pose. The emphasis was on developing technique and on understanding the greatness of history.

The importance of drawing as opposed to color, split academic opinion, with different theorists putting forward different ideas as to the value for appreciating one or the other. According to Le Brun color was "but an accident produced by the reflection of light, and that varies according to circumstances" whereas drawing, of course, was thought to be more rational and based on reason alone.

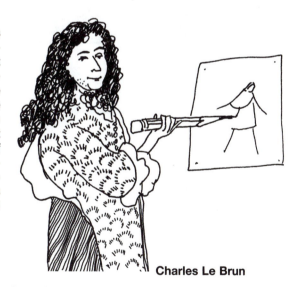

Charles Le Brun

Le Brun was such a respected teacher that his lectures became standard reading for any would-be artist of the 17th or 18th century. He even gave a celebrated lecture on his empirical theory of expression. This aimed to show how facial expression, of both people and animals, conveyed specific emotions, and could therefore logically be employed in painting.

TOP OF THE POPS FOR THE ACADEMY

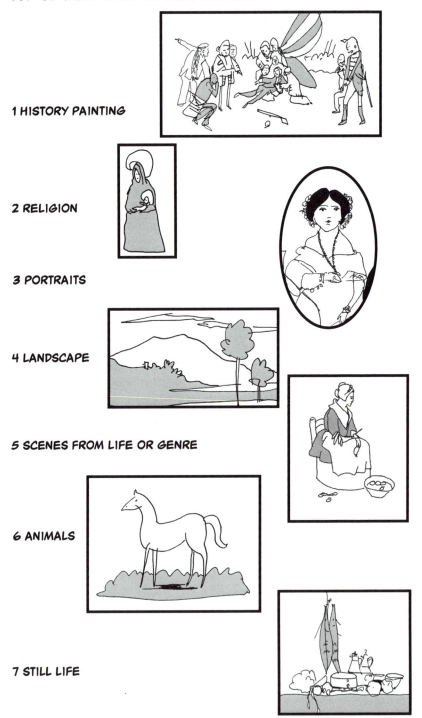

1 HISTORY PAINTING

2 RELIGION

3 PORTRAITS

4 LANDSCAPE

5 SCENES FROM LIFE OR GENRE

6 ANIMALS

7 STILL LIFE

NEOCLASSICISM

Throughout the centuries the idea of the greatness of Classical art fluctuated. Classicism returned, in Enlightenment Europe, when the **French Revolution** 1789–1799 ushered in a new civic society, that hated both the religious pomposity of the Baroque and the loose morals and frivolity of the Rococo.

As **Johann Winckelmann** 1717–1769 succinctly puts it:

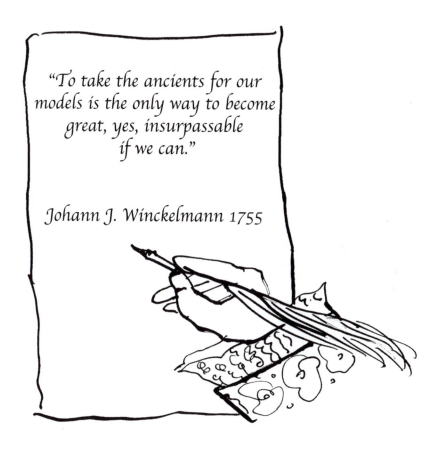

"To take the ancients for our models is the only way to become great, yes, insurpassable if we can."

Johann J. Winckelmann 1755

During the 18th century, the idea of the greatness of the Classical age became a totally accepted idea. It seemed to echo the greatness of newly confident, dominant, colonizing, Western European Empires. The Neoclassical revival produced art inspired by antiquity that was far more idealist than previous Classical revivals. **Neoclassicism** was a return to the assumed dignity of Imperial Rome, or Republican Greece and was embraced by the absolutist governments in Europe, as well as the emerging democratic republic in America.

This resurgence of interest in the Classical world was spurred on by early **archaeology** and the rise of the **Grand Tour**. It was during the 18th century that archeological excavations became a real science, and sites like **Pompeii**, in Italy, were studied. Northern Europeans, principally the British and German aristocracy, wanted to gain firsthand cultural awareness and knowledge of the Classical and Renaissance worlds and set off on grand tours. The principle destinations were Rome and Naples, where people marvelled at, and were tutored about, the culture, history, art, and archaeology of the past, while also trying to purchase a few antiques for their private collections back home.

Unlike many grand tourists, Lord Elgin 1766–1841 went to Greece. He brought pieces from the Parthenon frieze to England in 1816. Some now argue for their return to Athens.

LOOK AT ALL THESE LOVELY MARBLES I'VE FOUND!

Lord Elgin

HOW IDEAL

The art historian **Johann Winckelmann** 1717–1768 wrote about the "noble simplicity" and "calm grandeur" of the Classical works he popularized. This was of course Winckelmann's theory of the Classical world, and was not the theory of the Athenians themselves. Neoclassical artworks are **idealized**, so not naturalistic, and it is worth remembering the importance of naturalism to the Greeks. Their statues were even originally painted to make them more life-like. Winckelmann thought that idealized beauty was the aim of art, and that somehow art was a quick route to perfection and Platonic truth. (Which was not how Plato himself saw images.) Winckelmann suggested when painting or sculpting the human figure ideal proportions should be used— and no unsightly blemishes or veins could be included! Neoclassicism was a super-idealized revival of Greek or Roman art.

"GOOD TASTE, WHICH IS SPREADING MORE AND MORE THROUGHOUT THE WORLD, HAS ITS BEGINNINGS UNDER A GREEK SKY."

Johann Winckelmann
1717–1768

Apollo Belvedere
330 B.C.

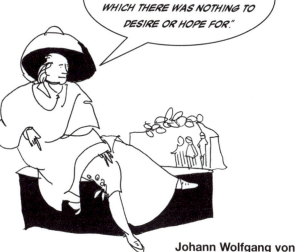

"THE APOLLO BELVEDERE—THE ULTIMATE BEAUTY BEYOND WHICH THERE WAS NOTHING TO DESIRE OR HOPE FOR."

Johann Wolfgang von
Goethe 1749–1832

"OF THE GREEKS AND ROMANS; THEIR MARBLES TELL THE EXACT TRUTH, BUT ONE HAS TO KNOW HOW TO INTERPRET THEM, AND THEY ARE MERE HIEROGLYPHS TO OUR WRETCHED MODERN ARTISTS."

Eugène Delacroix
1798–1863

Medici Venus 3
B.C. after the Greek
Praxiteles

"SO STANDS THE STATUE THAT ENCHANTS THE WORLD."

James Thomson
1700–1748

ECHOES OF THE FUTURE

The rediscovery of Classical art and ideas runs through the history of Western art. What is interesting is how each particular revival is different and is a product of its own time. Therefore each age has its own theory of Classical art.

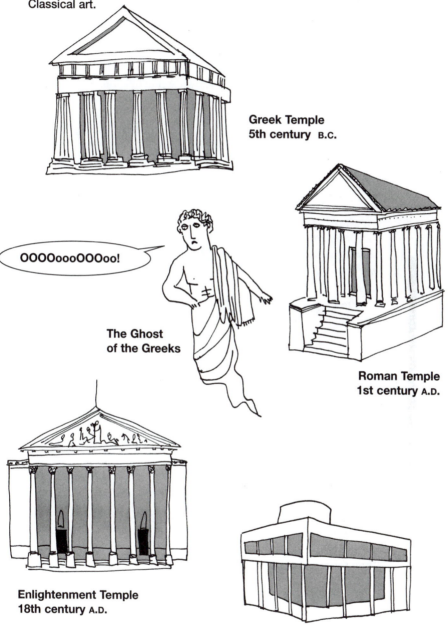

Greek Temple
5th century B.C.

OOOOoooOOOoo!

The Ghost
of the Greeks

Roman Temple
1st century A.D.

Enlightenment Temple
18th century A.D.

Modernist Temple
20th century A.D.

MAKING ART MODERN

Denis Diderot 1713–1784 was one of the most important philosophers and art critics during the French Enlightenment period. He was the chief editor of the huge seventeen volume *Encyclopédie ou Dictionnaire raisonné des sciences, des arts et des métiers* that aimed to collect together all knowledge. He also wrote about art, in fact he practically invented modern art criticism by rejecting the dominant views of art coming out of the European Academies. Diderot wrote, in a journalistic and accessible manner, about the annual art exhibitions held at the French Académie between 1759 and 1781. He expressed boredom with the new neoclassical style and religious art, suggesting that a more open, realistic and moral kind of art was necessary.

In essence, Diderot represented a belief that accepted traditions, like those of the church, were a thing of the past, and that critical reflection was the way forward. His writing is both philosophical and racy. Diderot was imprisoned in 1749 for his sceptical and anticlerical stance.

"IT SEEMS TO ME THAT I HAVE SEEN ENOUGH TITS AND BEHINDS. THESE SEDUCTIVE THINGS INTERFERE WITH THE SOUL'S EMOTIONS BY TROUBLING THE SENSES."

"(ART IS) TO MOVE, TO EDUCATE, TO IMPROVE US AND INDUCE US TO VIRTUE."

Denis Diderot

Diderot's search for moral art didn't fit with the prevalent academic tradition, which regarded history painting as the most significant type of art. This was because its role was supposedly to express and reflect on the most important moments of human achievement.

Diderot admired the work of **Jean-Siméon Chardin** 1699–1779, and the style of "genre painting." He thought it was moral because it was humble, not based on the church, but reflecting ordinary people's experiences.

AESTHETICS

People have always tried to create theories to unlock the code of beauty. What makes an *object*, or the *response* to an object, beautiful? There were differing ideas about beauty throughout the early history of Western art. At the same time, the question of what beauty is, was always treated as though it was self-evident: it was the main aim of art. From Aristotle and the Greeks came the idea that beauty was about function and proportion, and this idea persisted for a very long time. However, other theories did develop.

This is what some Renaissance figures had to say about beauty. You will notice how different their definitions are from the Greeks:

"WHAT BEAUTY IS I KNOW NOT, THOUGH IT ADHERES TO MANY THINGS... AS WHAT ALL THE WORLD PRIZES AS RIGHT WE HOLD TO BE RIGHT, SO WHAT ALL THE WORLD ESTEEMS TO BE BEAUTIFUL, THAT WILL WE HOLD FOR BEAUTIFUL, AND STRIVE TO PRODUCE."

Albrecht Dürer 1471–1528

"BEAUTY IS NOTHING ELSE THAN A CERTAIN LIVING AND SPIRITUAL GRACE WHICH THROUGH DIVINE RAYS INFUSES ITSELF FIRST INTO THE ANGELS; IN THESE ARE SEEN THE FIGURES OF EACH SPHERE, WHICH IN THEM ARE CALLED EXAMPLES AND IDEAS. BEAUTY THEN PASSES INTO THE SOULS, WHERE THE FIGURES ARE CALLED REASONS AND THOUGHTS, AND FINALLY INTO MATTER, WHERE THEY ARE CALLED IMAGES AND FORMS."

Marsilio Ficino 1433–1499

"BEAUTY IS NOTHING ELSE BUT THAT WHICH GIVES TO THINGS THEIR APPROPRIATE QUALITY TO PERFECTION."

"THE IDEA OF BEAUTY DOES NOT DESCEND INTO MATTER UNLESS THIS IS PREPARED AS CAREFULLY AS POSSIBLE."

Giovanni Bellori 1615–1696

Nicolas Poussin 1594–1665

These are some ideas of beauty from the 17th and 18th centuries:

"THOUGH BEAUTY IS SEEN AND CONFESSED BY ALL, YET FROM THE MANY FRUITLESS ATTEMPTS TO ACCOUNT FOR THE CAUSE OF IT BEING SO, INQUIRIES ON THAT HEAD HAVE ALMOST BEEN GIVEN UP, AND THE SUBJECT GENERALLY THOUGHT TO BE A MATTER OF TOO HIGH AND DELICATE A NATURE TO ADMIT OF ANY TRUE OR INTELLIGIBLE DISCUSSION."

WOOF WOOF WOOF!

William Hogarth 1697–1764

"ART IS CONSTITUTIVE—THE ARTIST DETERMINES BEAUTY, HE DOES NOT TAKE IT OVER."

"EXUBERANCE IS BEAUTY."

Johann Wolfgang von Goethe 1749–1832

William Blake 1757–1827

"BEAUTY IS THE EXPRESSION OF A CERTAIN HABITUAL WAY OF LOOKING FOR HAPPINESS."

Stendhal 1783–1842

"A THING OF BEAUTY IS A JOY FOREVER. ITS LOVELINESS INCREASES, IT WILL NEVER PASS INTO NOTHINGNESS."

John Keats 1795–1821

BEAUTY IS TRUTH

The English politician and philosopher the **Earl of Shaftesbury** 1671–1713 in his book *The Characteristics of Men, Manners, Opinions and Times 1711* said "all beauty is truth" and that beauty and goodness were "one and the same."

For Shaftesbury, beauty was an absolute. It was inherent in the form of things and appreciated by the mind rather than the senses. He viewed the artist as a skilled technician, who was able to make works that revealed beauty and consequently held a moral truth.

This was a big claim. No longer was beauty to do with pleasing decoration or pleasant things to look at—it was an absolute, moral standard, in which beauty was good.

The 3rd Earl of Shaftesbury

AESTHETIC JUDGMENT

In the 18th century ideas about beauty were reexamined with new vigor. The German philosopher **Alexander Baumgarten** 1714–1762 posed the question "What is beauty?" And coined the term *aesthetics* to describe what he was doing. In 1735 Baumgarten first used the term *aesthetic* in its modern sense. It comes from the Greek word *aesthesis* which means perception.

Baumgarten used it to think about art, about what makes a thing *beautiful*, *pleasing* or *ugly*, or indeed *fine* art rather than *craft*. Baumgarten said we all make "aesthetic judgments," as we see certain artworks as superior to others.

"REASON APPLIED TO ART WILL GIVE US A TRULY AESTHETIC UNDERSTANDING."

Alexander Baumgarten

Funnily enough, at almost the same time the, English painter **William Hogarth** 1697–1764 was writing a book called *The Analysis of Beauty* 1754 in which he described his commonsense belief that beauty related to *suitability*, *fitness* and *grace*.

"WHEN A VESSEL SAILS WELL THE SAILORS CALL HER A BEAUTY; THE TWO IDEAS HAVE SUCH A CONNECTION."

William Hogarth

Hogarth believed he had rediscovered how to instill grace within his paintings by employing a beautiful curvaceous line—**"the line of beauty."** Hogarth's views were based on practice and he was no philosopher, but he was, however, widely read and influential.

CRITIQUE OF JUDGMENT

Baumgarten was followed by an even more famous philosopher, **Immanuel Kant** 1724–1804 whose *Critique of Judgment* is the key text in all modern discussion of aesthetics.

Kant was a philosopher of the Enlightenment, who spent his entire life defining and redefining philosophical problems. In fact some argue that he is the greatest philosopher ever. His influence on the theory of art has been enormous.

He said there is no scientific rule for determining what beauty is:

"THERE CAN BE NO OBJECTIVE RULE OF TASTE WHICH SHALL DETERMINE BY MEANS OF CONCEPTS WHAT IS BEAUTIFUL."

Immanuel Kant

Kant complained that everyone was using this new term *aesthetics* without being clear what it meant. As a rigorous philosopher he set out in the *Critique of Judgment,* to try and solve these complicated questions once and for all.

"JUDGMENT IN GENERAL IS THE FACULTY OF THINKING THE PARTICULAR AS CONTAINED UNDER THE UNIVERSAL."

What is relevant here is how he tried to work out how to analyze *taste, beauty,* and what he called the *sublime.* He was very concerned with what *judgment* was. He believed that it formed the mediating link between the two great branches of philosophical inquiry, the theoretical and the practical, hence the *Critique of Judgment* is about much more than art.

KANT YOU BELIEVE IT

"BECAUSE THE BEAUTIFUL IS WHAT PLEASES IN THE MERE JUDGMENT AND THEREFORE NOT BY THE MEDIUM OF SENSATION IN ACCORDANCE WITH A CONCEPT OF THE UNDERSTANDING."

SO WHY DO I NEED TO KNOW ABOUT THIS FUSTY OLD PHILOSOPHER WHO NEVER LEFT KONIGSBERG AND NEVER PAINTED A SINGLE PICTURE?

"THE SUBLIME IS WHAT PLEASES IMMEDIATELY THROUGH ITS OPPOSITION TO THE INTEREST OF SENSE."

IN THE INTERESTS OF SENSE—COULD YOU MAKE THAT INTELLIGIBLE?

"IN ALL BEAUTIFUL ART THE ESSENTIAL THING IS THE FORM."

"FOR BEAUTIFUL ART, THEREFORE, IMAGINATION, UNDERSTANDING, SPIRIT AND TASTE ARE REQUISITE."

THAT'S THE FIRST BIT I UNDERSTOOD.

NO, YOU'VE LOST ME AGAIN.

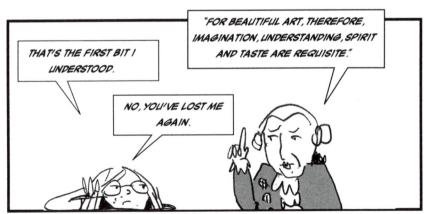

KANT'S AESTHETIC JUDGMENT

What Kant is arguing is that the *perception* of beauty—that is, 'the judgment' of beauty—involves imagination and understanding. Beauty is both subjective, not conceptually based, and, in some sense, objective as well, in that it is related to the *form* or the *organization* of the object. The unity of the aesthetic experience is about the interaction between imagination and understanding, but it goes beyond a simple conceptual rule, as Kant argues that aesthetic judgments have four categories:

1 Aesthetic judgments are **disinterested**, which means that we take pleasure in something simply because we judge it beautiful, rather than deciding it is beautiful because we find it pleasurable. Beauty necessarily produces this reaction. The point is that finding things *nice* or *pleasurable* can be brought about by anything, whereas beauty is much more specific.

2 Aesthetic judgments are **universal** in the sense that everybody would agree with the judgment because it is natural to do so, since the beauty is in the form. That's why aesthetic judgments can be made.

3 *Beauty* is an **intrinsic quality** of an object, it is necessary in the sense that it is just there, like the smell of something, or its color. But just to make life difficult Kant insists that universality and necessity are really a product of the nature of the human mind. He says that these features are like *common sense,* and that there is actually no objective property of an object that makes it beautiful. So beauty is a very special category, which in some sense becomes *truth.*

4 Through making aesthetic judgments, beautiful things appear to be **"purposive without purpose"** that is to say they are not like an ax, or a screwdriver, they do not have a specifically designed purpose, but we experience them as if they do. This peculiar property is part of the interaction of imagination and understanding that makes beauty such an interesting idea.

So you can see that beauty for Kant involves the eye, the mind, and the perception of the beholder, as well as in the object itself.

THE SUBLIME

BUT WHAT ABOUT THE SUBLIME? I KNOW THE RIDICULOUS BIT, BUT I COULD NEVER GET HOLD OF WHERE THE SUBLIME CAME FROM.

Actually, Kant says that the other aspect of aesthetic experience is that of the *sublime*. He based his discussion of the sublime on the work of **Edmund Burke** 1729–1797, who wrote the ***Philosophical Inquiry into the Sublime and the Beautiful*** in 1757, which separated beauty as being rational and the sublime as emotional.

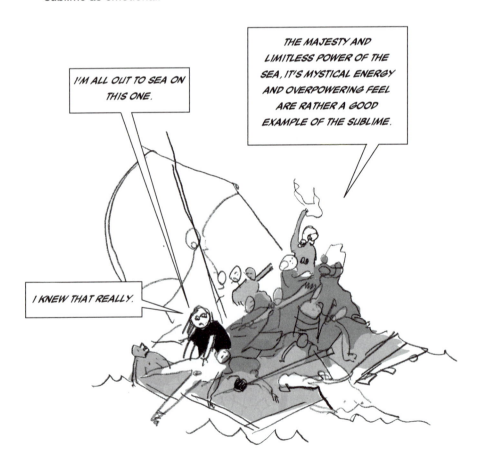

I'M ALL OUT TO SEA ON THIS ONE.

THE MAJESTY AND LIMITLESS POWER OF THE SEA, IT'S MYSTICAL ENERGY AND OVERPOWERING FEEL ARE RATHER A GOOD EXAMPLE OF THE SUBLIME.

I KNEW THAT REALLY.

IT'S MINDBLOWING

In Kant's idea of beauty there is a form of order, of necessity, but in the sublime, by contrast, there's a principle of disorder, of **purposivelessness**. There is no order and no limit to the idea of the sublime. Kant is getting at a difficult area of theory, he is talking about experiences that don't fit ordinary experience. The sublime, for example, may well involve violence and disorder. Perhaps a heavy storm is sublime, and the violence of it produces in us a kind of pleasure, and even perhaps a strange kind of awe. He says, this kind of event is *counterpurposive*. It is against a commonsense sort of perception, and is therefore puzzling. A huge fire can have this sublime quality, it is disorderly and has no real purpose, and is immense, scary and pleasurable all at once. The sublime is like our awe of some supernatural presence, of some grandiose natural spectacle of limitless energy.

This limitless and intense pleasure of the sublime comes from within. It is related to a negative pleasure that leads us to some higher thoughts by a complicated process which relates to this strange *purposivelessness*. The sublime tests our understanding and that is why Kant was so interested in it. You can't get your head round it and it exceeds our grasp.

"WE MUST SEEK A GROUND EXTERNAL TO OURSELVES FOR THE BEAUTIFUL OF NATURE, BUT SEEK IT FOR THE SUBLIME MERELY IN OURSELVES AND IN OUR ATTITUDE OF THOUGHT, WHICH INTRODUCES SUBLIMITY INTO THE REPRESENTATION OF NATURE."

ROUSSEAU AND THE ROMANTIC SPIRIT

Unlike the Enlightenment philosophers, the Romantic artists, writers and thinkers stressed the importance of the individual. The **Romantic Movement** can be seen as the opposite of the Enlightenment. It was not based on the objective ideas of rationalism and empiricism, but rather on the importance of the *self* and the *imagination* — a far more subjective position. This shift from objective to subjective can be seen as a result of the lack of room for human creativity and freedom in an empirically-defined enlightened world. Kant said that we can never see things objectively as *things-in-themselves* because we always understand the world through our own eyes, which is of course, from a culturally formed point of view.

Jean-Jacques Rousseau 1712–1778 is often mistakenly categorized as an Enlightenment thinker, but undoubtedly his writings and life inspired the Romantic period far more. His autobiographical book *The Confessions* 1781 describes his exceptionally colorful life. He ran away from home at 16, and inbetween falling for an older woman, a lowly seamstress, and giving away his four children to an orphanage, he also fell in love with **nature**. While wandering the countryside, with little money, he developed revolutionary ideas about the benefits of the "simple life." He thought that man was corrupted by civilization and was in a truer state "in nature," or "like nature," and he created the idea of the **"noble savage."** The great social and democratic revolutions, the Revolutionary War 1783 and the French Revolution 1789–1794, were partly inspired by Rousseau's influential treatise *The Inquiry into the Social Contract of Men* 1762. Rousseau's *contract* was between individuals who would need to relinquish some of their freedoms, in order to serve the community which would respect all individuals equally.

Romanticism was a movement in all the arts. It was a reaction against both Neoclassicism and the Enlightenment. It was the first time that an artist's feelings and emotions were seen as central to artistic expression. It valued the irrational, the subjective and the spiritual.

WHEN I SAID ROMANTIC I DIDN'T MEAN THAT KIND OF ROMANTIC.

Jean-Jacques Rousseau

GOETHE, GENIUS, AND COLOR

Johann Wolfgang von Goethe 1749–1832 was a highly popular German Romantic poet. He also studied paintings, sculpture, and architecture in both Northern Europe and Italy. He wrote a lot about art. He saw in Gothic buildings a free expressive spirit that was at odds with rational Neoclassicism. This freedom of spirit was one of the very qualities that Romantics, like Goethe, saw as part of an artist's psyche, and it is through this concept that we return at the idea of artistic *genius*, which we have seen was popular in the Renaissance.

The Romantic genius was untutored, free, like *nature*, or an unschooled child, and could speak about truths that others were not able to. This was a very different position to the academy or Neoclassical artists who needed to train, learn rules and become conversant with a tradition. Indeed, **Sir Joshua Reynolds** 1723–1792, who ran the Royal Academy in London, said the artist who had been tutored by himself was tutored by a fool!

In many ways the idea we have now of what an *artist* is like, is the product of Romanticism. Prior to the Enlightenment, most artists were thought of as little more than craftspeople working in guilds. The neoclassical artists thought of themselves in a very different way, they were scholars of past art and the classical world and could achieve great respectability like Reynolds. The rise of Romanticism changed all that.

Goethe also devoted himself to **Color Theory**. He was working 100 years after **Isaac Newton** 1642–1727 had shown, with a prism, how all colors were part of a unified system of optics. Goethe refuted the rationality of this empiricist system. He saw perceived vision as a property of the mind as much as of light.

"IT IS LIGHT, COLOR AND SHADOW THAT COME TOGETHER AND PERMIT OUR VISION TO DISTINGUISH ONE OBJECT FROM ANOTHER. WITH THESE THREE ELEMENTS—LIGHT, COLOR, AND SHADOW—WE CONSTRUCT THE VISIBLE WORLD, AND AT THE SAME TIME MAKE PAINTING POSSIBLE."

Johann Wolfgang von Goethe

THE MIRROR AND THE LAMP

The development of the Romantic sensibility can be seen as a radical change in the way thought and expression manifests itself. The historian **M.H. Abrams** b.1912 used the analogy of "the mirror and the lamp" in his 1953 book with that title. The "mirror" describes a style of thought from Plato to the Enlightenment, one concerned with deciphering and understanding the reflected, outside world. The "lamp", on the other hand, was the Romantic inner expression of self, which in turn helped illuminate the world.

The certainties of the Enlightenment were challenged by the rise in religious scepticism and the French Revolution. With the authority of the state and the church being questioned, a new type of artist was created, one that was inward looking—and was detached from mainstream society.

The idea of the artist in the Romantic period, was all about the individual, and how he was different from the rest of society. He looked different, dressed as a *bohemian*, which was a French term for a gypsy, and lived on the edge of society. From this vantage point the artist was opposed to the rest of society and able both to comment on it, and to contemplate things beyond it.

"IT IS THE LOT OF GENIUS TO BE OPPOSED AND TO BE INVIGORATED BY OPPOSITION."

Henry Fuseli 1741–1825

The connection between an individual's creativity and suffering became important for the Romantics. Artists painted themselves not only starving in garrets, but also suffering, Christ-like, in an almost religious manner. The youthful poet **Chatterton** 1752–1770, who took his own life at 17, epitomizes the idea of the unrecognized artistic genius, which was to become a favorite subject for Romantic poets and painters. The Romantic genius was able to see the world unrestrained by society and through his own experience of the world.

THE ROMANTIC LANDSCAPE

The German writer **Freidrich Wilhelm Joseph von Schelling** 1775–1884 thought, like Kant, that the only thing we have real direct knowledge of is our minds. The British poet **Samuel Taylor Coleridge** 1772–1834 agreed with this idea, which saw the mind as organic and in itself creative. This is different from the Enlightenment or empiricist view, which saw the mind more as a receptor of external observations and stimuli.

Writers and poets like Coleridge and **William Wordsworth** 1770–1850 were interested in the power of the mind. One of the reasons why they went walking in the mountains, or Wordsworth took to the Alps, was to experience untamed nature. Like Kant, they felt that the experience of a sublime, wild landscape would challenge their understanding of self. In much the same way they felt that their adoption of nature and simplicity could, through art, create a new morality. Book Six of Wordsworth's *Prelude* 1805 offers a fine example of this:

"THE IMMEASURABLE HEIGHT
OF WOODS DECAYING, NEVER TO BE DECAYED
THE STATIONARY BLASTS OF WATERFALLS,
AND EVERYWHERE THE HOLLOW RENT
WINDS THWARTING WINDS, BEWILDERED AND FORLORN,
THE TORRENTS SHOOTING FROM THE CLEAR BLUE SKY,
THE ROCKS THAT MUTTERED CLOSE UPON OUR EARS,
BLACK DRIZZLING CRAGS THAT SPAKE BY THE WAY-SIDE
AS IF A VOICE IN THEM, THE SICK SIGHT
AND GIDDY PROSPECT OF THE RAVING STREAM,
THE UNFETTERED CLOUDS AND REGION OF THE HEAVENS,
TUMULT AND PEACE, THE DARKNESS AND THE LIGHT..."

William Wordsworth

The **Picturesque** is a different but related idea about nature. In the 18th century the picturesque referred to a piece of real landscape that looked as if it could have been lifted from a painting by one of the French masters, say **Claude Lorraine** 1600–1682 or **Nicolas Poussin** 1615–1675. By the 19th century this meaning had reversed, so that a glorious landscape would be transferred straight to canvas. **William Gilpin** 1724–1804 even encouraged sightseeing to *picturesque* places so that you could view these natural masterpieces first hand, and suggested they be viewed through special eye glasses to compose the perfect picture.

HEGEL'S SPIRIT

After the Enlightenment had introduced the idea of linking art and empiricism along came **Georg Wilhelm Friedrich Hegel** 1770–1831 to put philosophy and art upon a rigorously systematic track that was, in effect, a system of everything.

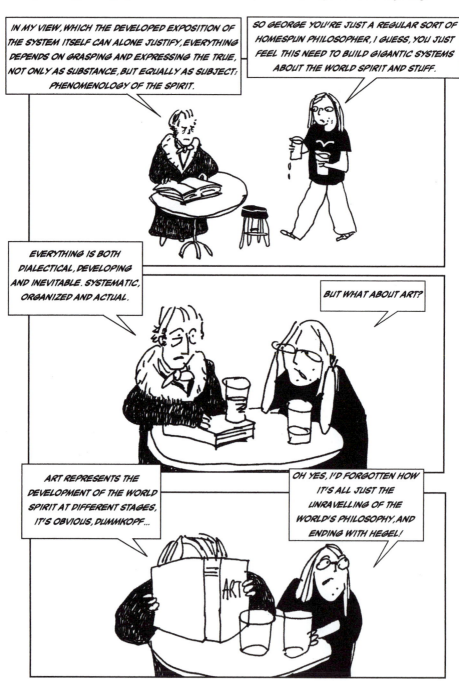

Hegel was both a rationalist and an idealist. He proposed that all world history and ideas could be accommodated in a single philosophical scheme, that he put forward in the **Phenomenology of Spirit** in 1807. By *spirit,* Hegel means "world spirit," which he saw as the collective drive of humanity and history. Hegel's historicizing philosophy was hugely influential in the 19th century. His theory of art coincides with the development of museums, the Neoclassical revival, and the acceptance of greatness in all things Greek or Roman. By proposing that art was a science, Hegel was really saying that art develops, and that its place within culture changes. He famously said:

THE FORM OF ART HAS CEASED TO BE THE SUPREME NEED OF SPIRIT. NO MATTER HOW EXCELLENT WE FIND THE STATUES OF THE GREEK GODS, NO MATTER HOW WE SEE GOD THE FATHER, CHRIST AND MARY SO ESTIMABLY AND PERFECTLY PORTRAYED, IT IS NO HELP, WE BOW OUR KNEES NO LONGER.

What this means, for Hegel, is not necessarily "the end of art," as is some-times assumed, but rather that art's function will be replaced by philosophy and science. Art for Hegel had done all it could. Painting and sculpture might well carry on, but their function now would be very different—as they would no longer be art. This idea was to be important in postmodernism, where there was a lot talk about *ends,* and these all relate in some way to Hegel's historicizing.

Hegel's aesthetics had a huge influence in Germany with the development of art history, and a lot of the early art historians were German. By calling art a science, Hegel was also saying that art shouldn't be viewed as some sort of manifestation of "human spirit" but rather that it **"embodied cultural eras."** This was an important new theory of how to look at art.

In *The Philosophy of Fine Art* 1835–1838 Hegel announced that there were three stages in art. They were the *symbolic,* the *classic,* and the *romantic.* Each of these terms represents a different relationship between 'spirit', form, and era.

1 The **symbolic** period refers to pre-Greek art, and includes the Eastern and Egyptian traditions. During this phase Hegel sees art as containing a distorted spiritual content. It represses the natural, and thereby manifests hidden modes through mysticism (as, for example, in some Asian art) or nonrepresentation (as in Islamic art).

Typical medium = architecture

2 The **classic** period, which is taken to be the Greco-Roman period, Hegel says the spirit is embodied and made manifest, as the link between nature and the divine is clear. In other words Greek culture had a sense of the relationship between the human and divine, and was able to present the human form as divine and natural all at once.

Typical medium = sculpture

3 The **romantic** period comes after the classic and is dominated by Christianity. This period is characterized by the spirit being manifest in the subjective experience of truth, rather than in some idealized idea of beauty. The empathy with which one sees "love" or "the passion" portrayed in Christian art shows that spiritual longing is key to this phase in art.

Typical medium = painting

THE EMPIRICAL APPROACHES TO ART

The late 18th and 19th centuries saw not only the development of the museum but also the academic discipline of art history.

Giovanni Morelli

The Italian **Giovanni Morelli** 1816–1891 scrutinized paintings and sculptures and collected together a mass of observed details about them. He developed the art historical method of **connoisseurship** and was particularly keen on observing how fingers, eyes and ears were treated in artworks, as then he could tell who painted what. It was the empirical evidence that was important.

Then there were art historians who were deeply influenced by Hegel's ideas about art embodying a particular age's spirit. **Alios Riegel** 1858–1905 equated "artistic intention" to Hegel's *spirit*. Together with **Heinrich Wölfflin** 1864–1945 and **Henri Foccillion** 1881–1945 he can be described as a **formalist** art historian. He was primarily interested in what things looked like and how style developed. Wölfflin wanted to create "art history without names," showing not individual achievement but rather the larger picture of stylistic development and change.

Aby Warburg

Next there was the **iconological** approach that wanted to contextualize the artworks culturally. This was really developed by **Aby Warburg** 1866–1929 and **Erwin Panofsky** 1892–1968. They thought the formal approach was rubbish, as it was all about form and not about subject matter. They wanted to work out what things meant and looked at all the surrounding documents they could, to contextualize a work. Panofsky even devised a three step plan to interrogate a work of art: it looked at the philosophy, the literature, and then the religion of the age that produced it.

Erwin Panofsky

THE INDUSTRIAL AGE

There is no doubt that the art of the 18th and 19th centuries was deeply affected on all levels by the huge changes in society brought about by developments made in agriculture, technology and industry. The so-called **Agricultural** and **Industrial Revolutions** may have started in Britain but they soon spread throughout Europe. These really were revolutions in that they utterly changed the way people lived—Europe moved from essentially an agrarian society to an industrial one in a matter of a few generations. These developments fuelled both the Romantic movements and the birth of the Modern age.

1701	The Seed Drill was invented by Jethro Tull.
1724	The Thermometer was invented by Gabriel Fahrenheit.
1733	The Flying Shuttle was invented by John Kay.
1761	The Marine Chronometer was invented by John Harrison.
1769	The Steam Engine was invented by James Watt.
1796	The Smallpox Vaccine was developed by Edward Jenner.
1800	The Battery was invented by Alessandro Volta.
1809	The Electric Light was invented by Humphrey Davy.
1829	The Typewriter was invented by W.A. Burt.
1835	Calotype Photography was invented by Henry Fox Talbot.
1835	The Calculator was invented by Charles Babbage.
1876	The Telephone was invented by Alexander Graham Bell.
1877	Moving Photographs were made by Eadweard Muybridge.
1885	The Machine Gun was invented by Harim Maxim.
1886	The Four-wheel Motorcar was invented by Gottlieb Daimler.
1895	The Cinema was invented by the Lumière Brothers.
1898	The Diesel Engine was invented by Rudolf Diesel.
1903	The Production Line was invented by Henry Ford.
1903	The Wright Brothers flew the first manned Airplane.
1905	Theory of Relativity was published by Albert Einstein.
1926	Television was invented by John Logie Baird.

RUSKIN AND THE VICTORIANS

John Ruskin 1819–1900 was the most notable critic of the British Victorian era. He wrote about all sorts of things—art, architecture and politics—but originally he wanted to be a poet. He was the great champion of **J.M.W. Turner** 1775–1851, who he knew, and who had received bad press for his nonacademic paintings. Ruskin's criticism is informed by ideas associated with John Locke. Ruskin followed Locke's position of the dualism of mind and body and believed that art should express the noble ideas of man and God. He saw nature as a supreme divine idea and therefore a key to meaningful art.

He urged Turner to:

"GO TO NATURE IN ALL SINGLENESS OF HEART AND WALK WITH HER LABORIOUSLY AND TRUSTINGLY, HAVING NO OTHER THOUGHTS BUT HOW BEST TO PENETRATE HER MEANING AND REMEMBER HER INSTRUCTION; REJECTING NOTHING; SELECTING NOTHING AND SCORNING NOTHING; BELIEVING ALL THINGS TO BE RIGHT AND GOOD, AND REJOICING ALWAYS IN TRUTH. THEN WHEN THEIR MEMORIES ARE STORED AND THEIR IMAGINATIONS FED, AND THEIR HANDS FIRM, LET THEM TAKE UP THE SCARLET AND GOLD, GIVE REINS TO THEIR FANCY AND SHOW IN WHAT THEIR HEADS ARE MADE OF."

YES SIR, NO SIR, RIGHT AWAY, SIR.

John Ruskin

Ruskin was horrified by the injustice caused by the changes in society brought about by industrialization and was an early advocate of socialism. In *The Stones of Venice* 1851–1853 he sees art as essentially a moral act which corresponds to the moral state of society, and the need to react to it.

Ruskin urged Britain to rediscover the Gothic. He saw Gothic art as more passionate, and able to express a greater spectrum of emotion, than Renaissance art, and this led to the **Victorian Gothic Revival**. He also believed that the lack of mechanization in Gothic art and architecture produced a richer form of creativity. He circulated these ideas widely in a pamphlet, *The Nature of the Gothic,* that was published at the newly formed London Working Men's College.

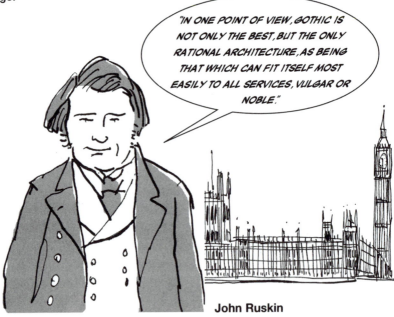

"IN ONE POINT OF VIEW, GOTHIC IS NOT ONLY THE BEST, BUT THE ONLY RATIONAL ARCHITECTURE, AS BEING THAT WHICH CAN FIT ITSELF MOST EASILY TO ALL SERVICES, VULGAR OR NOBLE."

John Ruskin

THE PRE-RAPHAELITE BROTHERHOOD

A particular reaction to industrialization was developed by the artists associated with the **Pre-Raphaelite Brotherhood**. This group also turned against Neoclassicism and the academic art being taught at Sir Joshua Reynolds' Royal Academy in London.

The Pre-Raphaelites sought to return to the type of art before Raphael, a return to nature, and a purer approach to art. They traced back the academic tradition of art to Raphael and the High Renaissance.

Pre-Raphaelite paintings often contain foliage and flowers, in wonderful detail. Their paintings were bright and colorful, and reminiscent of earlier pre-Renaissance art. (Ruskin was then championing the Gothic and the Romantics had popularized art and literature from the Middle Ages.) The Pre-Raphaelites chose not to dress their models up in semi-Classical robes, as the Neoclassicists did, but rather in contemporary or *real* clothing, or even in the historical dress of the English Medieval period. The Pre-Raphaelites were drawn to **Medievalism** because they saw it as the last great flowering of art, when art interwove perfectly with nature, Christian morality, and humanism, their great beliefs. Their paintings and ideas received a lot of criticism and ridicule. **Charles Dickens** 1810–1870 thought the use of medieval poses utterly absurd. But Ruskin thought they were wonderful.

REALISM

Realism refers to a *realistic* rather than *idealized* view of the world.

Realism was a theory of art that wanted to speak of social conditions, of the truth about work, and of the mundanity of everyday life. This was a complete transformation of the purpose and function of art.

Realism developed out of Romanticism, and found great beauty and meaning in the everyday. It wasn't until the 19th century that a strong sense of depicting things in their everyday sense—*as real*—came to be developed in art. This was partly as a reaction to Enlightenment thought, which brought changes in thinking about what art should be. Realist artists thought that by portraying the everyday, the real and the ordinary, they were making work that was in some way uniquely valid and meaningful.

Realism with a capital "R" refers to the 19th century French art movement which the painter **Gustave Courbet** 1819–1877 is associated. He painted gritty and realistic scenes of the rural poor. These were seen at the time as political and shocking, since art had before then concerned itself with idealized beauty.

MANET'S REALISM

Edouard Manet 1832–1883 was keen to make art that was realistic rather than idealized.

When Manet's painting of *Olympia* 1863 was shown in the Salon exhibition at the Louvre in 1865, it was its realism that created such a scandal. Pregnant women were advised not even to look at the painting and its position was moved to prevent vandals attacking it. Manet based his painting of Olympia, the Classical Goddess of Love, on a work by the Renaissance master **Titian** 1490–1576. Manet's painting was obviously not a Classical Goddess but a contemporary prostitute on display.

Titian *Venus of Urbino* 1538

Manet *Olympia* 1863

This shockingly realistic painting was very nonclassical. It did not adhere to the Neoclassical rules that were still dominant within the Académie's Salon. *Olympia* wasn't even an idealized *nude,* because she wore jewelry, toyed with a small slipper on her foot, and there was even a lady in waiting bringing her a large floral gift from an admirer or client. The other great innovation that stressed the *newness* of Manet's paintings was his technique. Unlike the academic Neoclassical painters, who were his contemporaries, Manet chose to abandon the smooth blended quality of painting and the translucent glazes that they used. He placed areas of color next to each other, showing the actual physicality of the paint. He was painting in a new way. The subject was realistic and new, and so was the way it was painted.

THE SOCIAL FUNCTION OF ART

The idea that art might have a social function comes out of Enlightenment thought, which believed in the importance of scientific and empirical thinking. A new science was developed by the French philosopher **Auguste Comte 1798–1857**: Sociology, or the science of society. Sociology was an academic discipline that looked to study the human relationships and values within cultures. If you study the inequalities within society, and industrial society was very unequal, you may well want to change that society. It was in this period, spurred on by the French Revolution's call for "Liberty, Egality and Fraternity," that we see the development of socialism, with early socialist thinkers, like **Pierre-Joseph Proudhon 1809–1865**, proclaiming "All property is theft."

Could art be one of the ways to change society?

Questions regarding the social function of art had, of course, been asked before. **Plato** in his famous work *The Republic* thought that the arts weren't of much use and could be a distraction. This really counts as the first sociological theory of art. He was arguing that poetry, for example, does not tell the truth, and that artists are therefore liars and impostors, and cannot be trusted. He makes a similar point about painting, that the artists are imitating objects, and therefore making inferior copies of them. Copies that were less than the ideal or true object. For Plato, art wasn't good for people, it was definitely bad for their morals.

MARX AND ART

Karl Marx 1818–1883, writing after the social uprisings and European Revolutions in 1848, developed a style of socialism that looked at the way power was distributed in society. He believed **industrial capitalism**, which made men so unequal, could be overthrown by revolution and eventually lead to a higher form of society—**communism**.

Plato asked the question "What is the moral impact of art on its audience?" Marx asked a slightly different question, "What is the ideological impact of art on its audience?" By *ideology* Marx meant a system of ideas that impacts on economic, or social structures, within society. Marx's other big question was "How does art reflect the social reality of its time?"

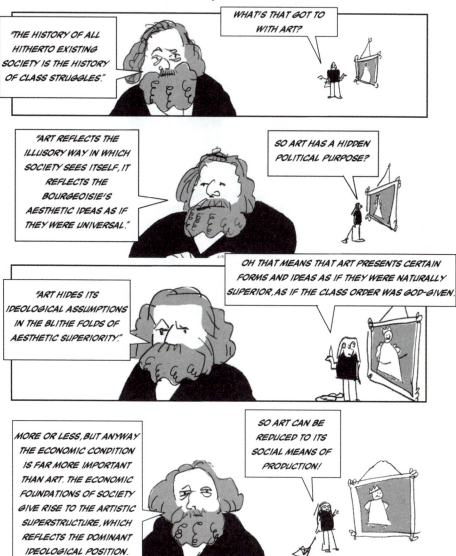

That art comes out of a social context, nobody can deny.

This leads to other questions:

What does understanding the specific *context* of a work of art tell us about the work itself, rather than the actual society in which it was made?

Does analyzing the work of art in relation to its social context tell us more about the work of art?

ART IS THE VISUAL HISTORY OF THE WORLD.

In sociological theories of art the relationship between aesthetics and social theory is always important. The sociologists say that you cannot properly understand art unless you first understand the society from which it emerges. This is a fair point, but it leads to another far harder question:

Can art stand on its own and be understood as itself, art, or is it always a mere product of society?

Well, to answer that question, perhaps you have to answer these questions:

1 Do art and social class have an integral connection that cannot be ignored?
2 Does art reflect an ideological, or partisan, view of the world?
3 Is art part of a ruling system of power that is imposed by an elite?
4 Can art be free of political, social or ideological concerns?
5 Is art political in exposing social injustice?

All of these issues appear and reappear in art, and in the study of the history of art, during the 20th century.

WILLIAM MORRIS AND THE SOCIAL FUNCTION OF ART

William Morris 1834–1896 was influenced by Marx, Ruskin, and the Pre-Raphaelites. He believed a full scale return to preindustrial techniques of making art and artifacts would be a way to challenge the degenerate nature of the new industrial society. He designed books, and hand-printed them at his Kelmscott Press. He set up old-fashioned workshops to print fabrics, make furniture and stained glass windows. He hoped to distribute these artifacts widely, with their pleasing designs from nature or medievalism. Then everybody, and not just the rich, could appreciate and use them.

Art, Morris believed, was good for everyone:

ART AND PHOTOGRAPHY

Marx not only talked about the way in which art reflected the culture of any period, he also thought about the techniques and methods of artists in different eras. Marx thought that the development of technology had a big impact on social and cultural development and this, in one sense, is demonstrated by the development of photography. In terms of the transformation of culture, the invention of photography is often compared to the invention of the printing press, which revolutionized the dissemination of culture and ideas during the Renaissance.

Photography was invented almost simultaneously by several different people in Europe, and this was brought about by developments in science and chemistry. Without going into technical detail we can say that there were four main villains:

1 The French physicist **Joseph Nicéphore Niepce** 1765–1833 made the first negative in 1816 and a bit later the first known photograph (which he called a heliograph) in 1826.

2 **Louis-Jacques Mandé Daguerre** 1787–1851 announced in 1839 the invention of a method for making a direct positive image onto a silver plate—which he called the daguerreotype.

3 The French, therefore, really kicked it off and **William Henry Fox Talbot** 1800–1877, although having worked along very similar lines, could only add the use of paper negatives.

4 **Sir John Herschel** 1792–1871 in 1819 discovered the chemicals to *fix* photographic images using hyposulphate.

The invention of photography was one of the biggest technological developments in the history of art, and one that changed forever art's representation of reality. Painting had often tried to represent things as they were, but photography in one sense made this redundant.

The French Academic painter **Paul Delaroche** 1797–1856, when he saw the potential of the daguerreotype said:

The development of photography brought about a situation in which an image of observed *reality* could be mechanically reproduced. This raised many theoretical questions for art, and artists responded in many different ways, as they realized the implications of this new invention.

Here are just a few of them:

1 Would painting be made redundant by photography?
2 Was the birth of photography the death of realism?
3 Would photography replace the imagination with technology?
4 Would the mechanical reproduction of images change our ways of looking at art?
5 Was photography itself a new art form?
6 Could photography make culture more democratic by eventually making everyone a photographer?
7 Would photography bring different cultures closer?
8 Would photography change our perception of the world?

IMPRESSIONISM

The **Impressionists** were concerned with realism and were also influenced by photography. They were a group of principally French artists that included **Claude Monet** 1840–1926, **Edgar Degas** 1834–1917, **Mary Cassatt** 1845–1926 and **Pierre Auguste Renoir** 1814–1919. They chose not to exhibit in the Académie's Salon in Paris in the 1870s and 1880s. Impressionist paintings, like those by Manet, are often characterized by their nonacademic finish and a loose spontaneous style of brushwork.

The Impressionist artists wanted their paintings to be so real that they sometimes worked outside, *en plein air,* which would help capture the realism of the life that they saw. They were also interested in visual phenomena—how we actually see.

The Impressionsts were trying to make art that found meaning in the society they lived in and the visual phenomena they experienced. Even a railway station, or smog, could be beautiful for an Impressionist. Now, that was really shocking to the Neoclassicists.

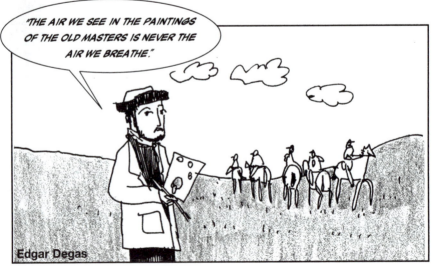

THE DISSOLUTION OF PROGRESS

At about this time there was a reaction to the idea of progress. In the late 19th century there emerged a style of antirationalism that challenged many Enlightenment ideas. This dissolution of progress was brought about by new theories in science and philosophy.

The scientific discoveries of **Charles Darwin** 1809–1882 showed clear relationships between humans and animals. Humans suddenly seemed similar to other species, and like others had developed through chance, mutation and adaptability.

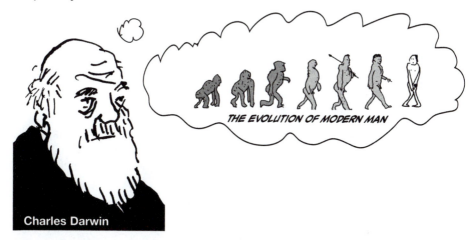

THE EVOLUTION OF MODERN MAN

Charles Darwin

The philosopher **Friedrich Nietzsche** 1844–1900 was a great nihilist and destroyer of systems, as well as being associated with the development of **Existentialism**, a philosophical tradition that reflected on human existence divorced from any metaphysical beliefs. Nietzsche's proclamation that we are living as if "God is dead," meant that there was no higher moral judgments outside of oneself. He thought everybody expresses a "will to power" and that interpretations were more important than "facts." So, traditional ideas of morality based on the church or on some humanist belief, were turned on their head.

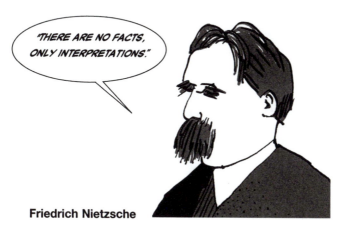

"THERE ARE NO FACTS, ONLY INTERPRETATIONS."

Friedrich Nietzsche

IT'S A TRAGEDY

Nietzsche's infamous *The Birth of Tragedy* 1872 turned Neoclassical ideas upside down. He describes the art of Greek tragic drama as presenting the human condition—a struggle between the **Apollonian** and **Dionysian**. He saw the Apollonian as rational and orderly, the Dionysian as drunken, mad and primitive. This duality shattered the Neoclassical idea of an idealized Greek age. To Nietzsche the Greeks were basically a "primitive" society and their art of drama was all the better for it. Nietzsche's philosophy and that of **Arthur Schopenhauer** 1788–1860, who he was influenced by, have been very important to artists and writers in the 20th century.

Schopenhauer believed that the world was not a rational place, and that throughout nature everything was struggling to overcome death, and exhibited a "will to life"—that was of course futile—as death was inevitable. This was rather a depressing philosophy, but art was important to it, as the realm of aesthetic experience was the only activity man did for its own sake, rather than as a manifestation of the "will to life." So contemplating works of art, for Schopenhauer, provided a possible respite from the futile struggle to survive.

One of the reasons that Schopenhauer's views have been so influential to artists may be because he thought so highly of them. He thought that artists were able to convey the tragedy of the human condition through their work, a similar view to that expressed by Nietzsche.

"WE SHOULD COMFORT OURSELVES WITH THE MASTER-PIECES OF ART AS WITH EXALTED PERSONAGES—STAND QUIETLY BEFORE THEM AND WAIT UNTIL THEY SPEAK TO US."

Arthur Schopenhauer

The German composer **Richard Wilheim Wagner** 1813–1883 regarded his discovery of Schopenhauer's writing as the most important event in his life. They both shared a deep pessimism about the human condition. As well as writing operas Wagner wrote about art. In his essay "The Artwork of the Future" 1849 he developed the idea of the *Gesamtkunstwerk* or "total work of art," or "synthesis of art." This idea was much more than just a multi-disciplinary presentation using all art forms. Like Greek tragedy, which he aimed to emulate in his operas, it was where all the arts combined to focus on the human condition with religious and social cohesion.

NEW WAYS OF SEEING

Charles Baudelaire 1821–1867 is widely regarded as one of the greatest poets of the 19th century. He was also a commentator on the changing nature of Paris at this time of industrialization, and he wrote about art. Baudelaire epitomises this new anti-rationalist aesthetic that focused on the totality of the human condition and is regarded as the father of modern criticism.

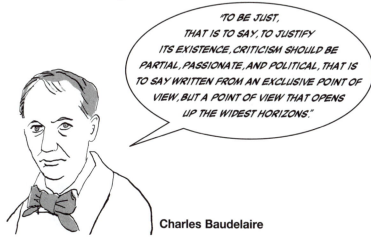

Charles Baudelaire

In *The Painter of Modern Life* 1863 Baudelaire tells us what he feels is good about the art of his age. Baudelaire championed artists who depicted real life as it was, especially real life in the new cities, like Paris, which were undergoing huge development and change. The artist should be detached from society, able like a dandy, or in his words a *"flâneur,"* to strut the city and 'botanize the asphalt' with his glorious presence, examining how the world they observed was different from the past. The difference was in the new fast-moving qualities of the city, "the ephemeral, the fugitive, the contingent," and these new urban subjects would require new artistic techniques to allow the artist "to marry" into the world of cafés, boulevards, beggars, prostitutes, and military processions.

DECADENCE

Baudelaire had particular views about realism, how ugliness and decay could be seen as beautiful. He didn't care at all about a moral art. He wanted an amoral art that would actually seem more real. His most notorious book of poems is *Flowers of Evil* 1857. This volume shocked his contemporaries with its unflinching visions of real-life sickness, lust and moral degeneracy. Baudelaire saw evil and sin as a part of human nature and thought the idea of man or society improving or becoming enlightened was a fantasy.

Baudelaire saw himself as a fallen angel, and embodying a new spirit. Together with other poets and artists, such as **Paul Verlaine** 1844–1896 and **Stéphan Mallarmé** 1842–1898, he formed a group called the **Decadents**. The cult of **decadence** is mainly associated with the *fin-de-siècle* in France—at the end of the 19th century. Championing the belief that progress was not always for the better, the Decadent writers, like Baudelaire, revelled in the sensual, outlandish and erotic.

"THERE IS WEEPING IN MY HEART LIKE THE RAIN FALLING ON THE CITY."

Paul Verlaine

The novelist **Joris Karl Huysmans** 1848–1907 in his book *Against Nature* 1884 epitomizes a Decadent vision— where the protagonist Des Esseintes appreciates the artificial over the natural and encrusts his pet tortoise with jewels. The artists associated with the Aesthetic Movement in Britain, like **Aubrey Beardsley** 1872–1898, were fin-de-siècle British Decadents who were out to shock with the erotic, symbolic and spiritual.

WHAT AM I GOING TO DO WITH THIS THEN?

Aubrey Beardsley
Drawing for *Lysistrata*

SYMBOLISM

Another 19th century art movement that was particularly influenced by the writing of Wagner was **Symbolism**. The term was first used to describe the poems of Mallarmé and later the visual art of **Odilon Redon** 1840–1916, and **Puvis de Chavannes** 1824–1898. Symbolist art rejected realism in favor of a more mysterious, mythological or physiological content.

ART FOR ARTS SAKE

One of the great artistic debates of the 19th and 20th centuries has been over the autonomy of art. During the closing years of the 19th century, at the start of the Modern period, and again during the late 1960s, artists and critics grappled with how engaged artworks should be with the real world—the world of politics and society.

Baudelaire did not believe in art having a specific social function. He thought art was for its own sake. This idea has its roots in the aesthetics of Kant who detached beauty from ideas of morality and truth. The French philosopher **Victor Cousins 1792–1867** first used the term *l'art pour l'art* in 1818, but the concept was popularized by **Théophile Gautier 1811–1872**, and most memorably by **James Abbott McNeill Whistler 1834–1903**.

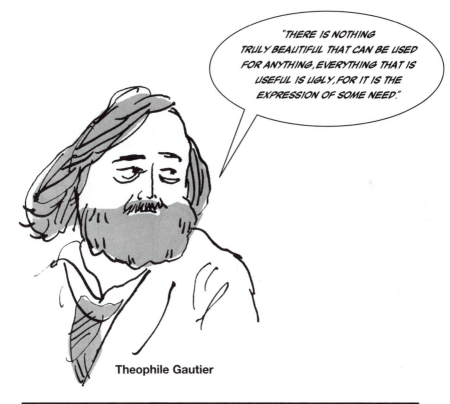

"THERE IS NOTHING TRULY BEAUTIFUL THAT CAN BE USED FOR ANYTHING, EVERYTHING THAT IS USEFUL IS UGLY, FOR IT IS THE EXPRESSION OF SOME NEED."

Theophile Gautier

Someone who disagreed completely with "art for art's sake" was **Leo Tolstoy 1828–1910**, the great Russian novelist. In *What is Art?* 1896 he argues that the sole function of art is to convey moral values, not to express form and beauty. He thought "art is not a pleasure, a solace or an amusement" but valuable when it communicated an experience of moral sensibility.

ART IN COURT

Whistler notoriously exhibited a painting, the **Nocturne in Black and Gold, The Falling Rocket** 1875, at the Grosvenor Galleries in London, in 1877. This exhibition brought the two opposing artistic ideas of the time head to head, the theory of the social function of art and the theory of "art for art's sake."

Ruskin, who wrote criticism in his own privately-published newspaper, derided the painting. He had many problems with Whistler's work, the main one was that it was *sketchy* and dressed up as being more significant than it was. He saw the paint as lacking finish; it wasn't clear what was being represented, and generally it was slapdash and badly made. The skills of observation and realism, that Ruskin championed, Whistler wanted to banish from art. His was a work of art for its own sake. It was about the subjective experience of the viewer, about the harmony of colors and arrangement of forms within the painting, and therefore it didn't matter at all that it was loosely painted. Ruskin was infuriated by this line of defense, and said so—this was no subject for a painting—it lacked any moral position and worse than that was just a frivolous product of the commercial marketplace. Whistler sued for libel.

The trial was a great Victorian spectacle. Ruskin's attack on Whistler was an attack not only on one artist but also on a new tendency in art at the time, particularly evident in the new movements from France, which the critic knew little about, but what he did know, he didn't like. Whistler, a witty raconteur, won the case, but was awarded only one farthing in damages and, as he was not awarded costs, was effectively bankrupted.

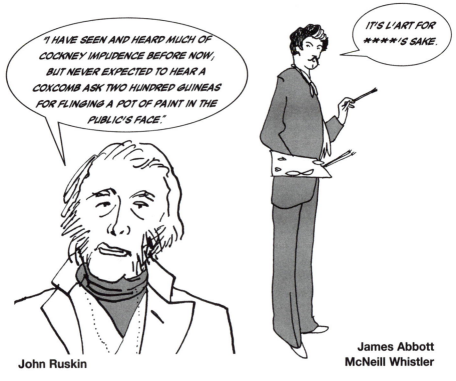

"I HAVE SEEN AND HEARD MUCH OF COCKNEY IMPUDENCE BEFORE NOW; BUT NEVER EXPECTED TO HEAR A COXCOMB ASK TWO HUNDRED GUINEAS FOR FLINGING A POT OF PAINT IN THE PUBLIC'S FACE."

IT'S L'ART FOR ****'S SAKE.

John Ruskin

James Abbott McNeill Whistler

INDUSTRIAL COLOR THEORY

At this time science and technology fundamentally affected art. The chemist **Eugène Chevreul** 1786–1889 studied how different colors related to each other and devised a *color wheel* comprised of 72 colors. He wanted to rationalize color theory for his fabric dyeing business. He proclaimed that: "Two adjacent colors, when seen by the eye, will appear as dissimilar as possible." In other words, that the experience of "a color" was dependent on what "other color" was next to it. He then tried to work out what happened in various scenarios.

The French art critic **Charles Blanc** 1813–1882 popularized Chevreul's theories in **Grammaire des Arts Décoratifs** 1881 a hugely influential text that was widely read by artists at the time, and one that certainly influenced **Pointillism**, or **Neo-Impressionism**, a technique developed by the painter **Georges Seurat** 1859–1891. Seurat tried to capture the effect of light, in paint, by applying millions of little dots of primary colors. In this way he was able to build up a full range of color by allowing the hues to mix optically (rather than just mixing the paint together on a palette). Seurat used the discoveries that Chevreul had observed. He wanted to develop the techniques that the Impressionists had popularized but from a more rigorous scientific basis.

JAPONISME

Artists like Manet, Whistler, and those associated with Impressionism and Neo-Impressionism were interested in creating a new representational but nonacademic or Neoclassical style of painting. Another trait they all shared was a fascination with all things Japanese.

A craze was sweeping Paris at the time—**Japonisme**—as it was named by **Philippe Burty** 1830–1890 a leading art critic during this period. Japan had only recently been open to trade, after being closed for 200 years, and this led to an influx of Japanese prints, textiles and artifacts being seen in the West.

Western artists were particularly interested in the way Japanese wood block prints celebrated two dimensional space. The prints in the **Ukiyo-o** tradition, by artists like **Hokusai** 1760–1849 and **Hiroshige** 1797–1858, show a completely different way of depicting space from that of European art, and relied on calligraphic lines, no shadow, and a stylized method of scenic framing. Artists delighted in the breadth of subjects in Japanese prints. All human life was there, including some highly charged eroticism.

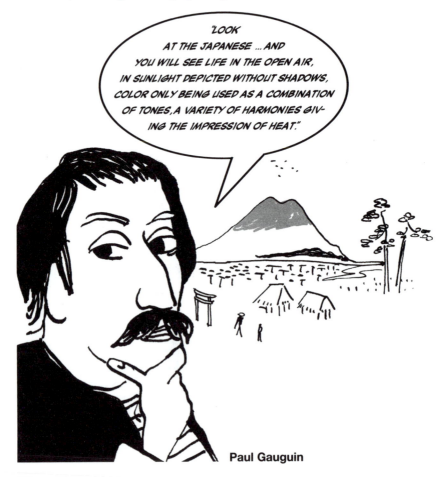

"LOOK AT THE JAPANESE ... AND YOU WILL SEE LIFE IN THE OPEN AIR, IN SUNLIGHT DEPICTED WITHOUT SHADOWS, COLOR ONLY BEING USED AS A COMBINATION OF TONES, A VARIETY OF HARMONIES GIVING THE IMPRESSION OF HEAT."

Paul Gauguin

It was in the 19th century that Westerners started to rethink their ideas about the art of other cultures, and it wasn't until the 20th century that this reappraisal fully recognized that *different* didn't mean *inferior*.

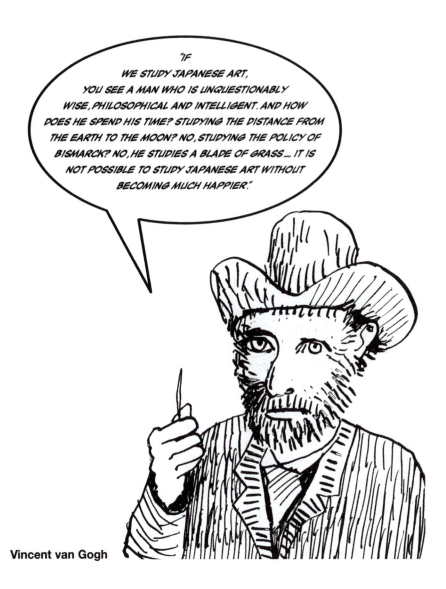

Vincent van Gogh

Van Gogh's 1853–1890 statement clearly depicts this different way of looking, and thinking about, the aesthetic that he found so exciting and liberating. It summarizes part of an Eastern approach, that values contemplation of the natural world, in order to think of greater spiritual things. This, in essence, is what a lot of Eastern art was doing, contemplating the totality of the universe in a single blade of grass. Rather than naturalistically examining the blade of grass, the artist is seeking to express the greater truth that lies behind it.

93

POSTIMPRESSIONISM

The art that came after, and was informed by Impressionism, is collectively known as **Postimpressionism**. This movement represents the gradual break with ideas of naturalistic representation in art. This was the result, in part, of the importance given to ideas of the self and of *self-expression* drawn from the popular new philosophical positions of Schopenhauer and Nietzsche. The term Postimpressionism was first used in 1910, by the British critic **Roger Fry** 1866–1934 when he curated an exhibition of paintings, *Manet and the Postimpressionists,* in London.

Key Postimpressionists are **Paul Cézanne** 1839–1906, **Vincent van Gogh** 1853–1890, and **Paul Gauguin** 1848–1903, who were all seen by Fry to have moved away from the clear representation associated with Impressionism.

FAUVISM

Fauvism was a very colorful movement in French Postimpressionist painting. The word *fauves* literally translates as "wild beasts" and was used by the art critic **Louis Vauxcelles** 1870–1943, in 1905, to describe the bright, expressive, *wild* paintings of artists like **Henri Matisse** 1869–1954, **André Derain** 1880–1954, and **Raoul Dufy** 1877–1953. This was an art that valued the idea of expression and emotion, and saw beauty in terms of pure color and form. **The Fauves** were the first movement in Western art to acknowledge the debt to the ethnographic or primitive art that they had seen in the Trocadéro Museum in Paris.

Henri Matisse

PRIMITIVISM

The influence of the art, and artifacts, of other non-Western cultures is clearly visible when looking at European art from the late 19th and early 20th centuries.

For modern artists the idea of the *primitive* defined a whole set of Western and non-Western societies which were seen as less civilized than modern, urban European ones. This was a Eurocentric view. Artworks from Africa or India were seen as primitive, as well as earlier European folk culture from the preindustrial rural cultures that were swiftly vanishing across Europe.

"I LOVE BRITTANY. I FIND SOMETHING SAVAGE AND PRIMITIVE HERE. WHEN MY CLOGS ECHO ON THE GRANITE EARTH, I FEEL THE DULL MUFFLED NOTE I AM SEEKING IN MY PAINTING."

Paul Gauguin Peasants

HOW EXOTIC DO YOU FEEL THEN?

THE NOBLE SAVAGE

The Romantic philosopher **Rousseau** invented the idea of the noble savage. He basically saw society as corrupt, and when man was born, or within a state of nature, he was pure, uncorrupted and good. He even went so far as to say in *The Discourses of Arts and Science 1750,* that all advancements within art and science had left mankind worse off than before.

Western artists also chose to see in the primitive a culture untouched by Western Christian orthodoxies. They thought that the taboos of Western culture were not present in primitive cultures—so that, to them, meant freedom, sex, and nonconformity.

WHO DO THEY THINK THEY'RE LOOKING AT?

"PRIMITIVE ART PROCEEDS FROM THE SPIRIT AND MAKES USE OF NATURE. THE SO-CALLED REFINED ART PROCEEDS FROM SENSUALITY AND SERVES NATURE. NATURE IS THE SERVANT OF THE FORMER AND THE MISTRESS OF THE LATTER. SHE DEMANDS MAN'S SPIRIT BY ALLOWING HIM TO ADORE HER. THAT IS THE WAY BY WHICH WE HAVE TUMBLED INTO THE ABOMINABLE ERROR OF NATURALISM. SO IN OUR PRESENT MISERY, THERE IS NO SALVATION POSSIBLE EXCEPT THROUGH A REASONED AND FRANK RETURN TO THE BEGINNING, THAT IS TO SAY TO PRIMITIVE ART."

YEAH, AND HOW MUCH LONGER DO I HAVE TO STAND HERE WITH MY ARM IN THE AIR?

Paul Gauguin

Primitive Object of Desire

There are many reasons why early modern artists were so strongly influenced by the art from other cultures. One reason is that the world was changing so fast that artists were exposed to many new influences. They saw a difference, or an opposition, between the changing world they were living in and the culture expressed within the primitive. The objects brought back from non-Western countries were greeted at the time by either bafflement or wonder.

The German art historian and critic **Wilhelm Worringer** 1881–1965 published an interesting book *Abstraction and Empathy* in 1908. This study linked the decoration and ornament used by primitive cultures to that of the new languages of modernist painting. He thought cultures used *abstraction* and decoration positively, to transcend the "dread of being alone." He saw this as the opposite of traditional Western art's use of naturalism and empathy.

CUBISM

Cubism has been called one of the most significant developments in Western art.

Cubism was a type of painting developed by **Pablo Picasso** 1881–1973 and **Georges Braque** 1882–1963 between 1907–1911. Picasso and Braque wanted to create a more truthful form of representation than naturalism, which we have seen underpinned so much Western art, from the Greek's onwards. They were deeply influenced by the way primitive cultures used representation, as in stylized African tribal masks.

Sometimes the paintings from this period are called **Analytical Cubism**. Later Picasso and Braque developed collages, or **Synthetic Cubism**, where newspaper cuttings, labels, and wallpaper—objects from the *real* world—were skillfully used to further complicate ideas of representation.

Therefore Cubism is all about representation—and its significance is that it was the culmination of a phase within Western art that challenged the Classical ideas and orthodox methods of representation. It opened the flood-gates for other artists to do likewise. Without Cubism there would be no Duchamp, no Pop Art, no Conceptual art, and no multimedia installations!

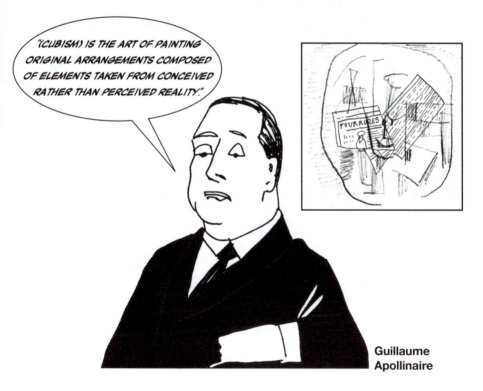

"(CUBISM) IS THE ART OF PAINTING ORIGINAL ARRANGEMENTS COMPOSED OF ELEMENTS TAKEN FROM CONCEIVED RATHER THAN PERCEIVED REALITY."

Guillaume Apollinaire

The French poet and critic **Guillaume Apollinaire** 1880–1918 was one of the first champions of Cubism. His pictorial or *calligraphic* poems were not unlike the Cubist paintings and collages he so much admired.

EXPRESSIONISM

It was not just French artists who were interested in primitivism. In Germany they also wanted to break from the balanced and harmonious world of Impressionism, and found inspiration in these primitive influences.

The **German Expressionists** valued robust self-expression, which they saw as noble and truthful. There were two main German Expressionist groups.

There was *Die Brücke* or The Bridge 1906–1913 founded by **E. L. Kirchner** 1880–1938. These expressionist artists embraced the idea of man in nature—and the artists often joined nudist colonies and lived in alternative communities.

WHERE DID I LEAVE MY TOWEL?

Then there was the more cerebral *Der Blaue Reiter* or the Blue Rider 1911–1914. This group was initiated by **Wassily Kandinsky** 1866–1944 and **Franz Marc** 1880–1916, but also included **August Macke** 1887–1914, and later **Paul Klee** 1879–1940. It was based in Munich, and first published Kandinsky's influential essay *The Art of Spiritual Harmony* 1912. This group was to become significant in the development of abstract painting.

> The absolute importance of self-expression was vigorously put forward by the German Expressionist artists, and can be seen to be adapted and carried on by the **Abstract Expressionists** in the 1950s. The *idea* of expressionism was later reused by the **Neo-Expressionists** in the 1980s.

THE MODERN

As we have seen for some artists living in this great industrial age of social development, there was a belief that their art should somehow be different from that of the past and reflect this rapidly changing society. Artists felt their work should be modern.

WHAT DO WE MEAN BY MODERN?

Originally when people spoke of objects or ideas being modern—they simply meant that they were contemporary or up-to-date.

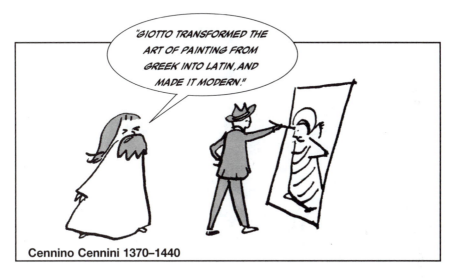

"GIOTTO TRANSFORMED THE ART OF PAINTING FROM GREEK INTO LATIN, AND MADE IT MODERN."

Cennino Cennini 1370–1440

Nowadays, people also use the term modern in a different way as well. It can refer to the "Modern era"—an historical period that runs for about 100 years from the 1860s, the start of the industrial age, to the late 1960s.

WHAT DO WE MEAN BY MODERNISM?

Modernism is the underlying philosophy of this Modern era. Within Modernism you have art that was noticeably different from that which went before. Modernism valued ideals of uniqueness and progress, while responding to the new, fast developing and changing, industrial world. Modernism in art is therefore a response to the changes in the Modern period—changes such as industrialization and urbanization.

MODERNIST ART

Modernist artists, whether they were painters, sculptors, photographers, writers, poets or critics, tended to share certain beliefs. They all felt that they were living in an environment that was fundamentally different from that of the past. They wanted to reflect this change and create a new type of art. Therefore ideas of tradition and history were rejected; what Modernists wanted was originality and newness. The rejection of established histories, beliefs and tradition also meant the rejection of older vernacular and decorative styles. A new internationalist spirit is evident in much Modernist art and architecture, and links with international socialist principles that were popular among many Modernist artists at the time.

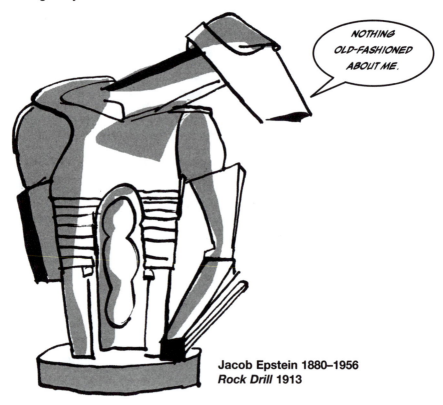

Jacob Epstein 1880–1956
Rock Drill 1913

The **avant-garde** was a Modernist idea associated with artists occupying the forefront of a developing culture. A position that was opposed to the mainstream culture. It derives from the French military term for advanced troops who stake out new positions in hostile territories. Some people saw the idea of an oppositional avant-garde ending in the 1930s, while others saw proto-Pop artists and early postmodern artists as avant-gardes. There are many different theories that try to explain the avant-garde. **Peter Bürger** b.1936 developed one that separated the idea of Modernism from the avant-garde. In *The Theory of the Avant-Garde* 1974, Bürger makes the distinction between art that is quite happy being art, like much Modernist art; and avant-garde art, which he sees as really radical, because it challenges the very *idea* of art.

100

FUTURISM

Futurism was an early 20th century avant-garde art movement that was started by the Italian poet **Filippo Marinetti** 1876–1944. Among the artists associated with this movement were **Umberto Boccioni** 1882–1916, **Carlo Carra** 1881–1966, **Giacomo Balla** 1871–1958 and **Gino Severini** 1883–1966. The Futurists thought that history, and old culture, were inherently bad. They wished instead to embrace all that was new. This led them to call for museums and libraries to be destroyed, while celebrating things like fast cars, bicycle races, electricity, machine guns and tanks.

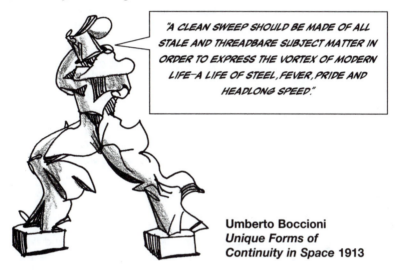

"A CLEAN SWEEP SHOULD BE MADE OF ALL STALE AND THREADBARE SUBJECT MATTER IN ORDER TO EXPRESS THE VORTEX OF MODERN LIFE—A LIFE OF STEEL, FEVER, PRIDE AND HEADLONG SPEED."

Umberto Boccioni
Unique Forms of
Continuity in Space 1913

VORTICISM

Vorticism was an English style of Futurism, started in 1913 by **Wyndham Lewis** 1884–1957. Like the Italian Futurists, Lewis wanted an art that celebrated the new machine age, and in his journal *Blast* he blasted old forms of art and culture, such as: France, English humor, Victorianism, aesthetes, the Anglican Church, popular writers and composers, do-gooders, and sportsmen. He then blessed the new: British industry, trade unionists, aviators, music hall entertainers, hairdressers, ports, and members of the avant-garde.

ANTI-ART

Dada was an *anti-art* movement. It began in Zurich in 1916, spread across Europe and then landed in New York. Dada art was irreverent and sometimes angry. It could be a **Hans Arp** 1887–1966 collage made with randomly pasted bits of paper, or a graffitied postcard of the Mona Lisa by **Marcel Duchamp** 1887–1968. Dada was against more or less everything. After the horrors and devastation of the **First World War** 1914–1918, with its utter carnage and massive loss of life, people seriously questioned the idea of an enlightened society. This was the first war fought on an industrial scale. The Dada artists had completely lost faith in their culture, and particularly in traditional art and aesthetics.

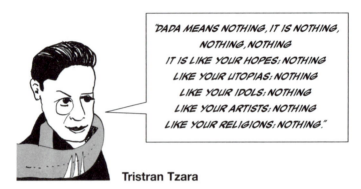

"DADA MEANS NOTHING, IT IS NOTHING, NOTHING, NOTHING
IT IS LIKE YOUR HOPES: NOTHING
LIKE YOUR UTOPIAS: NOTHING
LIKE YOUR IDOLS: NOTHING
LIKE YOUR ARTISTS: NOTHING
LIKE YOUR RELIGIONS: NOTHING."

Tristran Tzara

There were Dada performances, poems, films, photographs and typography, as well as what have become more conventional art objects. The movement was centered around the poet **Tristran Tzara** 1896–1963 and **Hugo Ball** 1886–1927 who ran the *Cabaret Voltaire* nightclub. Dada was all about shaking things up—especially the world of art. Dada performances were chaotic, aggressive and shocking. Dada poems were sometimes merely phonetic, like **Kurt Scwhitters'** 1887–1948 *Ur Sonata* which comprized of a rhythmic stream of unintelligible sounds.

In Berlin a more politicized movement sprang up. **George Grosz** 1893–1959 and **John Heartfield** 1891–1968 made satirical artworks aimed at the rise in right-wing nationalism, and **Hannah Hoch** 1889–1978 created intricate collage works that incorporated everyday litter as a subversive Dadaist act.

"I HEREBY DECLARE THAT TZARA INVENTED THE WORD DADA ON THE 6TH FEBRUARY 1916, AT 6PM. I WAS THERE WITH MY 12 CHILDREN WHEN TZARA FIRST UTTERED THE WORD... IT HAPPENED IN THE CAFÉ DE LA TERRASSE IN ZURICH, AND I WAS WEARING A BRIOCHE IN MY LEFT NOSTRIL."

Hans Arp

SURREALISM

The **Surrealists** were closely associated with the Dada artists. The Surrealist movement began in the 1920s and is focused around its founder, the writer and poet **André Breton** 1896–1966 and a select, but changing, group of artists and writers including: **Jean Arp** 1887–1966, **Joan Miró** 1893–1983, **Andre Masson** 1896–1987, **Salvador Dali** 1904–1989, **Francis Picabia** 1879–1953, **Yves Tanguy** 1900–1955, **Max Ernst** 1891–1976 and **Georges Bataille** 1897–1962.

The Surrealists also rejected the idea of civilization in the aftermath of the First World War. Drawing on **Sigmund Freud** 1856–1939 and his ideas of irrationality and the unconscious, Surrealist artworks and writings seem to further question the Enlightenment idea of human reason.

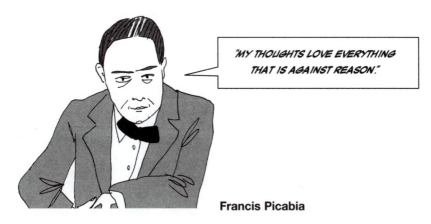

"MY THOUGHTS LOVE EVERYTHING THAT IS AGAINST REASON."

Francis Picabia

Surrealism means "transcending the real" and although as a movement it grew out of Dada, it was less about anti-art, and more about creating art from the unconscious. The Surrealists throughout the 1920s and 30s published a number of manifestos and organized group exhibitions. Surrealist artworks, although often stylistically different, showed an interest in the unconscious, in chance, in sexuality and the taboo.

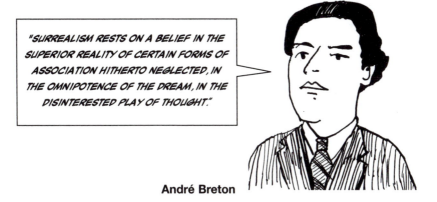

"SURREALISM RESTS ON A BELIEF IN THE SUPERIOR REALITY OF CERTAIN FORMS OF ASSOCIATION HITHERTO NEGLECTED, IN THE OMNIPOTENCE OF THE DREAM, IN THE DISINTERESTED PLAY OF THOUGHT."

André Breton

THE UNCONSCIOUS

Sigmund Freud published *The Interpretation of Dreams* in 1900 and it radically altered people's perception of the human mind, showing how unconscious thought (rather than conscious reasoned thought) could dictate people's behaviour. Freud thought that the traditional taboos of human society—killing, aggression, and violent sexuality—were its actual foundations, and he stated that:

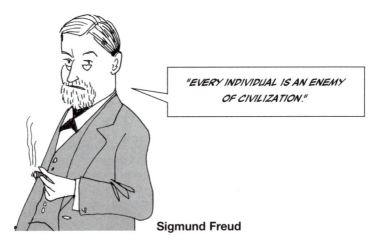

"EVERY INDIVIDUAL IS AN ENEMY OF CIVILIZATION."

Sigmund Freud

The Surrealists saw a relationship between the desires of the unconscious and the way people behaved in primitive and early civilizations. The cave paintings, such as those at **Lascaux**, had only recently been discovered and showed an important older culture where art could be seen as involved with ritual. The anthropologist **Lucien Levy Bruhl** 1857–1939 described in his book *How Natives Think* 1910, how primitive man's way of thinking was completely different from Western thinking, which was built on ideas of rationalism and logic. Likewise **Marcel Mauss** 1872–1950 showed that social acts like 'giving' were not rational, but possessed elements of mysticism and mystery. Unlike other artists who looked to the primitive, the Surrealists were interested in what primitive art revealed about primitive culture, because it might shed light on their own psyche.

"TO THEM (PRIMITIVE PEOPLE) THE THINGS WHICH ARE UNSEEN CANNOT BE DISTINGUISHED FROM THE THINGS WHICH ARE SEEN. THE BEINGS OF THE UNSEEN WORLD ARE NO LESS DIRECTLY PRESENT THAN THOSE OF THE OTHER; THEY ARE MORE ACTIVE AND MORE FORMIDABLE."

Lucien Levy Bruhl

AUTOMATIC WRITING AND DRAWING

The Surrealists wanted to tap into their unconscious, and even employed techniques that were used in Freudian analysis. **Max Ernst** created paintings using frottage or rubbing, which were open to accident and chance. While the *automatic writing* of **André Breton** or the *automatic drawings* of **André Masson**, were made by trying to create directly from the unconscious.

THE UNCANNY

Freud also wrote about *the uncanny*, or unhomely, in an essay of that title from 1925. The *uncanny* was an anxious feeling, that individuals experienced with strangely familiar objects. **Hans Bellmer** 1902–1975 took photographs and made sculptures of dolls that may seem very uncanny and far from *normal*, with their heightened life like sexuality.

Sigmund Freud

Hans Bellmer

FREUD AND ART THEORY

An arty intellectual tells it as it is:

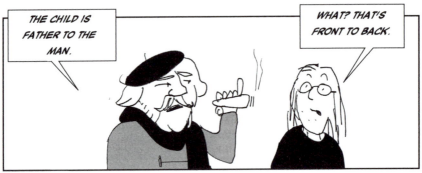

THE CHILD IS FATHER TO THE MAN.

WHAT? THAT'S FRONT TO BACK.

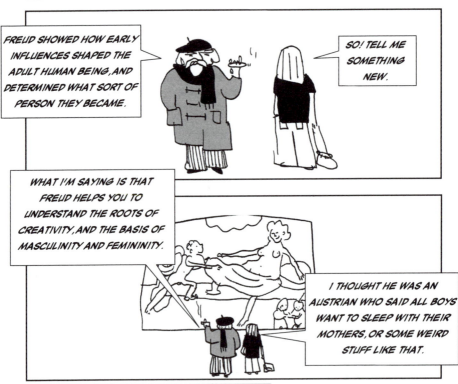

FREUD SHOWED HOW EARLY INFLUENCES SHAPED THE ADULT HUMAN BEING, AND DETERMINED WHAT SORT OF PERSON THEY BECAME.

SO! TELL ME SOMETHING NEW.

WHAT I'M SAYING IS THAT FREUD HELPS YOU TO UNDERSTAND THE ROOTS OF CREATIVITY, AND THE BASIS OF MASCULINITY AND FEMININITY.

I THOUGHT HE WAS AN AUSTRIAN WHO SAID ALL BOYS WANT TO SLEEP WITH THEIR MOTHERS, OR SOME WEIRD STUFF LIKE THAT.

WELL HE DID LIVE IN VIENNA, BUT WHAT HE SAID WAS THAT ALL HUMAN INFANTS ARE PSYCHOLOGICALLY FORMED THROUGH AN INTERACTION WITH THEIR PARENTS, WHICH FORMS THE PSYCHOLOGICAL PATTERN OF WHO THEY ARE AS ADULTS. LITTLE BOYS AND LITTLE GIRLS TAKE A DIFFERENT PATH TO ADULTHOOD.

DIFFERENT PATHS TO ADULTHOOD

MALE

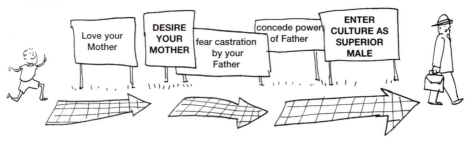

FEMALE

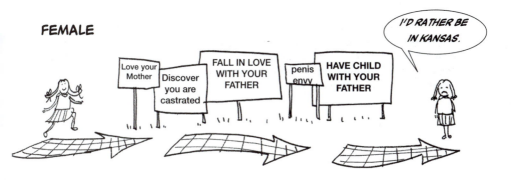

So is Freud important for art theory?

The short answer is yes, because he invented psychoanalysis.

The longer answer is that his theory uncovered what he believed were unconscious drives that motivate human activity and creativity, thus opening up an understanding of what art is about.

His ideas are contentious and many people disagree with them, but they cannot be ignored. This is particularly true when thinking about identity and art.

FREUD ON LEONARDO

Freud himself was very keen on art, especially antiquities, but he was also interested, as you might expect, in what motivated artistic activity and genius. In his work *On Leonardo,* written in 1910, he displayed the best and the worst of the Freudian approach to thinking about art.

His thoughts about the link between creativity and childhood experiences, those patterns that shape the particulars of character—in other words, what makes the artist—seem well argued. The worst aspect of Freud's approach is that it can be seen to reduce Leonardo's work to simply a sophisticated form of neurosis that can be *read* by the analyst or critic, to uncover the psychological motivations of the patient.

Whilst recognizing Leonardo's genius Freud basically argues that much of his artistic and scientific activity really had an unconscious defensive meaning, which was to protect him from learning about his own inner self. This may have some truth in it, but it is reductive, and this can be seen as a problem with Freudian interpretations.

Freud told the Swiss psychologist **Carl Jung** 1875–1961 that the "riddle of Leonardo's character" had suddenly become clear: "... at an early age he converted his sexuality into an urge for knowledge and from then on, the inability to finish anything ..." This can be interpreted as Freud's theory of the artist, and of the creative drive.

MARCEL DUCHAMP AND THE READYMADE

Marcel Duchamp 1887–1968 is sometimes thought of as a Dada artist, although he was reluctant to accept any allegiances with any movement. His early paintings were a mixture of Cubism and Futurism and gained him early recognition. *The Nude Descending a Staircase* 1912 caused a scandal when it was shown at *The Armory Show* 1913, a large survey exhibition highlighting, for New York audiences, the new Modern movements from Europe. *The Nude* may seem conventional now, but its mixture of woman, machine like movement, and Cubist angles, were indecipherable to many, and caused mocking front page headlines in the press.

It is not Duchamp's paintings, however, for which he is most well known, rather it is his idea of the **readymade**. The first readymade was the *Bicycle Wheel* 1915, a normal bike wheel attached to a wooden stool. A readymade was simply a mass-produced object presented as art. For Duchamp, the readymade showed that art could be removed from the aesthetic, and that *choosing* and *presenting*, rather than *making*, was the prime act of the artist. There were 21 readymades chosen or selected by Duchamp between 1915 and 1923. The most well known is called *Fountain* 1917 and was actually a urinal. Duchamp, under a pseudonym, entered it in a competition that

HERE'S ONE HE MADE EARLIER.

promised to show all submitted work. Even though he was one of the judges, Duchamp couldn't persuade anyone else it was art, so his work was rejected. He was testing the boundaries of what art was. What Duchamp wanted was for the readymades to concern the mind rather than the eye. Duchamp was really asking what would art be like if you got rid off all the qualities you associated with art; beauty, making, and craftsmanship?

"THE WORD ART ETYMOLOGICALLY SPEAKING MEANS TO MAKE, SIMPLY TO MAKE. NOW WHAT IS MAKING? MAKING SOMETHING IS CHOOSING A TUBE OF BLUE, A TUBE OF RED, PUTTING SOME OF IT ON THE PALETTE ... CHOOSING THE PLACE TO PUT IT ON THE CANVAS, IT'S ALWAYS CHOOSING. SO IN ORDER TO CHOOSE, YOU CAN USE THE TUBES OF PAINT, YOU CAN USE BRUSHES, BUT YOU CAN ALSO USE A READYMADE THING, MADE EITHER MECHANICALLY OR BY THE HAND OF ANOTHER MAN, EVEN, IF YOU WANT, AND APPROPRIATE IT SINCE IT'S YOU WHO CHOOSES IT. CHOICE IS THE MAIN THING—EVEN IN NORMAL PAINTINGS."

Marcel Duchamp

THE LARGE GLASS

Duchamp's work is full of cross references, puns, jokes and games. One of his most ambitious pieces is *The Bride Stripped Bare by Her Bachelors, Even* 1923, which is also known as *The Large Glass.* This object is made from sandwiching together two sheets of glass with a wire, paint, and foil image trapped in between them. The image is *unfinished,* and the glass although accidentally broken was never repaired because Duchamp thought it added to the composition. The objects depicted in the work are mechanical looking and it could be described as a "quasi-scientific diagram of the erotic impulses between people." The diagram is frozen, like an animation still, but one could imagine it actually coming to life and working. Each part of the glass means something, which although not immediately obvious, was described in the notes that Duchamp wrote to accompany the work.

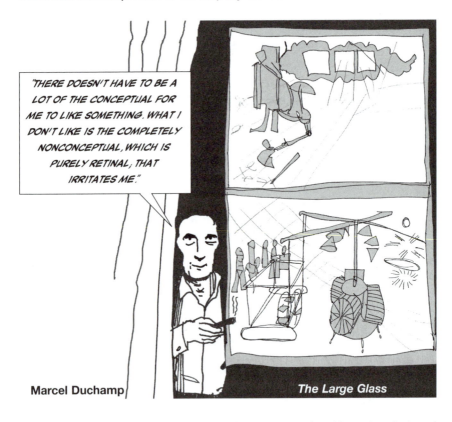

"THERE DOESN'T HAVE TO BE A LOT OF THE CONCEPTUAL FOR ME TO LIKE SOMETHING. WHAT I DON'T LIKE IS THE COMPLETELY NONCONCEPTUAL, WHICH IS PURELY RETINAL; THAT IRRITATES ME."

Marcel Duchamp

The Large Glass

Soon after making *The Large Glass* Duchamp stopped making art and played chess for 10 years. His last work, that took 20 years to make, was *Les Étants Donnés* 1946–1966 a hyperreal peepshow of a woman with her legs spread apart, that is viewed voyeuristically through two little holes in a huge wooden door. Again he seems to be asking us where the boundaries of art should be.

Marcel Duchamp has become one of the most influential artists of the 20th century. He is now even more influential than **Picasso,** and is seen by some as the father of **Conceptual art** and of **Postmodern** art practices.

ABSTRACT ART

Abstract art refers to the tradition of nonrepresentational art, which within Western art is associated with Modernism and the challenge to the old orthodoxy of representation or mimesis. Abstract art can be seen as the creation of a new visual language. Some of the first abstract paintings were made by **Wassily Kandinsky** 1866–1944, whose compositions moved from loose representations to truly non-objective art. His abstraction equated free forms and colors with *the spiritual*. He wrote a highly influential book *On The Spiritual in Art* in 1911. These ideas inform much early abstract art, such as those made by the early Modernist avant-gardes, which include:

The Suprematists, were the Russian abstract art movement founded by **Kasimir Malevich** 1878–1935 in 1913. Suprematist paintings used hard geometric shapes as a radical new language of form, that spoke about absolutes and pure emotion. Malevich's notorious *Black Square* 1913, can be seen as negating all previous art and was first exhibited like a traditional religious icon high in the corner of a room.

The Constructivists were another Russian movement, whose influence spread across Europe. Sculptures were made with industrial materials and tended to be about space, light and form. The movement was utopian, optimistic and accessible. The early Constructivists wanted a new type of art, for the new Post-Revolutionary age. Constructivism was originally informed by communist ideas that saw art as having the potential to be socially useful, and **Vladimir Tatlin** 1885–1953 designed a huge Constructivist tower, which was actually a radio mast. The politics got turned down a bit as the movement developed and its influence spread.

De Stijl translates as "the style" from Dutch. It was the name of a magazine founded by the abstract painters **Piet Mondrian** 1872–1944 and **Theo van Doesburg** 1883–1931. The artists associated with *De Stijl* made strict geometric abstract paintings which they referred to as **Neoplasticism.** This term was coined by Mondrian to stand for a new non-representational art that used only the purest forms—like squares—and purest primary colors. It was called plasticism because painting was a *plastic* or malleable art form.

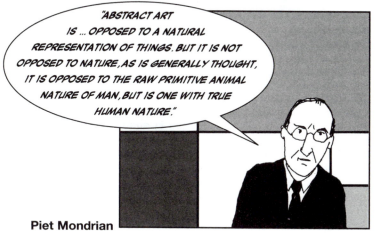

Piet Mondrian

111

ODD THEORIES OF ABSTRACT ART

There were many theories that the early abstract artists believed in, some of which are now widely regarded with scepticism.

Theosophy was a spiritual movement in the late 19th century that looked to realize the absolute truth by studying all religions. It was a movement which resonated with abstraction because of its search for a spiritual absolute. Many avant-garde artists, such as Paul Klee, Wassily Kandinsky, and Piet Mondrian, were all, at one time or other, theosophists. They all saw their work within this sacred milieu, searching for, or revealing spiritual order, unity and truths. A lot of abstract painters believed that painting could somehow capture a deeply significant invisible reality. Kandinsky even talked about his paintings representing "thought-forms," while others, like Duchamp, spoke of the "4th dimension."

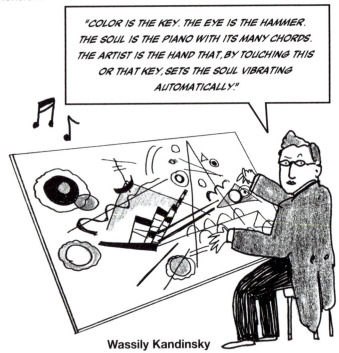

"COLOR IS THE KEY. THE EYE IS THE HAMMER. THE SOUL IS THE PIANO WITH ITS MANY CHORDS. THE ARTIST IS THE HAND THAT, BY TOUCHING THIS OR THAT KEY, SETS THE SOUL VIBRATING AUTOMATICALLY."

Wassily Kandinsky

Synesthesia was a scientific term that was again inspirational to painters and abstract artists. This was used to describe how a specific feeling in one of the senses can elicit a response in another of the senses. This is most apparent in the way some people experience color when listening to music. The painter Kandinsky was a synesthete. He saw his paintings as embodying musical compositions and harmonies. Color was therefore very emotionally charged for him. Synesthesia affected music as well. The composer **Alexander Scriabin** 1872–1915, a contemporary of Kandinsky, even made an organ to project light throughout his composition of *Prometheus* 1910, to enable all to experience this phenomena.

FORMALISM

For critics wanting to champion the new art they saw being made, a new theory was needed that broke with ideas of naturalism or representation. A theory that could accommodate the likes of Impressionism, Cézanne, and abstract art, but also could connect this new art with that of the past. **Formalism** was the answer. And it became one of the prominent theories of Modernism. It was developed by critics such as **Clive Bell** 1881–1964 and **Herbert Read** 1893–1968 in the 1920s, and was to re-occur in the 40s, 50s and 60s. Formalism is closely associated with the progression and acceptance of Modernist painting and sculpture. It is based on the idea of *form*. Form was what one was looking for in a work of art.

Clive Bell　　　　Herbert Read

One way to describe form would be to say that it is related to ideas of beauty and again its roots are in Classical philosophy. An argument for Formalism was put forward by Bell in his book *Art* 1914. Bell was associated with **The Bloomsbury Group**, a group of upper middle-class intellectuals such as **Virginia Woolf** 1882–1941 and **Roger Fry** 1866–1934, who supported early Modernism in Britain. They held salon like gatherings in Bloomsbury, the area of London next to the British Museum, before and during the First World War. Bell was a supporter of the Impressionists and organized the first Postimpressionist exhibition in England. This exhibition, along with his critical writing, helped popularize this new Modern art in the English-speaking world.

Roger Fry　　　　Virginia Woolf

SO HOW DO WE RECOGNISE SIGNIFICANT FORM?

For Bell, art was either good or bad, and if it was good it contained *significant form*. Significant form was a characteristic that might be shared by a whole collection of different types of art object, from all sorts of periods and cultures. It could be the windows at Chartres cathedral, Mexican sculptures, Giotto's frescoes at Padua, or the paintings of Cézanne.

For Bell significant form was a "combination of lines and colors" that appeal to the viewer's emotions and sensitivities. This may seem very subjective, far more so than its Classical roots that connect to a restrained and clear naturalism of expression. Bell's Formalism links to the philosophy of **David Hume** 1711–1776, who believed in the importance of subjectivity. Bell is clear that significant form is not just beauty in disguise, because beauty exists outside of art and significant form only within it. It is part of the very essence of art. Bell was clear that the subjectivity inherent in this type of Formalism was not going to mean that everyone had different ideas of good and bad art. To be responsive to significant form required education—and through education a consensus would be reached.

Bell's Formalism is therefore judgmental—it separates good art from bad art and as such has been criticized as being elitist.

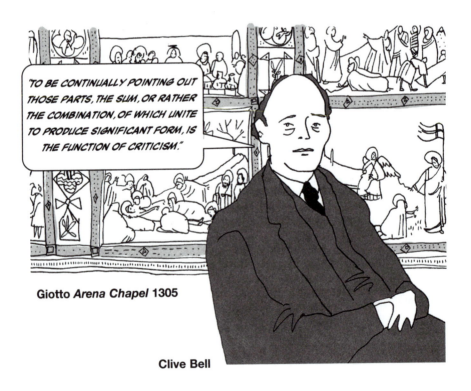

"TO BE CONTINUALLY POINTING OUT THOSE PARTS, THE SUM, OR RATHER THE COMBINATION, OF WHICH UNITE TO PRODUCE SIGNIFICANT FORM, IS THE FUNCTION OF CRITICISM."

Giotto *Arena Chapel* 1305

Clive Bell

INTRINSIC QUALITIES VS. EXTRINSIC QUALITIES IN ART

The other big idea of Formalism was that the work of art should contain all of its meaning inside itself. The *intrinsic* qualities were more important than the *extrinsic* qualities. Therefore representational art was often seen as bad because it focused on what was outside of the painting—what it represented. Political art, even if it was progressive, and abstract, like many of the paintings by the Italian **Futurists,** was likewise looked down upon because it focused on politics—and therefore on extrinsic qualities outside of the work of art. Art was a realm where only intrinsic qualities counted—it should be about form, emotions and sensibilities. As the French Modern painter **Maurice Denis** 1870–1943 said: "Remember that a picture, before being a battle horse, a nude, an anecdote or whatnot, is essentially a flat surface covered with colors assembled in a certain order."

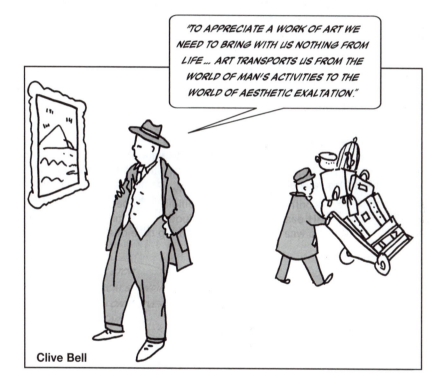

"TO APPRECIATE A WORK OF ART WE NEED TO BRING WITH US NOTHING FROM LIFE ... ART TRANSPORTS US FROM THE WORLD OF MAN'S ACTIVITIES TO THE WORLD OF AESTHETIC EXALTATION."

Clive Bell

Bell's position is obviously close to that of Whistler's defense of his ***Nocturne in Black and Gold*** which was, like Formalism, indebted to the theory of "art for art's sake."

HIGH ART/ LOW ART

Bell's Formalism separated good art from bad art, and in so doing referred back to the Enlightenment ideas of Kant. When Kant was writing about art in the 18th century he talked about universal beauty, and he pretty much insisted that this was an impersonal, detached and therefore a *rational* idea which allowed one to distinguish between great art and applied, or functional art. This led to the notion of **High Art** or great art, as opposed to the mundane everyday style of popular or **Low Art**. What had been a somewhat blurred distinction for many centuries hardened into a seemingly clear divide between what came to be called High Art which was serious, complex, beautiful and elite, and Low Art, which was frivolous, sentimental, cheap and popular.

The rise of capitalism, and of commodity culture, in some ways aided this invention of a High Art because it created a distinction between elite, bourgeois culture and everyday proletarian entertainment. Everyone likes to operate with clear distinctions and so High Art/Low Art became a workable means of saying "this work is serious and important and has prestige" as opposed to "that work which is frivolous and unimportant." A popular view was that High Art was "the best that had been thought or said" which clearly locates the sense of superiority over the seeming self-indulgence of cheap and popular art.

CHALLENGING THE DIVIDE

This division was challenged by many artists throughout the Modernist period. It is possible to see how a French Realist painter like Courbet was influenced by, and based his radical contemporary history paintings on, popular prints, as well as echoing a legacy of older Academic painting. In a similar way, Impressionist painters can be seen to use elements from prints, photography and fashions in their work. When Picasso was making his Cubist collages, he took the radical step of actually cutting up used newspapers and wallpaper, and letting these fragments stand for themselves, rather than depict anything with them.

LOOKS LIKE LOTS OF NEW MATERIAL OVER THERE.

Pablo Picasso

LOW ART AND DECORATION

The High Art/Low Art split is one of the reasons that, within Modernism, decoration was mainly seen as a bad thing. Decoration was closely associated with Low Art forms. Some Modernists saw it as an uncultivated language, and that it was somehow primitive which they took as a retrogressive idea. The decorative was based on irrational personal intuition rather than the cooler rationalism inherent within Modernism and its search for pure form or absolutes and order.

This is particularly evident in Modernist architecture—or the so called **International Style**. This movement is linked to the **Bauhaus,** and developed in the early Modern period. The Bauhaus was an art school, founded in Wiemer in 1919 by **Walter Gropius** 1883–1969. He believed that architecture was the *mother* of all arts and could therefore unite all strands of visual creativity. Clearly architecture was a functional art, yet he thought it could still achieve greatness. He stressed that simplicity was important, "that form should follow function" and the materials used should not be disguised, but be true to their uses.

For Bauhaus architects the decorative needed to be suppressed, as it disguised form, was not simple and not true. The German architect **Adolf Loos** 1870–1933 wrote in 1908 that:

"ORNAMENT IS CRIME."

Adolf Loos

In fact the French architect and champion of the International Style **Le Corbusier** 1887–1965 wrote in *The Decorative Art Today* 1925 that:

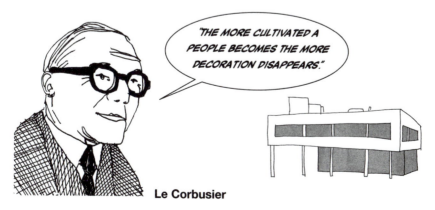

"THE MORE CULTIVATED A PEOPLE BECOMES THE MORE DECORATION DISAPPEARS."

Le Corbusier

In **Postmodernism** the decorative has been rediscovered. Instead of being seen as purely irrational, and primitive, the decorative is nowadays seen to speak meaningfully about specific cultural traditions. The so-called purity that the International Style or Modernism longed for can also be seen as marginalizing many aspects of the broader culture. Aspects that we now see as increasingly important which reflect local identities, gender, and multiculturalism.

Artists like **Henri Matisse** 1869–1954 were condemned by some Modernist critics as being too decorative, and consequently a bit superficial. But he thought decoration was an essential quality of a work of art.

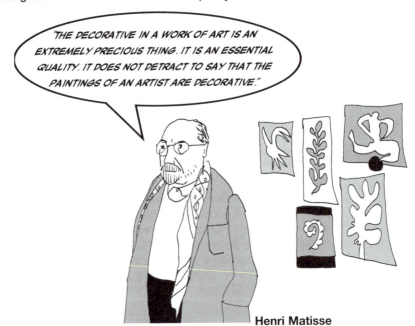

"THE DECORATIVE IN A WORK OF ART IS AN EXTREMELY PRECIOUS THING. IT IS AN ESSENTIAL QUALITY. IT DOES NOT DETRACT TO SAY THAT THE PAINTINGS OF AN ARTIST ARE DECORATIVE."

Henri Matisse

Less conventional Modern architects, like **Louis Sullivan** 1856–1924, or **Hans Scharoun** 1893–1972, have also used *the decorative*. This is now seen as a welcome challenge to the orthodox position of Modernism and therefore, before its time. Their eclectic ornamentation can be seen as a precursor to the Postmodern architecture of **James Stirling** 1926–1992 or **Robert Venturi** b.1925 who mix decorative motifs throughout their buildings. Venturi's ideas were developed when he and **Denise Scott Brown** b.1931 wrote about the new architecture of decorated sheds in their highly influential book *Learning from Las Vegas* 1968.

ART AND *BEING*

The important, if controversial philosopher, **Martin Heidegger** 1869–1976 worked with, or alongside, the Nazis in Germany—depending on who you talk to. He was very influential in postwar European thought, and a major influence in Existentialism, Deconstructionism and Postmodernism.

WASN'T HE THE GUY WHO WENT ON ABOUT BEING ALL THE TIME?

"To be is to do"
Socrates
"To do is to be"
Sartre
"Do be do bee doo"
Sinatra

Heidegger was very interested in ontological questions. That means he was concerned with the problem of *being*. His interest in art followed this move away from traditional questions, such as those about beauty or purpose, to think about the nature of being in art.

119

ART, *BEING*, AND *TRUTH*

Heidegger's major essay on art theory is *The Origin of the Work of Art* 1935. This work is basically a combination of an analysis of Kant's *Critique of Judgment* and his own concept of the aesthetic, which was based in Enlightenment rationalism. Where Kant looked for universal principles of aesthetics, Heidegger was more concerned with a kind of *mystical truth* that, he thought, painting in particular could develop.

His main idea was that we should look at art, less as objects, but as a way of arriving at truth. He said "art lets truth originate." Art for Heidegger, therefore, is about recognizing 'being' to discover truth. One of his prime examples is his description of van Gogh's painting of a pair of peasant's shoes. He sees this painting less as a representation of a peasant's shoes, but more as the embodiment of the whole of the peasant's life, his trudging in the fields, and the changing seasons. So it is the 'being' of the shoes we are discovering. One of his nonrepresentational examples is a Greek temple, where again he sees it embodying a whole civilization, their rituals and the decline of their society. For Heidegger it is through this embodiment that artworks speak of truth.

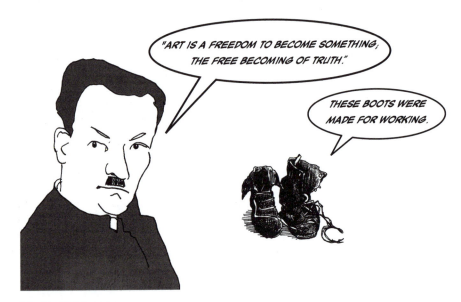

Martin Heidegger

In Heidegger's estimate art can produce truth, if you let it work. It can reflect new ways of thinking about the human condition. And its greatest purpose is to reflect on the nature of being.

Art allows the truth to happen; it does not predetermine it or make it conform to an already existing idea, art allows the truth to arise in the creation of the artwork itself. However, the truth that happens also involves the audience's response and so there is interaction as well. These are clearly interesting and open theories of art, a sort of Existentialist approach that allows for being rather than tradition.

120

SEMIOTICS AND STRUCTURALISM

A Swiss linguist, **Ferdinand Saussure** 1857–1913, who gave some fairly obscure lectures in the early 1900s, has been a powerful influence on theory and philosophy in the 20th century, mainly because he produced what became known as **Semiotics**, which was a precursor to **Structuralism**.

Saussure published virtually nothing in his lifetime, but his students wrote up and published his lectures during the 1920s, and from then on his influence just grew and grew.

Saussure was interested in the *structure* of language, and how a language worked as a system, as opposed to thinking about how a language historically developed. This led him to some interesting conclusions:

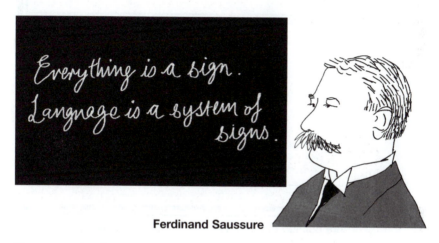

Ferdinand Saussure

The reason that Saussure's work became of interest to theorists, was because he was really concerned with how things came to function as *signs*. That means as representations of other things. Put at its simplest he was interested in the question of representation, of how one thing *stands for* something else. Saussure drew attention to the fact that words didn't have a natural meaning, the word *cow* doesn't refer to the "essence of cowness," but to an idea about cows.

Therefore a word is a sign:

THIS IS NOT A PIG???

WHAT IS A SIGN?

According to the American philosopher **C.S. Pierce** 1839–1914, a sign such as a smoke signal really acts semiotically. Smoke can be a sign that represents or stands for something else—it is smoke but it is also a message. All signs refer to other things, which is how they represent, an idea or an emotion.

Pierce thought signs operated in one of three ways:

1 Iconically—such as a picture that resembles what it signifies.
2 Symbolically—such as words that stand for what they signify.
3 Indexically—such as a footprint that is a trace of what it signifies.

Saussure pointed out that a sign was made up of two parts:

1 The **signifier**, which is the image, mark or word.
2 The **signified**, the thing to which it refers, the concept, object or emotion.

Saussure then argued that the relationship between the two is arbitrary, in other words not fixed and natural.

So, the signifier means something because we have a complicit agreement about what it refers to. We have a meaning system that we all understand.

ART AND SEMIOTICS

Saussure said that the structure or context fixes the meaning. So you could say a Semiotic theory of art is something like this:

Or maybe not...

Applying semiotics to art is a useful exercise because it helps us to think about how color, line, image and concept produce a *language*, or a grammar of artistic meaning, that is the art object.

Then the question "how does the art object function?" is answered by deconstructing it and by analyzing it semiotically.

THE FRANKFURT SCHOOL AND ART THEORY

The Frankfurt School wasn't a school at all, it was a collaborative research project that a group of philosophers who had links to the **Institute for Social Research** in Frankfurt formed. They were all interested in modernizing Marxism and understanding Modernity. The relationship between art and capitalism is the basis for all their contributions to art theory.

The work of **Theodor Adorno** 1903–1969 is complex, highly theoretical and very European in its insistence on the importance of knowledge in the understanding of art. It comes from a High Art perspective which opposes Low Art and mass culture. Adorno examined the world from the point of view of someone informed by Freud and Marx, and is interested in the impact of capitalist society on artistic production.

Adorno's theory of art addressed two main questions:

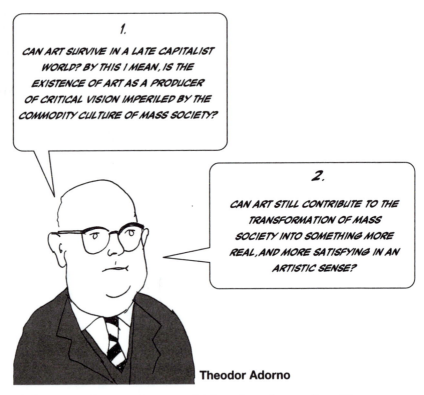

1. CAN ART SURVIVE IN A LATE CAPITALIST WORLD? BY THIS I MEAN, IS THE EXISTENCE OF ART AS A PRODUCER OF CRITICAL VISION IMPERILED BY THE COMMODITY CULTURE OF MASS SOCIETY?

2. CAN ART STILL CONTRIBUTE TO THE TRANSFORMATION OF MASS SOCIETY INTO SOMETHING MORE REAL, AND MORE SATISFYING IN AN ARTISTIC SENSE?

Theodor Adorno

Both of these questions revolve around Adorno's understanding of how mass commodity culture changes the way art is produced and consumed. His basic argument is that art once tried to express a critical view of life and society, but now under capitalism it tends to become just another "leisure industry."

Some people argue that he is too pessimistic about social change and lifestyles, but that is another question altogether.

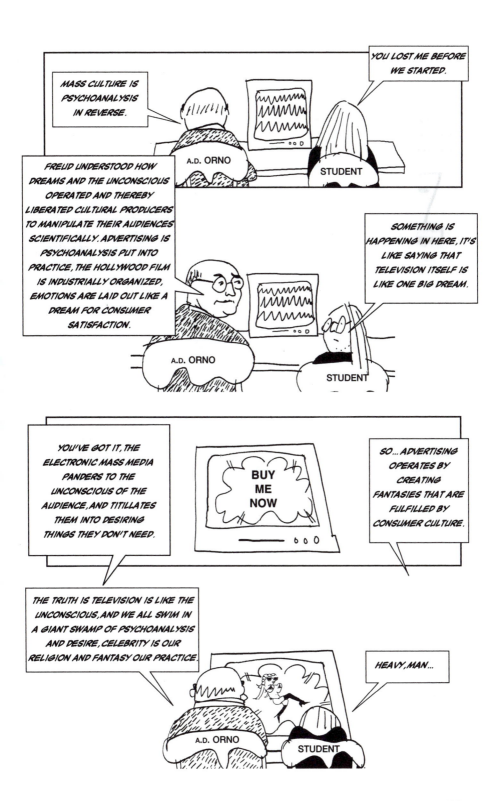

MECHANICAL REPRODUCTION AND WALTER BENJAMIN

Walter Benjamin 1892–1940 was a German Jewish theorist associated with the Frankfurt School. He has been described as a "mystical Marxist." He brought his scholarship to focus on many of the leading early Modernist writers such as Charles Baudelaire and Marcel Proust. He also wrote about the Baroque, urban shopping arcades, hashish and the electronic media. Indeed because of this breadth of interest his writings have been seen to capture the essence of Modernity.

The *Arcades Project* was started by Benjamin in 1927 and was still not finished when he fled Germany in 1940. This vast work is a reflection by Benjamin on a huge number of different ideas. Its point of departure is the old 19th-century shopping arcades in Paris, but in over 36 sections Benjamin reflects on all sorts of subjects such as, fashion, photography, boredom, advertising and the theory of progress. Benjamin thinks that the arcades embody an experience of history that is easy to overlook and sees the Modern age as one of commodification. Benjamin's seminal essay with respect to art theory is undoubtedly *The Work of Art in the Age of Mechanical Reproduction* 1936. He sees machines as able to liberate art itself.

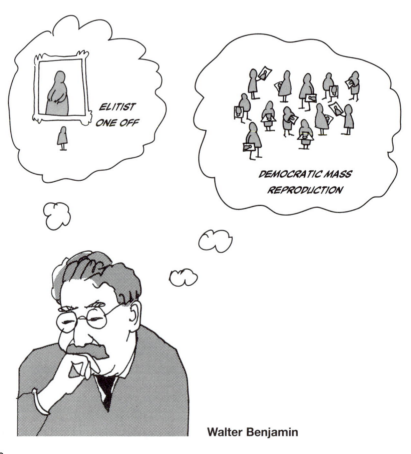

Walter Benjamin

The issues raised in Benjamin's *The Work of Art in the Age of Mechanical Reproduction* about technology and culture have haunted art theory since the 1930s. They were revisited by **Marshall McLuhan** 1911–1980 in the 1960s and formed the basis of much of Postmodernism's engagement with aesthetic and artistic questions in recent times. The issues are so intertwined that it is worth summarizing Benjamin's main arguments.

1 The nature of technological advance transforms the production and consumption of works of art, and the modes of experiencing those works of art. (This can be called the cultural/technical thesis.)

2 The means of technical reproduction destroys the *aura* of the work of art, undermining its authority through reproduction and liberating the work from history.

3 New means of technical reproduction, like photography and cinematography, can bring out aspects of the original that escape the naked eye, thus exposing to the viewer the inner life of the work.

4 These new means of reproduction reduce the distance between the object and its viewer, as it can bring the copy into situations which were previously inaccessible for historical and cultural reasons.

5 These changed conditions undermine the unique existence of the original work of art and call into question its authenticity. This allows for the possibility of new forms of art.

6 This change in the status of the work of art holds democratic potential in its liberation of the historical elitism of art practices and in the technological liberation of the viewer.

7 In penetrating the aura of the work of art Benjamin draws attention to the historical basis of this notion, to the mystique of authenticity surrounding the original work of art and to its basis in shared sociological experience.

8 The sacred, ritualistic dimension of the work of art is undermined by the processes of cultural/technological transformation and replaced with a new mode of perceiving, of exhibiting rather than of cult status.

9 Film in particular produces not the individual viewer but the collective subject who approach the work—not in a spirit of adulation, but of critique and of disinterestedness. This is the *shock effect* of film.

10 The new kind of viewer is *distracted* by film, rather than concentrating in the traditional manner, and that distraction is positive in that it confronts the viewer with the contradictions between the work and its reception.

AFFIRMATIVE CULTURE

Herbert Marcuse 1898–1979, is another Frankfurt School philosopher who took a slightly different direction. From a critical position he became known as a supporter of the 1960s counterculture. He is reputed to have coined the phrase 'Make love, not war'.

Marcuse referred to High Art as **"affirmative culture"** and by this he meant that it affirmed the values of the ruling and powerful within society. It did this by showing a vision of perfection, beauty or belief, which the masses could strive for but which they could not attain. For Marcuse affirmative culture needed to be abolished, so a more popular culture could take its place. He did not believe that an artist could make High Art which could have a subversive effect on the ruling and commissioning classes, but popular culture could. For Marcuse, popular culture—such as folk art, rock music, or political folk songs—had the ability to challenge existing social conventions and assumptions.

Marcuse was keen on things that were once called kitsch. *Kitsch* is a 19th century term that was used to differentiate Low Art commercial crowd pleasers from High Art. He thought kitsch had a subversive potential, so the real value of art is to be oppositional, popular and to challenge social injustice.

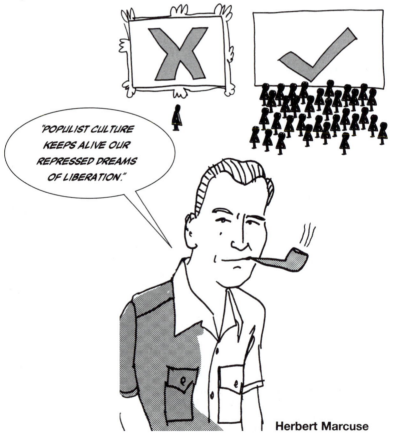

"POPULIST CULTURE KEEPS ALIVE OUR REPRESSED DREAMS OF LIBERATION."

Herbert Marcuse

THE MUSEUM WITHOUT WALLS

Many of the ideas of the Frankfurt School were further popularized during the 20th century. The French author and statesman **André Malraux** 1901–1976 wrote about art and aesthetics in the 1950s and put forward the idea of the **"museum without walls."** Like Benjamin, he saw the potential of a democratized art made possible through reproductions. Malraux thought that traditional museums had affected the way people viewed art, but through the millions of reproductions in circulation and the use of imagination a new nonelitist or separatist museum could be created—the museum without walls. This imaginary museum could make all art throughout history available to everyone, and by placing reproductions of Aztec art next to reproductions of Titian, Picasso, or Chartres cathedral, the art would metamorphose, and all art and humanity would benefit.

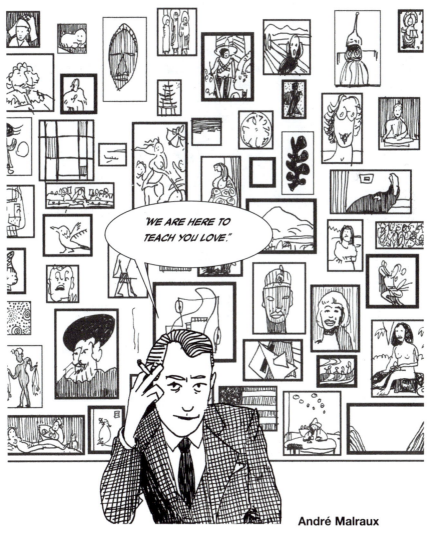

André Malraux

ABSTRACT PAINTING IN THE 1950S

Abstract **Expressionism** was the all-American art movement that emerged in New York after the Second World War. It can also be seen as developing out of European Surrealist *automatism*. Abstract Expressionism, or the New York School, emphasized rhythmic and emotionally charged painting. **Jackson Pollock** 1912–1956 was a key Abstract Expressionist, as were **Willem de Kooning** 1904–1997 and **Mark Rothko** 1903–1970.

"I PREFER TO TACK THE UNTREATED CANVAS ON THE HARD WALL OR FLOOR. I NEED THE RESISTANCE OF A HARD SURFACE. ON THE FLOOR I FEEL MORE AT EASE. I FEEL NEARER, MORE PART OF THE WORK, SINCE THIS WAY I CAN WALK ROUND IT, WORK FROM THE FOUR SIDES AND LITERALLY BE IN THE PAINTING. THIS IS AKIN TO THE INDIAN SAND PAINTINGS OF THE WEST. I CONTINUE TO GET FURTHER AWAY FROM THE USUAL PAINTER'S TOOLS SUCH AS EASEL, PALETTE AND BRUSHES. I PREFER STICKS, TROWELS, KNIVES AND DRIPPING FLUID PAINT OR A HEAVY IMPASTO WITH SAND, BROKEN GLASS OR OTHER FOREIGN MATTER ADDED. WHILST I AM PAINTING I AM NOT AWARE OF WHAT I AM DOING. THE PAINTING HAS A LIFE OF ITS OWN. I TRY TO LET IT COME THROUGH. IT IS ONLY WHEN I LOSE CONTACT WITH THE PAINTING THAT THE RESULT IS A MESS."

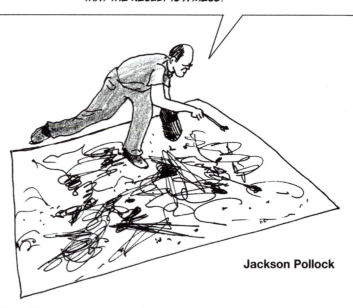

Jackson Pollock

Abstract art developed during the 50s and 60s and new movements and styles emerged, like the **Color Field Paintings** of **Barnett Newman** 1905–1970 or **Kenneth Noland** b.1924. These artworks stressed the internal qualities of the *painting* medium, whereas the abstract compositions of **Bridget Riley's** b.1931 **Op art** make your eyes pop and throb with precise but dizzying optical effects.

LATE MODERNIST ART

In many ways the essayist and art critic **Clement Greenberg** 1909–1994 didn't say very much that had not been said before. However, his name has now become synonymous with **Modernist Formalism**. He was the first to admit his theory of art was indebted to the criticism of Clive Bell and the Enlightenment theories of Kant. There is also a strong dose of Hegelian historicism and notable influences from Goethe in Greenberg's writing, so perhaps it is easiest to understand his aesthetic position as coming out of a long European tradition.

Greenberg's reputation is built on his essays such as *Avant-garde and Kitsch* 1939, *Towards a Newer Laocoön* 1940 and *Modernist Painting* 1961.

The Laocoön 2 B.C.

I SAID SIMILAR THINGS TO GREENBERG IN MY ESSAY "LAOCOÖN" WHEN I WANTED ART TO DIVORCE ITSELF FROM POETRY AND LITERATURE —THAT WHICH IT WAS NOT ABOUT.

Gotthold Ephraim Lessing 1729–1781

For Greenberg it was less the emotional response that governed the way the viewer saw art, but the way the art was *self-critical*. That is, the way that painting articulated the qualities that are unique to painting. Ever since painting was challenged by photography—and could no longer rely on just mimicking the outside world—it had to focus on what made it a *unique* art form. This clearly wasn't its ability to capture the likeness of a landscape, or of a model sitting in front of the artist, as now a camera could do that far better. What was unique to a painting was color, form and surface. Greenberg believed that when a form was refined or pure, it was its own content, it did not reflect what was outside of it. It was these formal qualities in the work of an artist like **Jackson Pollock** or **Morris Louis** 1912–1962 that Greenberg saw as new and significant.

"ONE IS AWARE OF THE FLATNESS OF THE PICTURE BEFORE ONE IS AWARE OF WHAT THAT FLATNESS CONTAINS... WITH AN OLD MASTER PAINTING ONE TENDS TO SEE WHAT IS IN IT BEFORE ONE SEES IT IS A PAINTING. WITH A MODERNIST PAINTING ONE SEES IT IS A PAINTING FIRST."

Clement Greenberg

PAINTING BECOMES ITSELF

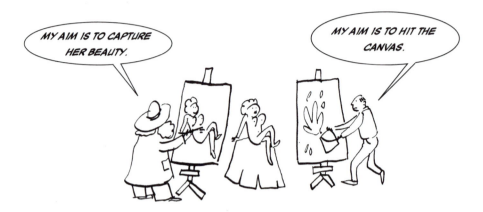

For Greenberg, painting was different from the other arts by being paint-ing—by being first and foremost paint and canvas. It was these qualities that a true Modernist work would stress. In his essay *Modernist Painting* a lineage, or canon, is charted, much like Bell's, showing significant form. Greenberg's canon starts with Manet and moves via Impressionism to Cézanne, and then onto the Abstract Expressionist and Color Field painters. These works are primarily paintings, and as the medium refines itself through progression a clearer content of form and color—the intrinsic qualities of painting—emerges.

This emphasis on the qualities, or essences, of a medium can be translated to other media. Modernist sculpture also breaks with representation to concentrate on its intrinsic qualities: physical space, balance, and material. Greenberg saw **Anthony Caro's** b.1924 sculptures, which had abandoned the plinth and spread themselves out across the floor, as good examples of the latter.

AMERICAN ART EXPORTED

The postwar period saw the New American Painting, which Greenberg wrote about, institutionally supported within the USA and then exported around the globe. During the Cold War the CIA arranged exhibitions across Western Europe of New American Painting, as propaganda to champion American values and ideals. Indeed, Greenberg's own writing, with its emphasis on progression and refinement, implies a cultural superiority that aided America's postwar ambitions.

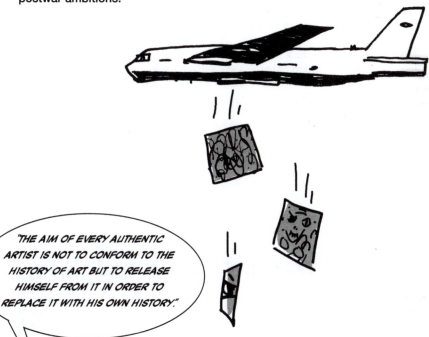

"THE AIM OF EVERY AUTHENTIC ARTIST IS NOT TO CONFORM TO THE HISTORY OF ART BUT TO RELEASE HIMSELF FROM IT IN ORDER TO REPLACE IT WITH HIS OWN HISTORY."

The American author and critic **Harold Rosenberg** 1906–1978 was, like Greenberg, a great supporter of Abstract Expressionism. But unlike Greenberg it was not the detached formal characteristics of the work which, he considered, gave this new style of painting its meaning. Rather it was something very different. He saw the painting's value as records of their creation—he coined the term **Action Painting**—and saw the canvases as arenas that embodied a passionate and engaged struggle by the artist's individual psyche with their material.

Harold Rosenberg

MINIMALISM

Minimalism within the visual arts refers to the simple and austere sculptures or *specific objects* created by artists like **Donald Judd** 1928–1994 or **Carl Andre** b.1935 in the 1960s. They constructed repeating, multiple forms that were frequently made from industrial materials such as bricks, plywood or sheet metal.

One of the key texts concerning the emergence of Minimalism is Judd's *Specific Objects* from 1965. In this article the artist charts the emergence of a new style of work, which he sees as completely rejecting the idea of illusion. What you see is what there is. This makes Minimalism quite literal, and during the 60s it was sometimes referred to as A B.C. art, which neatly captures its no-nonsense approach. There is meant to be no mystery in Minimalism, so, unlike Greenberg's Formalism, Minimalism did not need as its foundation ideas which derived from Kant's aesthetics of beauty.

The Abstract Expressionist painter **Robert Motherwell** 1915–1991 couldn't see **Frank Stella's** b.1936 *Black Paintings* from the 1950s as paintings—because they seemed so lacking in *composition* or *form*. But that was why the Minimalists thought them interesting. They were literally what they were.

Frank Stella *Marriage of Reason and Squalor II* 1959

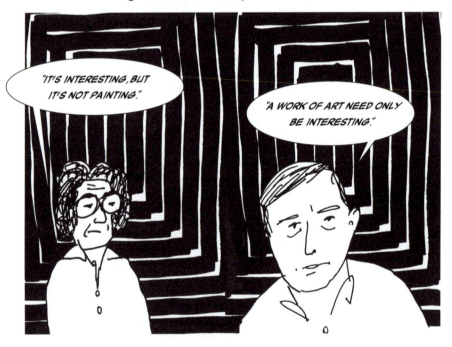

Robert Motherwell Donald Judd

An American critic, closely associated with Clement Greenberg, **Michael Fried** b.1939, thought Minimalism was *theatrical* and that this was inappropriate for art. He saw the tradition of Western painting as being in constant opposition to *theatricality*. In *Art and Objecthood* 1967, he wrote of how the theatrical quality of much Minimal art seemed to negate its self-contained qualities—and therefore it was very different to Modernist painting which in principle at least it seemed connected to.

Minimalism was theatrical because the viewer was made aware of himself in front of each artwork. The sculptures did not treat the beholder as if he were not there, like much Modernist painting did. In a later book, *Absorption and Theatricality: Painting and Beholder in the Age of Diderot* 1980. Fried expands on this idea of a self-contained art, an art which did not recognize the *beholder*. Fried traces this type of art back to the 1750s and the genre paintings championed by Diderot.

Donald Judd *Untitled (Stack)* 1967

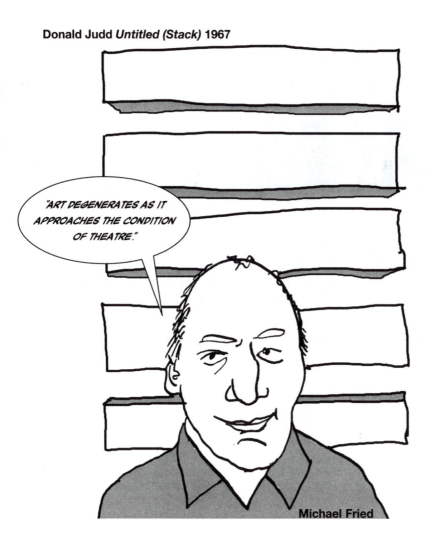

"ART DEGENERATES AS IT APPROACHES THE CONDITION OF THEATRE."

Michael Fried

The relationship between the artwork and the human body is an important question in Minimalism. For example, the way that the viewer might contemplate their own *body* while looking at one of these huge, but pared-down sculptures.

One of the origins of this debate is in the work of **Maurice Merleau-Ponty** 1908–1961 and his discussion of *embodiment*.

In his *Phenomenology of Perception* 1945 Merleau-Ponty describes this embodiment as:

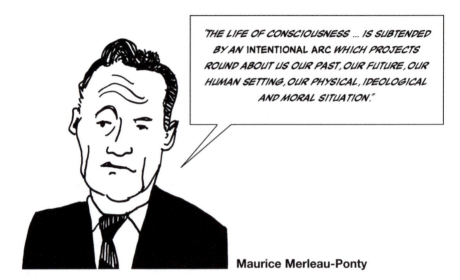

"THE LIFE OF CONSCIOUSNESS ... IS SUBTENDED BY AN INTENTIONAL ARC *WHICH PROJECTS ROUND ABOUT US OUR PAST, OUR FUTURE, OUR HUMAN SETTING, OUR PHYSICAL, IDEOLOGICAL AND MORAL SITUATION."*

Maurice Merleau-Ponty

What Merleau-Ponty is talking about here is both the way in which we create our perception of ourselves in the world, and how that perception is shaped by our human reality; our embodiment, in other words.

He is interested in trying to think about how we come to understand our *physical* and *mental* world, and how the two interact in constructing our *culture* and *world*. In a nutshell, Merleau-Ponty says "the body is our general medium for having a world," and this seemingly obvious statement leads to a whole series of ideas about being and perception.

Merleau-Ponty wrote three essays on painting. He was particularly interested in sight, and how the artist's embodied self is at the root of his relationship with the world and his creativity. Merleau-Ponty's most well-known essay on art is *Cézanne's Doubt 1945*. In this he sees Cézanne recovering a prerational contact with the world; his paintings carry back the essence of nature to the viewer. It is Cézanne's embodied vision that is equal to nature rather than a representation of it. It is this experience that made Cézanne's work so powerful for Merleau-Ponty. He said the meaning of Cézanne's paintings "will not become any clearer in the light of art history ... (his) technique or even his own pronouncements on his work," it is rather within the paintings themselves and what they reveal about Cézanne's contact with the world.

FEMINIST CRITIQUES OF MINIMALISM

The critic **Anna Chave b.1953** wrote an analysis of Minimalism, *Minimalism and the Rhetoric of Power* 1990 in which she suggested that most Minimalist work could be seen as a celebration of masculinity, control and power. It was, she considered, all prefabricated macho building materials, technology and industrial precision, coupled with a dubious aesthetic of aggression.

"WHAT (MOST) DISTURBS (THE PUBLIC) ABOUT MINIMALIST ART MAY BE WHAT MOST DISTURBS THEM ABOUT THEIR OWN LIVES AND TIMES, AS THE FACE IT PROJECTS IS SOCIETY'S BLANKEST, STEELIEST FACE; THE IMPERSONAL FACE OF TECHNOLOGY, INDUSTRY AND COMMERCE; THE UNYIELDING FACE OF THE FATHER: A FACE THAT IS USUALLY FAR MORE ATTRACTIVELY MASKED."

Anna Chave

THERE ARE OTHER ART MOVEMENTS ASSOCIATED WITH MINIMALISM:

Arte Povera, the 60s Italian movement, also relates to Conceptual art. It is characterized by the use of *poor* art materials, like that of **Giovanni Anselmo b.1934** who made a sculpture with a lettuce and a granite plinth, that poetically explored materiality, form and decay.

Earthworks and **Land art** have also been connected with Minimalism, and certainly some works share a similar aesthetic. They tend to be huge art works that exist outside in the landscape. This movement can be seen as a reaction to the industrial manufactured qualities of Minimalism. Through their site-specific nature, and total inability to be moved, they became a statement against the commodification of art. **Robert Smithson's** 1938–1973 huge *Spiral Jetty* 1970 or **Walter De Maria's** b.1935 *Lightning Field* 1977 are perfect examples of this grandiose elemental practice.

AGAINST INTERPRETATION

Susan Sontag 1933–2004 is an important 20th century American writer. She has also contributed many ideas in art theory. In her collection *Against Interpretation* published in 1966, and specifically in the essay of that title, Sontag stressed the idea that art has always been to do with ritual and the irrational or *magical*, and that to search for meaning (as many critics do) is to miss the point. By being "against interpretation" she is arguing that art should be appreciated as a complete whole—with the formal and visual qualities being more important than a fixation with meaning. This position led her into a lot of hot water when she championed the formal qualities in the work of the Nazi film maker **Leni Riefenstahl** 1902–2003. In another essay, *Notes on Camp,* she sees the artifice and exaggeration in Rococo art as being synonymous with aspects of contemporary popular culture, such as Hollywood films or Tiffany lamps. This was an influential and early Postmodern idea—that of the equivalence between mass produced objects and unique ones.

Another text, *The Pornographic Imagination* 1969, looked at the writings of **Georges Bataille** 1897–1962 and the **Marquis de Sade** 1740–1814. Sontag believed that pornography was able to address truths that other areas of art did not.

Susan Sontag

Her most influential book, though, is *On Photography* 1977, a collection of essays that questions the commonly held idea that photographs are representations of reality. She sees them as images that are different from the experiences that are photographed.

ART AND PSYCHOLOGY

Ernst Gombrich 1909–2001 has written the most widely read art book of all time *The Story of Art* 1950. This book seeks to establish the canon of Western art, which he writes about in an open and accessible way. Some people though, find a big problem with the idea of there being a *canon* of important art. Who is to say what is in it, or what isn't in it? And who decided art was a competition anyway with the prize of canonization? For Gombrich, however, all art is to do with excellence and therefore the truly excellent deserved to be revered. A scholarly consensus could decide what was what, and because he was a big scholar it meant he was perfectly able to say what was any good.

Gombrich's big contribution to art theory was in the area of art and psychology. In *Art and Illusion 1960,* he tried to dissect how the contemporary interest in psychology could explain questions about represen-tation and *style* within naturalism or mimetic art. Gombrich devised the theory of "making before matching," by answering the question:

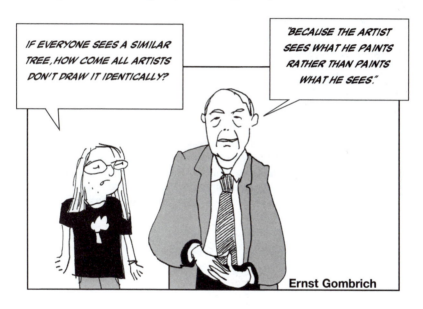

IF EVERYONE SEES A SIMILAR TREE, HOW COME ALL ARTISTS DON'T DRAW IT IDENTICALLY?

"BECAUSE THE ARTIST SEES WHAT HE PAINTS RATHER THAN PAINTS WHAT HE SEES."

Ernst Gombrich

In *Meditations on a Hobby Horse* or *The Roots of Artistic Form* 1951, Gombrich questions the idea of representation further. A simple child's hobby horse, made from a broom, does not look anything like a real horse, and therefore can not be said to be an image of a horse, but it represents a horse by being a substitute horse. This idea, like "making before matching," he sees at the heart of naturalism, rather than the more commonly assumed idea of imitation, and this position links to ideas in semiotics.

WAYS OF SEEING

John Berger b.1926 is a British critic and writer who returned to Benjamin's ideas of artistic reproduction in *Ways of Seeing* 1971, a four-part television series, which was later developed into a book. Berger's main interest was in looking at the conflicts between creativity and property, or capitalist ownership. This was essentially a Marxist position and he took issue with other leading critics in Britain who he thought were merely glorifying the present social system and its history. Like Benjamin he was also interested in the social effects of technology on culture and art.

"EVER SINCE I WAS STUDENT I HAVE BEEN AWARE OF THE INJUSTICE, HYPOCRISY, CRUELTY, WASTEFULNESS AND ALIENATION OF OUR BOURGEOIS SOCIETY AS REFLECTED AND EXPRESSED IN THE FIELD OF ART AND MY AIM HAS BEEN ... TO DESTROY THIS SOCIETY."

John Berger

In *Ways of Seeing* Berger looked at how reproductions separate *meaning* from its original context and how this can be used in new and alarming ways. Images act as signs that embody shifting meanings, due to where they are seen or what they are montaged against. This can create new meanings that the original works, in their first locations, perhaps never possessed.

He also lays into Western oil painting, which he sees clearly as a product of capitalist society, that celebrates ideas of possession and ownership. **Franz Hals'** 1580–1666 career, for example, is examined through Dutch capitalism. He points out that the artist was a pauper when he painted his wealthy patrons, and suggests that knowledge of this fact may change the way we look at the work. Possession also underpins his investigation of the *male gaze*. The male gaze is the assumption that, within the Western tradition of paintings, the viewer is always male. Therefore, any image of a woman in a painting is actually addressed to a male viewer. And this reflects a sterotypically male idea of *woman*.

POP

The 1960s movement, **Pop art**, is epitomized by **Andy Warhol's** 1928–1987 celebrations of soup cans, or **Roy Lichtenstein's** b.1923 comic book paintings. These, and many other Pop artworks, ask the viewer to contemplate art's relationship to the mass culture, which it so relies on.

There has always been a dialogue between mass culture and art, between the High and the Low. Throughout the late Modern period this relationship can be seen in a variety of different ways, for example in the paintings of the French realist Courbet, in works by Dada artists and in Cubist collages. A precursor to Pop Art is undoubtedly art made by assemblage. The term *assemblage* was coined to describe a practice of collaging real life three dimensional objects into artworks. It can be seen as developing from Cubist collages and sculptures. Assemblage is associated with American work from the late 50s and early 60s by proto-Pop, or **Neo-Dada**, artists like **Robert Rauschenberg** b.1925 or **Jasper Johns** b.1930. In France a particular brand of Pop/Assemblage was developed called **Nouveau Réalism** (New Realism). It was named by the critic **Pierre Restany** 1930–2003 in his manifesto of Nouveau Réalism in 1960. The artist **Yves Klein** 1928–1962 was very closely associated with this group and some of his work contains a great Dadaist spirit.

Pop art was not originally understood as it is today. The British critic **Lawrence Alloway** 1926–1989 first used the term *pop art* in 1955. He was a member of the **Independent Group**, a collection of artists and critics who met at the Institute of Contemporary Art in London. In drab, postwar, Britain this group was very excited by the new comics, packaging and magazines which were then just beginning to be imported into Britain from America. Alloway saw these glossy color publications, such as *Playboy*, *Mad,* and *Esquire*, which were full of photographs and advertising as being 'pop art', which would be "a source of new and unexpected inspiration" for artists. **Richard Hamilton** b.1922, an artist member of the group, described Pop Art as:

"POPULAR, TRANSIENT,
EXPENDABLE, LOW-COST,
MASS-PRODUCED, YOUNG, WITTY,
SEXY, GIMMICKY, GLAMOUROUS,
AND LAST BUT NOT LEAST BIG
BUSINESS."

THE POLITICS OF POP

Pop Art can be seen as complacent with its acceptance of the culture and aesthetics of capitalist society. But perhaps it is more silent than complacent. When Andy Warhol exhibited canvases of soup cans or college race riots, or when Richard Hamilton painted cars and advertisements, they are both reflecting on the obsessions of the age in which they lived, and asking us to suspend judgment. This critical detachment is one of the strengths of Pop Art and one of its gifts to much of Postmodernism.

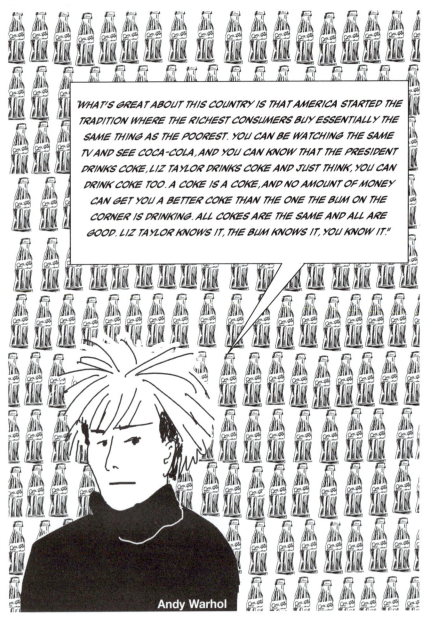

"WHAT'S GREAT ABOUT THIS COUNTRY IS THAT AMERICA STARTED THE TRADITION WHERE THE RICHEST CONSUMERS BUY ESSENTIALLY THE SAME THING AS THE POOREST. YOU CAN BE WATCHING THE SAME TV AND SEE COCA-COLA, AND YOU CAN KNOW THAT THE PRESIDENT DRINKS COKE, LIZ TAYLOR DRINKS COKE AND JUST THINK, YOU CAN DRINK COKE TOO. A COKE IS A COKE, AND NO AMOUNT OF MONEY CAN GET YOU A BETTER COKE THAN THE ONE THE BUM ON THE CORNER IS DRINKING. ALL COKES ARE THE SAME AND ALL ARE GOOD. LIZ TAYLOR KNOWS IT, THE BUM KNOWS IT, YOU KNOW IT."

Andy Warhol

POP AND THE END OF ART

The American philosopher and critic **Arthur C. Danto** b.1924 when confronted with Andy Warhol's *Brillo Box* sculptures at the Stables Gallery in 1964 saw them not only as emblematic of an artist who was immersed in the new capitalist mass-produced world of packaging and commerce, but also as representative of the *end of art*. By this he meant that none of the old definitions and theories of what art was, could accommodate this work. These *Brillo Boxes* were not original—they were facsimiles of those in the supermarket. They were not hand made by the artist. Warhol called his studio the *Factory* and had assistants silk screen the boxes. So what was it that made them art and those in the supermarket not art?

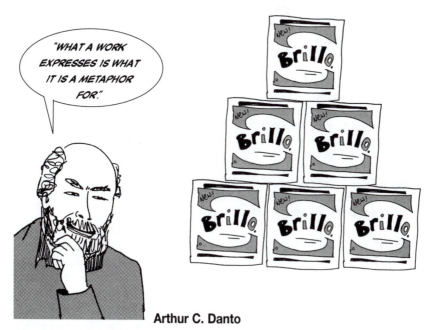

"WHAT A WORK EXPRESSES IS WHAT IT IS A METAPHOR FOR."

Arthur C. Danto

This led Danto to speculate on what were the essential qualities within a work of art. He decides that all art must represent something, but this representation is not through what it looks like but rather its historical context. He imagined a gallery full of identical paintings from different periods, which would all mean different things, but all look essentially the same. Now, as nonart things could also represent something, the other quality art must have is an expression of the artist's wishes, and this expression is through metaphor. Danto argued that the date when something was made was very important in determining its art status. The *Brillo Boxes* were "daring, impudent, irreverent and clever," for Danto, as they occur after the end of art. That is, after the dominant orthodox trajectory of what art was thought to be, had collapsed.

The American philosopher **George Dickie** b.1926 had a simpler idea. He stated that an object is a work of art if an artist, gallery, or institution of the *art world* declares it to be one. But this **institutional theory of art** was not enough for Danto, he maintained that an art object has to earn its status as art, institutional acceptance is not enough.

DEMATERIALIZING THAT ART OBJECT

The impact of Pop Art, Neo-Dada and Minimalism caused some earlier theories of art to be questioned. From the mid-60s onwards the idea of art can be seen to have entered an *expanded field*. The old boundaries of what constituted art were being dismantled to allow a broader spectrum of postmodern practices.

The critic **Lucy Lippard** b.1947 charts some of these developments in her book *Six years: The Dematerialization of the Art Object 1973* which shows how one pioneering generation of artists responded to the withering of Modernist practice. One result seems to have been the actual *dematerializing* of the art object. The aesthetics of the art object became less and less important as the *concept of it* became more so.

CONCEPTUAL ART emerged in the 60s and is really a specific type of art making where the *concept* of the work *is* the art. It is about ideas rather than objects, and sometimes doesn't include objects at all. It can be seen as a challenge to, and interrogation of, the traditional values associated with art. It has its roots perhaps with Duchamp's readymades which he named as 'art' in a gesture to detach the *making* and the *retinal* from art.

In 1967 the artist **Sol Lewitt** b.1928 published his *Paragraphs on Conceptual Art* in which he stressed the concept as the most important part of the work, really the place where the art is:

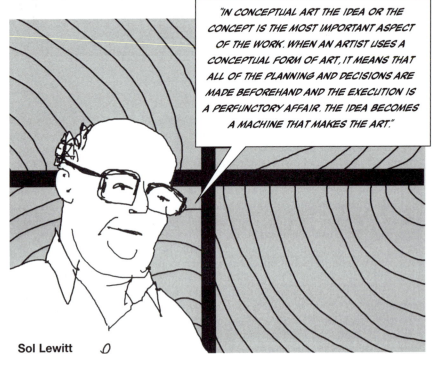

"IN CONCEPTUAL ART THE IDEA OR THE CONCEPT IS THE MOST IMPORTANT ASPECT OF THE WORK. WHEN AN ARTIST USES A CONCEPTUAL FORM OF ART, IT MEANS THAT ALL OF THE PLANNING AND DECISIONS ARE MADE BEFOREHAND AND THE EXECUTION IS A PERFUNCTORY AFFAIR. THE IDEA BECOMES A MACHINE THAT MAKES THE ART."

Sol Lewitt

This can be seen to refer back to Duchamp who said:

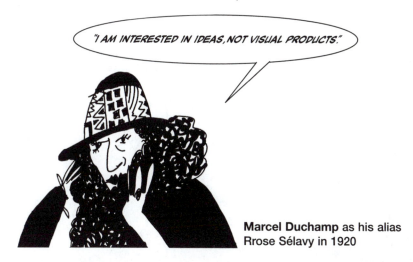

Marcel Duchamp as his alias Rrose Sélavy in 1920

In one sense all art is about ideas, but what Conceptual art did was to elevate these over the visual. Artists used art as a philosopher might use a text to question the boundaries of knowledge, reason or experience. A lot of Conceptual art can therefore be seen as similar to philosophical *propositions*. The artist **Joseph Kosuth** b.1945 could present a work like *One and Three Chairs* 1965 that questions ideas around meaning. What is a chair? Is it a real chair? A photograph of a chair? Or a dictionary definition of a chair? Kosuth wrote *Art after Philosophy* in 1969, another key text of Conceptualism. In it he states that philosophy is over and has been replaced by art, and that art's nature should be an "inquiry into the foundations of the concept—art."

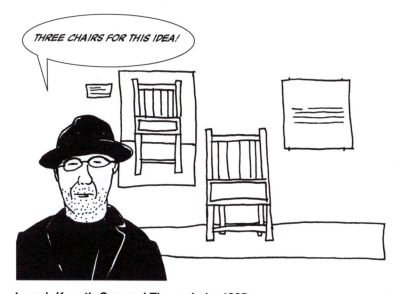

Joseph Kosuth *One and Three chairs* 1965

Kosuth's idea of art, as an inquiry, through art, into its own meaning, echoes the logical positivist philosophy of **Ludwig Wittgenstein** 1889–1951 who stressed the problematic nature of language. For Wittgenstein philosophy was not about the search for *essential truths*, but rather about the elimination of nonsense, or untruths. It was centered around critical self-inquiry, and although he employed language he was very aware of its limits and of what could not be said:

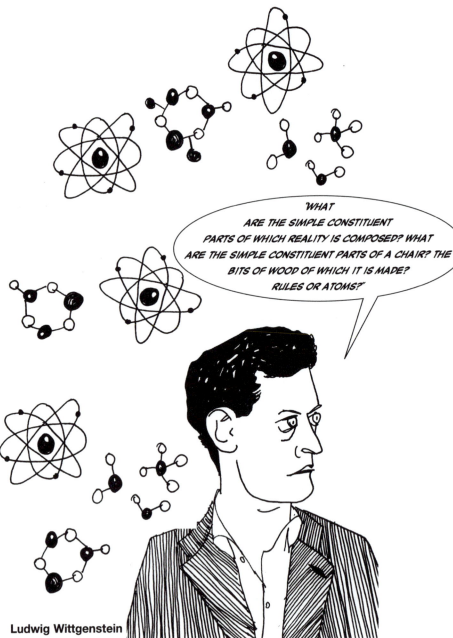

Ludwig Wittgenstein

AFTER THE 1960S COULD ART EVER BE THE SAME AGAIN?

The social and political changes that the 1960s inaugurated fed through into art theory. A shift developed in the late 70s towards semiotics, cultural theory, identity politics, Feminism and Poststructuralism. The influence of various forms of Marxism, psychoanalysis and gender theory all impacted on art.

Some of the main trends include:

Art schools and art theory became more professional. Contextual studies was replaced by a knowledge of critical theory for artists, curators, art historians, and critics.

Theorists debated ideas of identity and identity politics. The subsequent idea of a multicultural society emerged. This meant questions of race, class, gender, feminism, and sexuality took on an increasingly significant role.

The art world became steadily more institutionalized and incorporated into state policy. Museums, super-museums, and 'art-tourism' developed into a huge business. By the millennium the art world had developed into a truly worldwide institution.

There developed what became known as *the culture wars*. These were debates about the public funding of art and the political alignments of artists. Who were artists making work for? A notorious example of this was the outrage over photographer **Robert Mapplethorpe's** 1946–1989 work. The scandal arose when the National Endowment of the Arts supported a retrospective exhibition of his work, which included homoerotic and sado-masochistic imagery. Republican **Senator Jesse Helms** b.1921 tried to force amendments to stop grants funding what he saw as *pornography.*

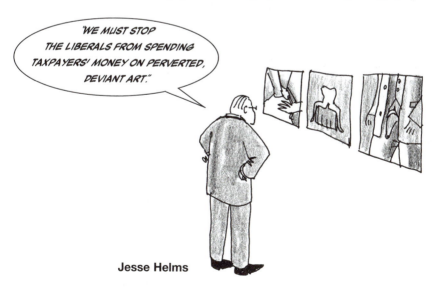

"WE MUST STOP THE LIBERALS FROM SPENDING TAXPAYERS' MONEY ON PERVERTED, DEVIANT ART."

Jesse Helms

1960S FEMINISM—THE SECOND WAVE

The development of the Women's Movement in the 1960s and 70s was highly significant for women artists, because it asked why the art world and art history were so male dominated. Politicized women's art groups emerged—like **W.A.R.** *(Women Artists in Revolution)* in New York. They examined the bias of the art world and demanded change. One of Andy Warhol's entourage **Valerie Solanas** 1936–1988 issued the **S.C.U.M. Manifesto** *(Society for Cutting Up Men)* and shot Warhol in 1968 because:

"LIFE IN THIS SOCIETY BEING, AT BEST AN UTTER BORE AND NO ASPECT OF SOCIETY BEING AT ALL RELEVANT TO WOMEN, THERE REMAINS TO CIVIC-MINDED, RESPONSIBLE, THRILL-SEEKING FEMALES ONLY TO OVERTHROW THE GOVERNMENT, ELIMINATE THE MONEY SYSTEM, INSTITUTE COMPLETE AUTOMATION AND DESTROY THE MALE SEX."

Valerie Solanas

This was not the first time that this gender inequality had been thought about. Despite the injustices of society there had obviously been some women artists throughout history, though it must be noted that they seemed to receive less recognition than their male counterparts and had less opportunities to exhibit or even make work. However, the issue took on a new urgency in the politicized 60s.

An early response to the lack of visible recognition for women artists was to *rediscover them*. Feminist art historians researched archives and began to study the work and lives of the women artists they found there. This initiative brought to light many women artists who had been marginalized by orthodox, male-orientated, art history.

Feminist art theory was concerned with more than just revisionism and rediscovery. The whole question of gender within art was open to study. The critic **Linda Nochlin** b.1931 wrote a highly influential essay in 1971 *Why Have There Been No Great Women Artists?* Its title pointed to the fact that historically women artists had been denied the opportunities open to male artists. They had been denied education, excluded from the academies and guild based apprenticeships, and were consequently far less able to compete in the male dominated art world.

This sociological approach to art history dispelled the received idea that artistic genius was responsible for great art. It also suggested that the reclamation of past artists was not the answer. Indeed the very idea of *genius* was problematic as it could only ever be achieved by men and was a masculine construct.

In 1928 **Virginia Woolf** 1882–1941, in her essay *A Room of One's Own,* concluded that to be a successful writer and a woman, you needed talent, a private space and money. Then you would be able to ignore other people's opinions and make the work you wanted to.

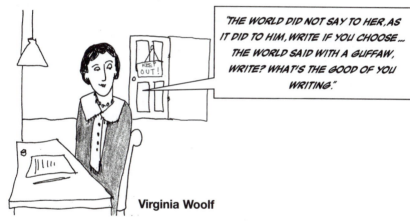

"THE WORLD DID NOT SAY TO HER, AS IT DID TO HIM, WRITE IF YOU CHOOSE ... THE WORLD SAID WITH A GUFFAW, WRITE? WHAT'S THE GOOD OF YOU WRITING."

Virginia Woolf

The hurdles that women had to overcome to become artists were described by **Germaine Greer** b.1939 in her book *The Obstacle Race* 1979, where she pointed out that prior to the 19th century having either a father who was an artist or a rich supportive family were necessities for any female artist.

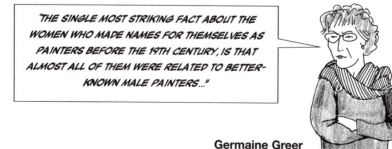

"THE SINGLE MOST STRIKING FACT ABOUT THE WOMEN WHO MADE NAMES FOR THEMSELVES AS PAINTERS BEFORE THE 19TH CENTURY, IS THAT ALMOST ALL OF THEM WERE RELATED TO BETTER-KNOWN MALE PAINTERS..."

Germaine Greer

Griselda Pollock and **Rozsika Parker** brought this investigation of women in art up to date. In *Old Mistresses: Women, Art and Ideology* 1986, they investigated the work and lives of women artist from the Middle Ages right up to the 1970s and 80s.

Developments in Feminism led to artists wanting to make overtly *feminist* art-works. One of the most celebrated is **Judy Chicago's** b.1939 *The Dinner Party* 1974–1979. It was a huge installation, made by a collective of women, and utilizing many of the so-called *feminine arts* such as needlework and decorative ceramic painting. A triangular table was arranged with 39 settings each dedicated to an individual woman from history, with a further 999 women's names written on a porcelain floor. The triangular table was both nonhierarchical and represents a celebration of female sexual identity.

Questions of identity were central for many women artists during the 60s and 70s. There was a rejection of the *gendered art form* of painting. Artists chose to move their practice into new art forms, which they saw as less tainted by a male-dominated history. This could be a reclamation of so-called feminine crafts like knitting or embroidery, or a move to a wealth of other practices, such as performance, or working conceptually and in new media. Feminist art directly challenged many of the ideas within Modernism, and can therefore be seen as marking the moment when art became Postmodern.

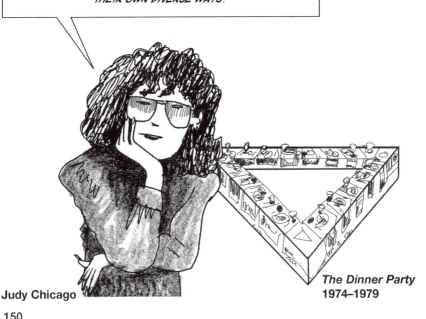

"HISTORY HAS BEEN WRITTEN FROM THE POINT OF VIEW OF THOSE WHO HAVE POWER. IT IS NOT AN OBJECTIVE RECORD OF THE HUMAN RACE—WE DO NOT KNOW THE HISTORY OF HUMANKIND. A TRUE HISTORY WOULD ALLOW US TO SEE THE MINGLED EFFORTS OF PEOPLES OF ALL COLORS AND SEXES, ALL COUNTRIES AND RACES, ALL SEEING THE UNIVERSE IN THEIR OWN DIVERSE WAYS."

Judy Chicago

The Dinner Party
1974–1979

SOME OF THE MAIN TRENDS IN THE ART OF THE 1960S AND 70S INCLUDE:

Process art refers to artworks, mainly from the 60s, that show how a process acts upon an object. **Hans Haacke** b.1936 made a piece recording grass growing on a cube, while other artists explored objects decaying, burning, melting or falling apart.

Performance art is when the *art* is what the artist is performing with his or her own body. It is not theatre as it is *real* and no one is an actor pretending to be someone else. Its roots can be traced back to the early avant-gardes, particularly Dada. It was through **Happenings** and other 60s crossover art forms that Performance became well known. They were often chaotic, expressive and spontaneous events, with activities relying on chance and audience participation. Their counterculture credentials ensured they had a subversive non–High Art edge.

Kinetic art is art that moves or uses movement and was popular during the late 60s. It has a long history, Constructivist artists like **Naum Gabo** 1890–1977 made kinetic sculptures, and Duchamp's readymade the *Bicycle Wheel* was made to be spun. In the 50s artists like **Yves Tanguy** 1900–1955 constructed elaborate machines that performed complex vigorous movements, while **Alexander Calder's** 1898–1976 formal mobiles also gently turn.

Installation art. All art is installed or displayed, but with Installation art, artworks are created to be in a specific dialogue with each other and their environment. 'Installations' may use multiple objects arranged in a particular way, or relate to a particular site or place. Installation art became popular in the 60s and is now a dominant art form. Its origins can be traced back through the site-specific paintings and sculptures that rely on their architectural settings, like pretty much all early Christian art.

Video art has now become one of the most popular forms within contemporary art, whether being shown in darkened rooms or on old TV sets. The use of prerecorded moving images grew out of the film and installation practices of the late 60s and adapts accordingly with current developments in technology.

THIS IS NOW

IDENTITY POLITICS

From the 60s through to the 90s there developed a political and cultural movement that became known as *identity politics*. This movement came out of the counterculture of the 1960s. It was anti-authoritarian, for personal liberation, and against late capitalist culture. The movement reflected a new mode of self-awareness that belongs very much to Postmodernism. It is either the politics of liberation, or a new form of narcissism, depending on where you come from.

Identity politics impacted on art theory by posing new questions about what sort of art should be made and for whom. The questioning of identity also meant questioning the historical and narrative traditions that had dominated art, art history, and art education.

People progressed from thinking about art in terms of class, and from an historical or nationalistic viewpoint, to realizing that art was an important way of investigating their identity, repressions, anxieties, cultural history and all-around place in the world.

The discovery of the idea of *identity* went hand in hand in the late 60s, 70s and 80s with critiques of gender inequalities, patriarchal culture, and Anglo-Saxon cultural dominance. The end of the colonial empires in the West began to mean the end of a "traditional view of art," that was in fact merely a Western Enlightenment view. Radical critiques of the ethos of art came from every quarter; from feminists, identity theorists, anticolonialists, queer theorists, Eastern artists and even from the street.

ORIENTALISM

Identity politics directly challenged the dominant Western ideas of Empire and colonialism. **Edward Said** 1935–2003 in his book *Orientalism* 1978 pointed to the way in which a discourse of *Orientalism* was created by the West. Westeners appropriated this *other* world of the Orient as exotic, strange, and fundamentally inferior. He deconstructs these ideas in literature, art, and politics, and shows how, particularly when linked to Imperial power, they operate to control and rationalize the treatment of the other. Said draws attention to how visual culture carries and transmits relations of power and identity.

He talks about Orientalism operating in three main areas:

1 THE HISTORICAL CONSTRUCTION OF IDEAS OF THE EAST. THIS DEVELOPED FROM THE CRUSADES ONWARDS.

2 THE ENLIGHTENMENT DISCOURSE OF ORIENTALISM.

3 THE GENERALIZED MYTHS AND STEREO-TYPES OF THE EAST. THESE OPERATE AT A SUBLIMINAL AND CULTURAL LEVEL IN THE WEST. THEY ARE ABOUT ORIENTAL *ESSENCES*, SUCH AS *EXOTICISM*, *SEXUALITY* (THE FASCINATION WITH THE HAREM), AND *INDOLENCE*.

Edward Said

Said's argument centers on a complicated set of mythological ideas that function in both academic culture and the popular consciousness. These interact to produce an identity for the East which is the opposite of our Western self-image of control and order. The Orient is seen in some strange way as feminine, exciting, dangerous, and quixotic.

By exposing these Western myths Said was questioning the authenticity and identity of Western Enlightenment values.

Said had put the metaphoric cat amongst the Parisian pigeons.

IDENTITIES

Art in the Postmodern era can often be seen as embodying ideas of cultural representation. This meant that art theory reflected on the ways in which all art is implicated in the struggle to define and explore the meaning of the cultures we inhabit. In terms of talking about identity and otherness, and the new forms of culture that were emerging, **Stuart Hall** b.1932 has become an important figure. During the 1970s Hall criticized the British establishment, by showing how the British media misrepresented the black communities living in Britain. Hall is one of the key advocates of *reception theory* that shows how language operates in a framework of power. For Hall, the audience actively interprets all texts (such as television programs, books, or paintings). The audience actively *decodes* meaning that has been *encoded* in the text. Each member of the audience will decode the text slightly differently, they may accept it or reject it, and this interpretation is based in part on the access to the frameworks of power and knowledge that they have. Reception theory, by showing the way that meaning is located "somewhere between the reader and the text," has been very influential when theorizing art, as it highlights the role, and makeup, of audiences.

In 1976 Hall published one of the first serious studies of youth culture, *Resistance Through Rituals: Youth Subculture in Post-War Britain*, which examined the way subcultures defined their identity. He is, however, best-known for his investigation into identity based on the experiences of the Caribbean Diaspora:

"THE DIASPORA EXPERIENCE ... IS DEFINED, NOT BY ESSENCE OR PURITY, BUT BY THE RECOGNITION OF A NECESSARY HETEROGENEITY AND DIVERSITY; BY A CONCEPTION OF IDENTITY WHICH LIVES WITH AND THROUGH, NOT DESPITE, DIFFERENCE; BY HYBRIDITY. DIASPORA IDENTITIES ARE THOSE WHICH ARE CONSTANTLY PRODUCING AND REPRODUCING THEMSELVES ANEW, THROUGH TRANSFORMATION AND DIFFERENCE."

Stuart Hall

Hall sees two main kinds of identity, the "identity of being" and the "identity of becoming." The first type of identity is based on commonalities, but the second is based on an active process of identification. This leads, Hall believes, to the conclusion that individuals have more than one identity. They have identities.

Said, Hall and then **Homi K. Bhabha** b.1949 are concerned with reflecting on the experience of being *someone else* within a dominant culture, and how this shapes and influences ways of thinking about identity. This debate has interesting ramifications for art, and Bhabha has been influential in writing about these in art journals and exhibition catalogues.

Bhabha's main areas of interest are identity, ethnicity and culture, and he is one of the leading theorists who describes the postcolonial experience. **Hybridity** is a term Bhabha uses a lot to describe the contemporary, postcolonial and Postmodern condition.

In the *Location of Culture* 1984 he talks about how he tries to analyze culture without falling into the rampant individualism of a lot of Postmodern thought:

"WHAT IS AT ISSUE IS THE PERFORMATIVE NATURE OF THE PRODUCTION OF IDENTITY AND MEANING, THE REGULATION AND NEGOTIATION OF THOSE SPACES THAT ARE CONTINUALLY, CONTINGENTLY OPENING OUT, REMAKING THE BOUNDARIES, EXPOSING THE LIMITS OF ANY CLAIM TO A SINGULAR OR AUTONOMOUS SIGN OF IDENTITY OR TRANSCENDENT VALUE—BE IT TRUTH, BEAUTY, CLASS GENDER, OR RACE."

Homi K. Bhabha

What Bhabha is saying is that the very mixed, hybrid nature of the post-colonial and Postmodern world gives art an important function. That function is not to produce some transcendent *beauty* or *knowledge* but to create a *space* in which the interaction of people and cultures can be thought through. This is a positive view of hybridity and art. Art becomes a site for deciphering creative cultural practices.

Bhabha is important to art theory precisely because he took the question of identity beyond the confines of the dominant Western culture. He relocated the debate about art to one central to the wider political domain of the colonial and post-colonial struggle. Put at its simplest this reaffirms the shift of focus in art theory towards a critical sense of art as the *politics of representation*.

THE POLITICS OF REPRESENTATION

Bhabha contributed catalogue essays for two important exhibitions that seem to test this idea of art as being a site for reflection on the politics of representation. The first exhibition was *Magiciens de la Terre* at the Pompidou in Paris in 1989. This show brought together 50 Western and 50 non-Western artists, who each made work that somehow related to the *earth* or *land*.

This exhibition posed many questions. Was an Aboriginal floor painting by the **Yuendumu Community** in the Australian Central Desert really at all similar to British artist **Richard Long's** b.1945 *Red Earth Circle* that it was placed next to? Were these two objects, despite there strong visual similarities, coming from traditions which were so completely different that all connection was meaningless?

Magiciens de la Terre did however try to address issues of multiculturalism, identity, ethnicity and culture, and avoided the charge of blatant Eurocentricism which had been levelled at New York's MoMA's exhibition *Primitivism in 20th Century Art,* five years earlier. MoMA's exhibition had seemed to show the exotic primitive other nourishing the Western canon.

The second exhibition was the 1993 *Whitney Biennial* in New York. This exhibition's curatorial focus was again centred on questions of race, ethnicity, representation and power, specifically this time in the United States. It was a stimulating show and portrayed an angry and divided nation. One exhibitor, **Daniel J. Martinez** b.1957, created an interactive artwork that consisted of a series of entrance badges, that visitors put on, that constructed a sentence: "I can't imagine ever wanting to be white." The curatorial team emphasized the tone for this provocative show by displaying monitors throughout the foyer with video footage of a black man, **Rodney King,** being beaten by the Los Angeles police, an event which, the previous year, had sparked anger and serious rioting in the city.

POSTMODERNISM

What do we mean when we talk about Postmodernism and art?

There is no easy answer, but a number of critics all noticed that aspects of art and culture seemed to change in the late 60s or early 70s. The artist **Brian O'Doherty** b.1935 writing in *Art in America* in 1971 stated that "the Modernist era is over." Then the French philosopher **Jean François Lyotard** 1924–1998 spoke about the decay in confidence of Modernism and the Modernist project, while the German theorist **Jürgen Habermas** b.1929 wrote an influential essay critiquing Modernism as "an incomplete project."

Postmodernism is a term that gives all sorts of people trouble, probably because it is used in so many different ways. Here's a list of uses that you may come across, postmodernism is:

1 That which comes after Modernism.

2 A philosophical movement that combines Poststructuralism and other strands of the critical deconstruction of meaning.

3 A movement in art and architecture.

4 A movement in all arts and literature.

5 A new form of globalized society which is dominated by instantaneous electronic communications.

6 A culture that is saturated in visual images in which all intrinsic meaning has gone and context is everything.

7 A kind of irony and cynicism that even the mass media use.

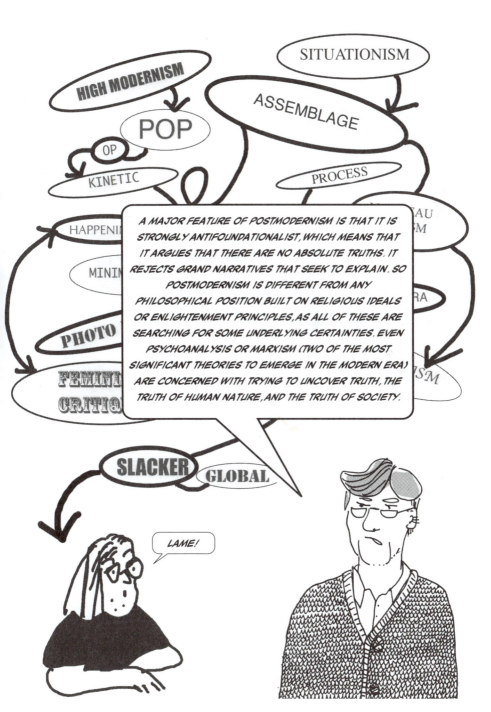

SITUATIONISM

HIGH MODERNISM

ASSEMBLAGE

POP

OP

KINETIC

PROCESS

HAPPENI

MINIM

PHOTO

FEMINI
CRITIQ

A MAJOR FEATURE OF POSTMODERNISM IS THAT IT IS STRONGLY ANTIFOUNDATIONALIST, WHICH MEANS THAT IT ARGUES THAT THERE ARE NO ABSOLUTE TRUTHS. IT REJECTS GRAND NARRATIVES THAT SEEK TO EXPLAIN. SO POSTMODERNISM IS DIFFERENT FROM ANY PHILOSOPHICAL POSITION BUILT ON RELIGIOUS IDEALS OR ENLIGHTENMENT PRINCIPLES, AS ALL OF THESE ARE SEARCHING FOR SOME UNDERLYING CERTAINTIES. EVEN PSYCHOANALYSIS OR MARXISM (TWO OF THE MOST SIGNIFICANT THEORIES TO EMERGE IN THE MODERN ERA) ARE CONCERNED WITH TRYING TO UNCOVER TRUTH, THE TRUTH OF HUMAN NATURE, AND THE TRUTH OF SOCIETY.

SLACKER GLOBAL

LAME!

DOWN WITH GRAND NARRATIVES

Jean François Lyotard was one of the original philosophers of Postmodernism. He wrote **The Postmodern Condition: A Report on Knowledge** 1979, that became one of the key early texts of Postmodernism. He aimed to look at how meaning occurred in both language and culture.

One of his big ideas was about the decline of **grand narratives** (or *metanarratives*) that had dominated Western history, and that had traditionally held culture and society together. What he meant by a grand narrative was one of the big stories that had underpinned Western thinking and which required undivided loyalty and belief, like *nation* and *empire*. These he saw as manmade constructs. He thought these sorts of beliefs were no longer viable or relevant and therefore a new type of Postmodern condition was emerging: an age where **little narratives**—such as local networks and single-issue groups—would become increasingly important. In the past there had been times when grand narratives had decayed and times when they had been believed in. Lyotard thought now was a definite post-grand-narrative age.

"POSTMODERNISM ... IS NOT MODERNISM AT ITS END BUT IN THE NASCENT STATE, AND THIS STATE IS CONSTANT."

Jean François Lyotard

Lyotard discussed art specifically in his 1971 work **Discours, figure.** He suggested that Western culture privileges language above the visual image. Illustration, he pointed out, is always considered as a lesser counterpart to a printed text. Lyotard, however, wished to invert the established hierarchy of things. He believed that the visual is in fact more important than the written, that the visual image can communicate in a way that is more potent and liberating than the reason of language.

From this position Lyotard goes on to argue that Postmodern aesthetics should place an emphasis on the visual over the discursive. He is saying that the impact of art is more important then the meaning of art. The sensation of art, its transgressive feeling, is more important than the interpretation of it.

This is very postmodern: Down with meaning! In with the immediate! In with the sensation!

Lyotard uses two terms *figural* and *discursive* to demonstrate the distinction between the Postmodern art of *surface*, *impact* and *sensation* and a Modernist art of *meaning, depth* and the *knowledge of interpretation*. Modernism, in its rationalistic approach, is like a grand-narrative that seeks to impose itself on everything, a brutality of reason.

The figural he sees as being similar to what Freud described as the primary processes of the *unconscious.* The antirational urges of being. The discursive is rational, which Freud says is a secondary process that is in conflict with the unconscious. So Freudian impulses are linked to a Poststructuralist critique of language and meaning to give us a different mode of thinking about art theory—one that can be seen as liberating.

Lyotard is always looking for what he calls the *decodification* and subsequent *decolonization* of the patterns of experiencing art and reality. This seems to mean attempting to experience art through the uncontrolled emotions and responses that can bypass the reactions that language, logic and the intellect organise and codify in ways that reflect social forms of censorship and control. This nonrational, sensory approach of Lyotard's relates to ideas about the sublime. Indeed Lyotard talks about the sublime in a way that picks up on Kant's much earlier work. This is deeply ironic since Kant was, quite frankly, a raving rationalist. For Lyotard, though, the sublime was beyond human understanding and therefore valuable because it was beyond reason. Unlike Kant, Lyotard saw the possibility of art presenting this *unpresentable* quality of the sublime, and this was particularly true of abstract art.

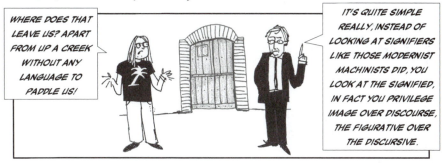

In *Trans/Formers* 1977 Lyotard turns his attention to Duchamp, whom he praises highly for his pointlessness. He appreciates *The Large Glass* because it cannot really be understood (even with the notes that Duchamp wrote to accompany it.) It is a mystery because it "figures the unfigurable" with its portrayal of a four-dimensional woman.

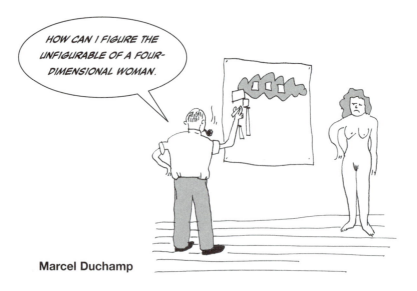

Marcel Duchamp

The idea of art as a *sensory* experience rather than an intellectual experience, paves the way for favoring the image over the narrative and the figural over the discursive. This becomes an important theme in much Postmodern art theory, and seems to liberate everyone from the sterile critiques of art that had come out of much Modernist and sociologically-based art theory from the 1960s.

The Unpresentable

DECONSTRUCTION

In the development of Postmodern thought, **Jacques Derrida** 1930–2004 played a very big role. His prime interest was in language and linguistic theories and he claimed he invented the theory of **Deconstruction** which was to have a huge influence on art and art theory.

Deconstruction is a method of approaching all cultural and visual texts. It aims to take them apart, to understand how they were constructed. It does not take things at their face value.

LISTEN I'M REALLY GONNA WORK THIS ONE OUT FOR MYSELF.

Methods of Deconstruction

Derrida turned Structuralism on its head. He thought that within the system-bound language of Structuralism which Saussure devised, the sign always failed to signify absolutely because it was evolving and not fixed. He also had a problem with the **binary oppositions** that underpin structuralism—the opposition of sign and signifier. This was because binary oppositions like north and south, male and female, black and white always favor one position, which he thought was unacceptable and an illusion. It is this unacceptable illusion, which he called the "metaphysics of presence," that he saw as a foundation for Western culture.

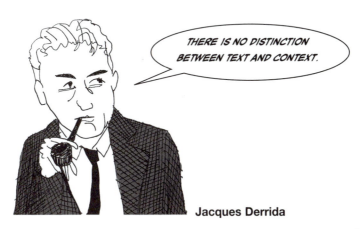

THERE IS NO DISTINCTION BETWEEN TEXT AND CONTEXT.

Jacques Derrida

163

THE TRUTH IN PAINTING

Derrida's main contribution to art theory is his book *The Truth in Painting* 1978. Before Derrida came along most contemporary European aesthetic theory was shaped by Heidegger's ideas of truth in his *Origin of the Work of Art*. Derrida changed the focus of the debate by arguing that one doesn't look into a painting for some great truth, but by examining the wider cultural contexts one begins to understand the missing frame and context of the work of art.

Truth in Painting opens with the words: "Someone, not me, comes and says the words: 'I am interested in the idiom of painting."

This is very Derrida in that from the outset the identity of the narrator is displaced, the whole question of who is setting the discussion is reversed, or put into focus, in order to question the reader's assumptions. Derrida goes on to discuss the possible responses to an historical statement by Cézanne, who said, "I owe you the truth in painting and will tell you." For Derrida, truth in painting is the same as truth in language. It is an impossibility because any truth is both absolute and totalitarian and based on binary oppositions (truth/falsehood). He opts rather to talk *around* painting, to *supplement* it rather than explain it. He points out discrepancies within other theories and is interested in the *effect* and connections that people make when looking at a painting.

For Derrida it would be a complete impossibility to have a definite interpretation of any artwork. All of his work is about how meaning is determined not by the authority of a voice that constructs meaning, but by the missing cultural context that defines it. So revealing the missing frame or context in the work of art is the major concern of *The Truth in Painting*.

In another of his essays, entitled "**Parergon**," a term which is derived from Kant, Derrida sets out an argument saying that Kant makes a distinction between the Greek terms *ergon*, or "work," and *parergon*, or "outside the work." Then Derrida translates, in his own way, parergon as an "accessory, foreign or secondary object," a "supplement," "aside," or "remainder" that is outside of the work. The integrity of the work (*ergon*) depends on the necessary secondariness of the outside (*parergon*) or once again on the context. So *context* for Derrida is everything. That is, everything that is outside of the work.

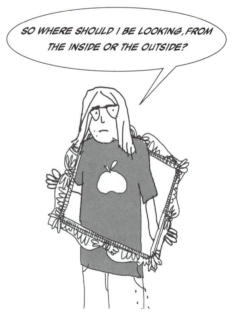

SO WHERE SHOULD I BE LOOKING, FROM THE INSIDE OR THE OUTSIDE?

ARCHAEOLOGIES OF KNOWLEDGE

The French theorist **Michel Foucault** 1926–1984 was less a philosopher than an historian examining "systems of thought." He was interested in why we think the way we do. Foucault employed what he called *archaeology* to investigate power structures and transgression in these systems. One of his best-known studies involves looking at the idea and role of the subject in *madness*. He traces how the concept of madness was invented around 1600 (before then one can't talk of madness because the concept hadn't been formed.) Prior to the Renaissance *mad* people might have been highly regarded for revealing aspects of truth. Madness, he suggested, was silenced by, firstly the institution of law, which designated madness as a *crime,* and secondly the institution of medicine, that saw madness as *an illness*. Foucault used a similar methodology to look at the idea of homosexuality, which he saw as a 19th-century invention by the same institutions. Prior to that time the binary opposition between homosexual and heterosexual did not, he suggests, exist and ill-defined sexual acts may or may not have been regarded as transgressive.

His writing on the British philosopher **Jeremy Bentham's** 1748–1832 *Panopticon*, a courtyard-style prison where a single guard could watch a whole host of inmates, has been highly influential for artists. Its analogy of sight, surveillance and power was seen to correspond with the concept and organization of the structure of the *gaze*.

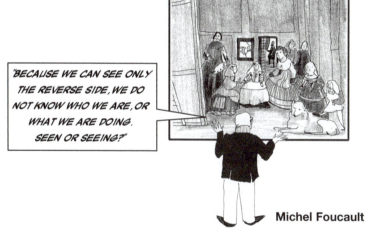

"BECAUSE WE CAN SEE ONLY THE REVERSE SIDE, WE DO NOT KNOW WHO WE ARE, OR WHAT WE ARE DOING. SEEN OR SEEING?"

Michel Foucault

Foucault often wrote about painting. In his study of **Velasquez's** *Las Meninas* 1656, he saw the picture as a radical departure from earlier art, being a self-conscious "representation of representation" itself. In **Magritte's** *Treachery of Images* 1929 (better known as *Ceci n'est pas une pipe*) he recognized a painting where word and image are unusually given equal status. His essay *Of Other Spaces* 1967 has also been seen as important for art. Here he spoke of *heterotopias* or enacted *mixed* and nonperfect utopias. These included nudist colonies and old people's homes, that don't so much reflect a "perfect utopian" vision of society but rather present an alternative *realized* vision. With his discussion of how heterotopias mirror society, analogies can be drawn with how art may similarly operate.

THE DEATH OF THE AUTHOR

An idea that became central to early Postmodernism was the "death of the author." Although the roots of this theory can be traced back to Hegel, and it is undoubtedly indebted to Structuralism, it is more closely associated with **Roland Barthes** 1915–1980 and **Michel Foucault.**

Semiotics, as we have seen, shows that 'signs' have no fixed meanings. They operate only in relationship to other elements within the same system. One of the consequences of looking at art within this methodology is that art becomes just another system. This results in the *meaning* of an artwork being revealed by deconstructing the system.

In his essay ***The Death of the Author*** 1968 Barthes sees the artwork or text as an assemblage of unoriginal ideas that operate in relationship to each other, and that can be deconstructed. Part of the traditional idea of author-ship is that you *originate* or create something new. Within Structuralism this is impossible.

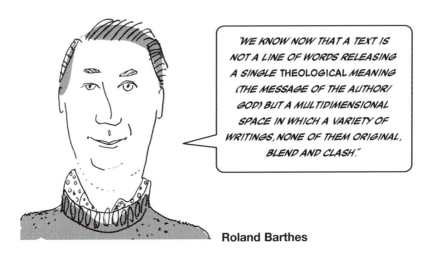

'WE KNOW NOW THAT A TEXT IS NOT A LINE OF WORDS RELEASING A SINGLE THEOLOGICAL MEANING (THE MESSAGE OF THE AUTHOR/ GOD) BUT A MULTIDIMENSIONAL SPACE IN WHICH A VARIETY OF WRITINGS, NONE OF THEM ORIGINAL, BLEND AND CLASH."

Roland Barthes

Foucault responded to this essay a year later with *What is an Author?* This essay, like that of Barthes, sees the idea of a singular author as a fiction. This creation is necessary as it gives the reader the ability to locate a supposed single voice that governs the whole text. Foucault gives this created fictive author, who cuts and pastes a whole plethora of unoriginal ideas, a function—the *author function*. This is to sort these different ideas and voices "separating one from the other, defining their form and characterizing their mode of existence."

Structuralism and the idea of the "death of the author" also asks us to question the importance of the artist's intentions when making a work of art. This is because, as with any text, it is the reader who creates the meaning when they decipher the work.

Who cares what the artist *thinks* he has made a painting of, it is your interpretation that is important. It is how you read the signs.

EVERYONE CAN BE AN ARTIST

The German artist **Joseph Beuys** 1921–1986 was sacked from teaching at the prestigious Düsseldorf Academy in 1972, for accepting all the applicants who applied to the sculpture course he ran. He thought that everybody could be an artist and that his teaching was his greatest art. He developed politicized installations and performances, that were initially based on a semifictitious account of his past. Apparently, as a pilot in the Second World War, he was shot down over the Crimea, and subsequently looked after by nomadic tribespeople who wrapped him in fat and felt to keep him warm. He later came to mythologize this *experience* in his artworks.

Beuys modeled himself as a shamanistic guru and saw his art as directly relating to society. He developed a type of social sculpture. In one work he planted 7,000 oak trees throughout Europe's suburbs. A lot of his performances can be seen as an extension of his teaching; in some he gave lectures or enacted a personal moralistic position—such as when he lived for four days with a coyote in a New York gallery.

Joseph Beuys *I Like America and America Likes Me* **1974**

SIMULATION AND HYPERREALITY

HELP WHERE HAS THE REAL GONE? I'VE REALLY LOST IT NOW.

The ideas of **Simulation** and **Hyperreality** put forward by the French sociologist **Jean Baudrillard** b.1929 were very influential for art theorists trying to describe much Postmodern art.

Baudrillard states that the Postmodern age has become very confused as to what is real and what is a reproduction. In fact, he goes so far as to state that we have lost the ability to differentiate between them. He is *not* saying that everything is artificial, because for us to recognize the artificial we need to know what is real. That is the problem.

For Baudrillard there has been a progression of three main orders of the *simulacrum,* or *representation,* since the Renaissance. In the first order, Premodern culture, we can clearly recognize a copy as a representation of the real. In the second order, brought about by 19th-century industrialization and mass production, the copy has become harder to separate from the real. Where is the original in a photograph or print for example? In the third order of the simulacrum, which is the Postmodern age, the representation *determines* the real. Do we now know something is real because we actually know it as a reproduction? Baudrillard questioned the reality of the first Gulf War (1991), which in the West he thought was seen purely as a reproduction. It had a foregone conclusion, was fought using technology reminiscent of video games and was broadcast live on television.

PAINTING? PHOTOGRAPH? PRINT? PLASTIC? OR REAL?

WHAT IS REAL?

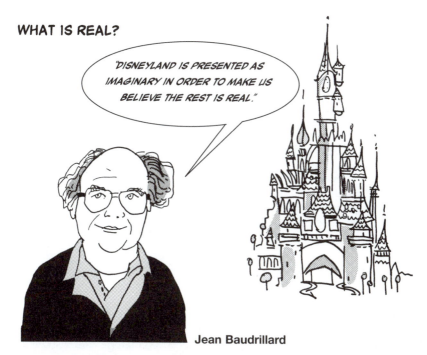

"DISNEYLAND IS PRESENTED AS IMAGINARY IN ORDER TO MAKE US BELIEVE THE REST IS REAL."

Jean Baudrillard

One way the loss of the *real* might manifest itself in an artwork is through the mixing of genres, styles or signs. This is not a unique phenomenon of Postmodernism (some aspects of genre-mixing are present within Modernism as well—in **James Joyce's** 1882–1941 *Ulysses* 1922 where each chapter employs a different literary style for example) but it does seem to be more self-conscious in Postmodernism.

As the American critic **Hal Foster** b.1955 has noted it is because:

"... THE (POSTMODERN) ARTIST BECOMES A MANIPULATOR OF SIGNS MORE THAN A PRODUCER OF ART OBJECTS, AND THE VIEWER AN ACTIVE READER OF MESSAGES RATHER THAN A PASSIVE CONTEMPLATOR OF THE AESTHETIC..."

Hal Foster

By using things out of their original context—and combining found objects (or ideas) artists can create new meanings. Sometimes this can be done with a D-I-Y attitude.

169

BRICOLAGE

The concept of bricolage or Do-It-Yourself (France's leading D-I-Y store is called Monsieur Bricolage) has been used to describe the way that fragments of found quotations or actual objects can be combined within Postmodern art practice. A painting by **Julian Schnabel** b.1951, for example, could contain references and quotations from all sorts of historical styles of painting, all put together in a *make and do* aesthetic.

CLAUDE LEVI-STRAUSS
The anthropologist **Claude Levi-Strauss** used the term *bricolage* in **The Savage Mind** 1962 to describe how early man thought, (so the pre-Modern echoes the Postmodern). The art *bricoleur* picking up material and using it in an improvised manner is not acting irrationally. He is *making do,* using what is *at hand,* often with great sophistication and creativity.

"MYTHICAL THOUGHT FOR ITS PART IS IMPRISONED IN THE EVENTS AND EXPERIENCES WHICH IT NEVER TIRES OF ORDERING AND REORDERING IN ITS SEARCH TO FIND THEM A MEANING. BUT IT ALSO ACTS AS A LIBERATOR BY ITS PROTEST AGAINST THE IDEA THAT ANYTHING CAN BE MEANINGLESS WITH WHICH SCIENCE AT FIRST RESIGNED ITSELF TO A COMPROMISE."

Claude Levi-Strauss

THE ALLEGORICAL IMPULSE

Allegory has been a part of art since Classical times, but in Postmodernism it took on a new significance. **Craig Owens** 1950–1990 in *The Allegorical Impulse* 1980 puts forward the idea that allegory was resurfacing in Postmodern art. Allegory is when one narrative might mean another—like **George Orwell's** 1903–1950 *Animal Farm* 1945, where a story about pigs is actually a story about Communism in Europe. Owens developed his theory of allegory from Walter Benjamin's text on Baroque German drama. In Postmodern art, objects may be seen as having allegorical meanings—a garden gnome isn't any longer an innocent gnome, but a kitsch signifier of consumerism and taste.

For Owens, artists who use *appropriation*—or "who generate images through the reproduction of other images"—are showing how these representations hold multiple meanings. Artists, like **Sherrie Levine** b.1947 who faithfully re-photographed **Edward Weston's** 1886–1958 photographs from the 1930s, present us with one thing, but ask questions about originality, authorship and the way art is made.

A lot of Postmodern work seems to use *parody*, which is the repeating of something with a type of knowing distance. Warhol's studio, the Factory, might be seen as parodying a real factory and in doing so questions the creative process. His *Oxidation Paintings* 1977–1978 (made by urinating on metallic canvases—which then permanently oxidize) loosely resemble the drips and splatters of a Jackson Pollock and so parody Abstract Expressionist painting and even perhaps refers to the alcoholism prevalent within that earlier soul-searching movement.

A Kitsch Signifier

POSTMODERNISM AND LATE CAPITALISM

The American critic **Frederic Jameson** b.1934 wrote a highly influential account of Postmodernism in ***Postmodernism, or The Cultural Logic of Late Capitalism*** 1984. He believed Postmodernism was a natural outcome of late multinational capitalism. In this phase of capitalism Jameson saw the individual becoming more and more removed from having any real contact with the economic systems that they were a part of, and therefore losing touch with the real. Jameson wrote extensively on art and culture. He saw postmodernism as celebrating "a new kind of flatness or depthlessness, a new kind of superficiality in the most literal sense," and as an aesthetics of commodity-driven populism.

"THE DEGREE ZERO OF CONTEMPORARY CULTURE; ONE LISTENS TO REGGAE, WATCHES A WESTERN, EATS MACDONALD'S FOOD FOR LUNCH AND LOCAL CUISINE FOR DINNER, WEARS PARIS PERFUME IN TOKYO AND RETRO CLOTHES IN HONG KONG."

Frederic Jameson

Jameson revisited Heidegger's ideas of truth in art when he compared van Gogh's painting of a peasant's shoes with **Andy Warhol's *Diamond Dust Shoes*** 1980. Whereas Heidegger found truth and being in van Gogh, Jameson saw *surface* and *blankness* in the Postmodern Warhol.

OTHERNESS

The idea of *other,* "that which is different from you but also defines you," can be traced back to the writings of Hegel. It was however, really developed in psychoanalysis and the writings of Freud and later **Jacques Lacan** 1901–1981. Within feminism, identity politics and postcolonial discourse, the idea of the other has been useful as it enables theorists to focus on the way one culture speaks about another. There is a tendency for one culture or gender to misrepresent another culture or social group by investing in it opposite values to those it claims its own, as with Orientalism.

Jacques Lacan **Sigmund Freud** **Georg Hegel**

The **mirror-stage,** in psychoanalytic theory, is used to describe the moment a baby (through looking in a mirror) realizes that it is an entity in itself and disconnected from the rest of the world. This stage reflects a binary opposition, that of self and other. Within psychoanalytic theory this opposition is something we all experience, but within some cultures this process—that of *othering*—is associated with disempowerment.

Lacan distinguishes between the Other (with a capital "O") and the other (with a small "o"). The 'other' (small 'o') he sees as representing others like oneself. It is a dialogue with this other that helps to form the human ego. The Other (capital "O") is different. It represents what he calls the "epitome of symbolic difference"—the center which gives the subject identity. This Other creates identity and does so by misrepresentation.

OH?

For feminist critics, the concept of the masculine norm that defines and distances itself from woman is a powerful one. In **Simone de Beauvoir's** 1908–1986 book *The Second Sex* 1953 she sees women as being defined by the ways they are different from men—they are Other.

Otherness, in Feminism, centers on how gender (recognized masculine and feminine qualities) is constructed by the dominant male society. Gender, it is suggested, is composed of a set of socially imposed systems that encode sexual difference; which are prescribed by "the powerful" in an unbalanced binary opposition.

Many woman artists have embraced this idea of the female construct, the most well known example is **Cindy Sherman** b.1954 who photographed herself in her *Untitled Film Stills* 1977–1980 as a variety of B-Movie stars.

THAT'S O WITH A CAPITAL "O"

Simone de Beauvoir

THE ABJECT IN ART

Postmodernism recognizes and tries to address the limitations of binary oppositions, which always preference one position. It is therefore possible to see Postmodernism as *postmale*, *postwhite*, and *posthumanist*.

The theorist **Julia Kristeva** b.1941 has contemplated the premirror stage as a tool to think about how the unconscious can present deeply buried representations of self and other. In the premirror stage, she suggests, there is a formless circulation of sexual impulses traversing the child's and the mother's bodies, both inseparable in the child's view. Kristeva sees art as able to present this unconscious liminal moment, in the same way that psychoanalysis can.

"(THE ABJECT IS) THE PLACE WHERE MEANING COLLAPSES, THE LIMINAL, THE BORDERLINE, THAT WHICH DEFINES WHAT IS FULLY HUMAN AND WHAT IS NOT. IT IS PRECISELY THAT WHICH CANNOT BE IMAGINED, AT THE EDGE OF MEANING, WHICH THREATENS TO ANNIHILATE THE EXISTENCE OF THE SOCIAL SUBJECT."

I CAN TELL I'M NOT GOING TO GET ANYWHERE FAST WITH THIS DAME.

Julia Kristeva

Kristeva saw the *abject*, as she termed it, as that which was borderline to the body and society. A corpse, for instance, is an example of the abject as it reminds us of our own mortality. So do other functions like vomiting, excreting and menstruation. The abject was an area of great interest for artists in the 1990s. It was felt that a new movement, one that was in part derived from Surrealism, was in the process of forming. Although encompassing all sorts of styles abject art tended to shock by incorporating and using unpleasant materials. Sculptures might be made of shit, or hair, or blood and there was a definite confrontational and sexual content in much of the work. **Mike Kelley** b.1954 created sculptures out of soiled children's toys and, as for **Paul McCarthy** b.1945—it was all ketchup, bodies and heavy breathing!

I ONLY WANTED A CUDDLE.

Two French theorists **Hélène Cixous** b.1937 and **Luce Irigaray** b.1930 are also important in this Postmodern discourse on gender. Both of these theorists further developed Poststructuralist ideas about the position of vision within Western culture and how that culture was, wait for it:

PHALLOLOGOCULARCENTRIC!!

Hélène Cixous	**Luce Irigaray**

Which means: (phallo) male (logo) rational (ocular) centered on sight.

Both Cixous and Irigaray developed theories about language. These were based on writing rather than sight (painting or drawing). They felt that language was by default a male construction. Consequently this language made women speak as though they were *male,* so they proposed a new *écriture féminine* (female writing). Their texts, for example are quite poetic and sentences might be left half-finished, with meanings derived from rhythms as well as written words. Irigaray was far more political and separatist than Cixous. Cixous thought the development of an *écriture feminine,* was available to all, regardless of gender, because it was merely opposed to *male-orientated* language.

PSYCHOANALYTICALLY DECONSTRUCTING
THE MALE *GAZE*

A text that had a huge impact on understanding the *male gaze* and how the idea of a *gaze* operates was put forward by the critic **Laura Mulvey** b.1941. In *Visual Pleasure and Narrative Cinema* 1975 she uses a psychoanalytical approach to deconstruct how women are portrayed in Hollywood films. She considered that the portrayal of women within film is always passive—and for the pleasure of an audience which is male. Women, of course, watch films, but in traditional cinema it is a male audience that is addressed as it is the male audience that holds power in a unequal *phallocentric* world. From a psychoanalytical viewpoint, the female figure in a film represents a threat to the male audience. The way the male counters this is through the pleasure of looking (voyeuristic-scopophilia) by eroticizing the woman or by casting her as an embodiment of guilt.

FORMLESSNESS

The idea of *l'informe* or formlessness relates to the abject. The concept of *l'informe* begins with the writing of the surrealist **Georges Bataille** 1897–1962. When Bataille was editing the Surrealist journal *Documents* 1929–30 he wrote a *Critical Dictionary,* an anti-dictionary of odd phrases and ideas. One of the entries is on *l'informe*. Bataille describes *l'informe* as something that 'brings things down' the opposite to form and structure, something a bit like 'spit'! This idea of 'bringing down' links with other of Bataille's concepts such as eroticism, and baseness, ideas that, like *l'Informe,* are an attack on high-minded Humanism. In his essay **"Base Materialism and Gnosticism,"** Bataille criticizes a distinction between form, which is idealized, and base materialism, which is "external and foreign to human aspirations." He talks of eroticism as being the basis of the sacred, and scatology as an expressive value. By using such concepts Bataille questioned philosophical order and tradition through baseness, trash, and violence.

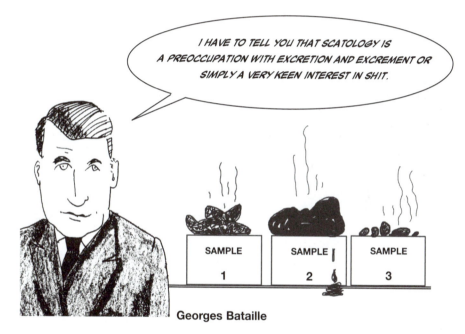

Georges Bataille

An interesting exhibition *L'informe: mode d'emploi (Formless: A User's Guide)* in Paris in 1996 looked to the concept of *l'informe* as a way of reading (or rereading) a history of Modernism—to make a link or trajectory between the interests and concerns of the Surrealists and some Modernist painting (notably Jackson Pollock, with his drips and fallen cigarette-ends), and then on to the neo-avant-gardes (of the 1960s) and finally to the radical Postmodern artists (like Cindy Sherman and Mike Kelley). The exhibition can be seen as an attack on Greenberg's Formalism, and, even though it included Greenberg's favorite artist Pollock, it read his work in a very different way. Pollock's canvases were being admired not as autonomous formal arranged surfaces but rather as scatological splattered and debased ones.

ENTROPY

The American artist **Robert Smithson** 1938–1973 is famous for his large earthwork *Spiral Jetty* 1970 at the Great Salt Lake in Utah. This work, like many other of Smithson's projects, can be seen to illustrate his theory of entropy, which seems to echo ideas of *l'informe*.

Entropy is the **Second Law of Thermodynamics**. For Smithson it showed that order is unstable and easily lost. This loss of order, this instability, and openness to change was something Smithson tried to build into his artworks. His art was all about accepting that things get created and then they decay. The *Spiral Jetty* changes and submerges over time. It is not stable.

Robert Smithson

RHIZOMES

During the late 1990s and early 2000s **Gilles Deleuze's** 1925–1995 philosophy and writing has become very influential for artists and theorists. Indeed it was so highly respected by Foucault that he claimed the 20th century would be remembered as the "Deleuzian century." Deleuze's work is complex and can roughly be split into three groupings. He has: written monographs on past philosophers and philosophical concepts; written about individual artists and art forms, especially cinema; and coauthored works with the psychoanalyst **Felix Guattari** 1930–1992, including the huge two volume opus *Capitalism and Schizophrenia* 1983–1987. This is how Deleuze describes this coauthored work:

"WE DON'T CLAIM TO HAVE WRITTEN A MADMAN'S BOOK, JUST A BOOK IN WHICH ONE NO LONGER KNOWS—AND THERE IS NO REASON TO KNOW—WHO EXACTLY IS SPEAKING, A DOCTOR, A PATIENT, AN UNTREATED PATIENT, A PRESENT, PAST OR FUTURE PATIENT. THAT'S WHY WE USED SO MANY WRITERS AND POETS, WHO IS TO SAY IF THEY ARE SPEAKING AS PATIENTS OR DOCTORS ... THE PROCESS IS WHAT WE CALL A FLUX... THE FLUX IS A NOTION THAT WE WANTED TO REMAIN ORDINARY AND UNDEFINED. THIS COULD BE A FLUX OF WORDS, IDEAS, SHIT, MONEY, IT COULD BE A FINANCIAL MECHANISM OR A SCHIZOPHRENIC MACHINE: IT GOES BEYOND ALL DUALITIES. WE DREAMED OF THIS BOOK AS A FLUX-BOOK."

Felix Guattari **Gilles Deleuze**

Deleuze was no essentialist and thought that ideas and organisms had a predisposition to change or *become*, so this meant he was opposed to ideas of being. His idea of becoming is central to all his thinking. His concepts of "difference and repetition" neatly capture the openness of his system. As Deleuze has a problem with being, he sees each manifestation of an idea as totally different, as an original "mode of assembling the world," and as a creative *repetition*. He saw contemporary thought as structured and evolving like a non-hierarchical matrix. So ideas would not have a *tap root* but *rhizome roots*—like creeping plants—with masses of potential exits and entries.

Deleuze was also interested in film because: "It brings to light an intelligible content which is like a presupposition, a condition, a necessary correlation through which language constructs its own *objects*." What Deleuze is getting at here is that cinema is not about deciphering a language but produces an "open and extending affect." His book on the painting's of **Francis Bacon** 1909–1992, *The Logic of Sensation* 1981, follows a similar theme, looking at *sensation* or *affect* in the artworks, which leads Deleuze to think about various specific ideas, such as the figural, color, and sensation itself.

QUEER THEORY

In the discussions about art and identity, the question of how groups and ethnicities are represented and thought about is important, as is the question of *subjectivity* and how subjectivity is given or constructed. In the last two decades **Judith Butler** b.1956 has become influential in this debate. She is a philosopher, a critic, a feminist and a radical political theorist who is more accessible than many other academic writers. In her books *Gender Trouble* 1990 and *Bodies That Matter; On the Discursive Limits of Sex* 1993 she talks about the problem of gender identity. Her work is very wide-ranging, but her central idea about the *performative* nature of sexuality is seen as particularly radical.

"THERE IS NO GENDER IDENTITY BEHIND THE EXPRESSIONS OF GENDER... IDENTITY IS PERFORMATIVELY CONSTITUTED BY THE VERY EXPRESSIONS THAT ARE SAID TO BE ITS RESULTS."

Judith Butler

What Butler is critiquing is the idea that gender is a fixed essence — a natural reality that underpins everything we do. She sees no correlation between *sex* (male, female) and *gender* (possessing masculine or feminine qualities) and *desire* (as being directed towards the opposite gender). This argument, that gender and desire are flexible, clearly undermines the stable and accepted notions of gender, being determined by sex, that operates in most cultures, and which is reinforced by theorists such as Sigmund Freud.

THERE IS NO ORIGINAL OR PRIMARY GENDER, A DRAG IMITATES, BUT GENDER IS A KIND OF IMITATION FOR WHICH THERE IS NO ORIGINAL.

Butler is saying that gender *becomes* what it is in a process of social and cultural interaction and development. So *practice* is more important than *essence*.

Butler's ideas are important to **queer theory**, which also draws on the archeological investigations into the constructs of sexuality by Foucault. She challenges the concept of people having essentialist or definite identities based on gender or sexuality. By *queering* perspectives and certainties through reflection on the experiences of the gay, lesbian, bisexual and transgender communities, queer theory addresses the perceived constructs of the individual subject as well as mainstream society.

THE BODY AS A BATTLEGROUND

Judith Butler's discussions about gender and sexuality bring to the fore the question of *the body,* a topic which has been prominent in recent art theory.

Women artists, in particular, have discussed the changing relationships between women, the body and its representation in art and in so doing have critically challenged the dominant discourses of art theory. Obviously the way in which the female body has been represented throughout history reflects ideas about women, sexuality and femininity which are now being powerfully reconsidered. However, it is not just women artists who think about the body, and how it is represented in art. Everyone has a body, and the way that they inhabit it, and think about it, is a fundamental part of being human. The *reality* of the body, and of its conception and corporeality, has become important for a number of complicated reasons:

1 Due to recent developments in Feminism, and psychoanalytic theory, there has been a major reconsideration of the commonsense notion that the body is solely a natural biological entity. The physical body is seen as not having to necessarily define gender.

2 Questions of sexuality, sexual orientation, and sexual health all center on the body.

3 After Foucault the body was rethought as the site of discourses about the physical; the Descartian mind/body split was no longer seen as a viable principle.

4 There has developed a counter discourse about the female body which attacked the phallocentrism of classic Freudian ideas and proposed theories of sexual difference that did not mark out the female as the site of *lack* or secondary, inferior discourses.

5 The role of the body in colonial discourse challenges the assumption of biological differences and inferiority to the Eurocentric white body.

6 The *medicalization* of the body in recent history—that is both the medical and consumerist refashioning of the body in terms of both medical panics, like AIDS, and the rise of a culture of reshaping the body by plastic surgery.

7 The cult of the body endemic in fashion, body building, tanning, the perfect body of the celebrity culture and of narcissistic consumerism.

Somehow in the last twenty years the very nature of being human, of inhabiting a body, has become much more problematic. The body has been radically refigured and contested and the complex anxiety about human subjectivity, which is commonplace in Postmodern thought, has informed a great deal of current art.

181

DIGITAL

In the last two decades computers and microchips have transformed many aspects of life and the way people think and act. The creation of a *digital world* has had many impacts. It has produced both dazzlingly sophisticated "information technology" and created "information poverty" for those people who cannot access this new world. Some theorists see the digital as having created an entirely new realm of imagination and human consciousness.

Marshall McLuhan 1911–1980 thought that technology ushered in the potential of interconnected global villages, and, although his ideas predate the vast expansion of digital communication, they have proved highly influential when theorizing the digital. As McLuhan said in 1964: "Today, after more than a century of electric technology, we have extended our central nervous system in a global embrace, abolishing both space and time as far as our planet is concerned."

Others, like **Paul Virilio** b.1932, are less optimistic about the digital embrace because, while the digital world allows one to be everywhere at once, it also means one is nowhere at all.

There are, though, a number of key realities that seem to make art and the art world so different in today's digital climate:

1 The arrival of the Internet (or World Wide Web). The Internet originated as the ARPAnet in the 1960s (Advanced Research Projects Agency Network). The first ARPAnet message was sent in 1969, but the system crashed as the sender got to G in **LOGIN**. The first web cam image broadcast in 1991 was a coffee pot outside a room at Cambridge University. The Internet took off big time in the late 1990s with the arrival of *navigators, search engines,* and what theorists call the condition of *hypertextuality*—or the interconnectedness of all texts.

2 Artists were quick to start making artworks using the Web, or about its theoretical implications.

3 Some artists see *virtuality* as an entirely new globalized artworld separate from the old museums and centers of control.

4 As some forms of knowledge are transformed by being storable, digitalized, interconnectable and capable of being transformed by artificial intelligence, some theorists see ideas of authenticity as only predigital.

KEY CYBERTHEORISTS ARE

Donna Haraway b.1944 issued *A Cyborg Manifesto* in 1985. She saw the constructed identity of a *cyborg* as a creative way of thinking about the *individual*. As a feminist she questioned the construction of female identity and said she would rather be a cyborg than a goddess as she saw: "Nothing about being female that naturally binds women. There is not even such a state as 'being' female, itself a highly complex category constructed in contested sexual scientific discourses and other social practices."

Sherry Turkle b.1948 who, in *Life on the Screen: Identity in the Age of the Internet* 1995, investigated how questions of identity are confused by cyberculture. As a Postmodern psychologist she even sees the *role playing* that can be done on the internet as having the potential to be therapeutic.

Sadie Plant b.1964 in *Zeros and Ones: Digital Women and the New Technoculture* 1997, connects aspects of cyberculture with Feminism, showing both the involvement of women in early computing but also the possibility of the new nongendered spaces that virtuality creates.

"IT IS AN INTERESTING OBSERVATION THAT A CULTURE THAT SEEMS SO BENT ON STANDARDIZATION, CENTRALIZATION, HIERARCHIES, ETC.-THE COMPUTER BEING THE EPITOME OF ALL THAT-SHOULD BE DEVELOPING INTO A CULTURE WHICH SEEMS TO DEMAND QUITE THE OPPOSITE. SUDDENLY, THE SKILLS WHICH HAVE BEEN PROMOTED SO MUCH IN THE PAST-THAT IS A STRAIGHTFORWARD AND VERY LOGICAL WAY OF THINKING , I.E. THE CLASSIC MALE THINKING-BEGINS TO BECOME QUITE DYSFUNCTIONAL."

Sadie Plant

Sean Cubitt b.1953 in his book *Digital Aesthetics* 1998 connects the digital with the history of aesthetics, and argues that the digital offers a new, true, democratic space, and that digital arts are vital to its development.

Lev Manovich b.1960 has also advanced theories about the impact of the digital in the arts. In *Soft Cinema: Navigating the Database* 2004 he looks at how software impacts on art making for both filmmakers and other artists, enabling them to address the new contemporary sociocultural *conditions* in which we live. While *The Language of New Media* 2001 provides a theoretical account of the digital, and tries to answer, "What are the ways in which new media relies on older cultural forms and languages and what are the ways in which it breaks with them?"

MUSEUMS

Museology is the theory of what museums do. If you think about it for a moment, museums and art galleries are absolutely central to the current development of art, they pretty much shape and define a lot of what goes on in the art world. So what is a museum or art gallery for?

One view is that museums were historically the institution in which the discourses of *dominant* art were drawn together to produce bourgeois culture in the age of Imperialism. In other words, as the art historian **Donald Preziosi** b.1941 puts it: "Since its invention in late 18th-century Europe as one of the premier epistemological technologies of the Enlightenment, the museum has been central to the social, ethical, and political formation of the citizenry of modernizing nation-states."

Very recently of course everyone has begun to rethink what museums are about, or should be about, and this has had very interesting consequences. **Tate Modern** is an example of how a new breed of *super museums* has set out to reinvent themselves and to try and transform the relationship between art, audiences and government. This is a difficult process but many museums around the world are attempting similar things, in part because art is increasingly seen as one aspect of *cultural policy* an area that governments are keen to develop as part of the new information age.

The central questions are: What do museums and art galleries do? Who decides what they do? And can all art be accommodated by the museum?

Tate Modern, London

Since the 60s artists have been engaged with questioning the dominance and authority of the museum. At that time, artists like **Daniel Buren** b.1938 made works that offered an *institutional critique* by reflecting on the social, cultural and aesthetic conditions in which they were shown. More recently **Andrea Fraser** b.1965 has taken this practice to the new cultural spaces of the super museums, when she made a video work of an eroticized audio tour describing the curvaceous architecture of the ‑**Guggenheim Museum** in Bilbao.

SLEEPING IN MUSEUMS

In 1998 the French philosopher and critic **Nicolas Bourriaud** b.1965 published a collection of essays that aimed to define a new tendency he had observed in recent international art. His theory of *relational aesthetics* was based around the observation that a lot of artists were making work that was interactive and was aimed not at an elite gallery audience, but at casual observers or passersby. In such work the artist acts as an *organizer* and invites people to participate in some form of activity.

Examples of relational art include work like the stall that the artist **Gabriel Orozco** b.1962 set up in a public square. It sold and distributed oranges, thereby creating a visible community of people who had visited it. In another work Orozco put up a hammock for anyone to use in the garden at New York's MoMA. This sort of work deals with ideas of community and participation. The artist takes a back seat and waits for us to relate to his or her idea and so help create the piece.

The British art historian **Claire Bishop** b.1979, writing in the journal *October,* saw relational art's engagement with the public sphere as idealized, romantic and verging on kitsch. She favored a more *political* approach that would better describe the lack of social harmony in contemporary society. She discussed the work of **Santiago Serra** b.1966, who makes work by paying people to do useless things, like asking the attendants at a museum to hold up all the heavy furniture, or poor workers to have a line tattooed on their backs, which reflects on the hidden value of labor in society—so less 'relational aesthetics' and more 'relational antagonism'.

IT'S ALL JUST VISUAL CULTURE ...

We are now in a culture that has produced so many conflicting theories as to what art is, and so many diverse art practices, that it is hard to be sure of what art is anymore. Perhaps we shouldn't talk about it as though we do know. With the old split between art and craft or avant-garde art and kitsch thrown into question, it has been suggested that it is more useful to regard art as part of a larger visual culture. This idea stresses that art is just one element in a wider culture of visual products (no better or no worse)—decorative designs, clothes, video games and the like. For such theorists this visual culture can then be studied using a model from cultural studies or the *new art history,* that is one that looks at the ways or reasons that art objects might be made in relation to questions within the broader culture, in relation to the positions of, say, power structures, gender or technology.

One trouble with the visual culture model is that not all art is visual. Some contemporary artists, for instance, work with sound or other nonvisual media. Perhaps we have to say "it's all just culture ..."

The theoretical point to make is that everything we started off associating with art—beauty, function, cultural purpose and even technique—has been thrown into question in the Postmodern world. Art is a form of visual curiosity, which means that it is always in some sense about how we view ourselves and others in the world. It is this "aesthetics of curiosity" that underpins many of the ideas that artists and art theorists have been, and still are, engaged with.

READING LIST

Many theoretical texts by artists and philosophers are republished in:
Art in Theory 1900–2000, eds. Charles Harrison and Paul Wood, Blackwell Publishers, 2002.
Feminism-Art-Theory, An Anthology 1968–2000, ed. Hilary Robinson, Blackwell Publishers, 2001.
Art in Theory 1815–1900, eds. Charles Harrison, Paul Wood, Jason Gaiger, Blackwell Publishers, 1998.
Art in Theory 1648–1815, eds. Charles Harrison, Paul Wood, Jason Gaiger, Blackwell Publishers, 2001.

Good books on art theory include:
Theory Rules: Art as Theory/Theory and Art, by Jody Berland, University of Toronto Press, 1996.
But Is It Art?: An Introduction to Art Theory, by Cynthia Freeland, Oxford Paperbacks, 2002.
Art Theory: An Historical Introduction, by Robert Williams, Blackwell Publishing, 2003.
Art and its Objects, by Richard Wollheim, Cambridge University Press, 1980.

The best historical surveys on art are:
The Story of Art, by E.H. Gomrich, Phaidon Press, 1995.
A World History of Art, by Hugh Honour and John Fleming, Laurence King, 2002.

Introductions to Modern and contemporary art include:
Art Since 1900: Modernism, Antimodernism and Postmodernism, by Hal Foster, Rosalind Krauss, Yve-Alain Bois, Benjamin Buchloh, Thames & Hudson, 2004.
This Is Modern Art, by Matthew Collings, Weidenfeld Nicolson, 2000.
Art Today, by Brandon Taylor, Laurence King Publishing, 2004.

The disciplines of art history are discussed in:
The New Art History: A Critical Introduction, by Jonathan Harris, Routledge, 2001.
Critical Terms for Art History, Robert S. Nelson and Robert Shiff, University of Chicago Press, 1996.
The Art of Art History: A Critical Anthology, by Donald Preziosi, Oxford Paperbacks, 1998.

Broad overviews on visual culture are:
Visual Culture Reader, by Nicholas Mirzoeff, Routledge, 2002.
The Feminism and Visual Culture Reader, by Amelia Jones, Routledge, 2002.
The Nineteenth Century Visual Culture Reader, by Vanessa R. Schwartz, Routledge, 2004.

And if you get stuck on any terms or words:
Megawords, by Richard Osborne, Sage Publications, 2002.